Basic Perspective Drawing

Basic Perspective Drawing
a visual approach

John Montague

VNR Van Nostrand Reinhold Company
New York

For Julian and Alexandra

Printed in the United States of America

Published by Van Nostrand Reinhold Company Inc.
115 Fifth Avenue
New York, New York 10003

Van Nostrand Reinhold Company Limited
Molly Millars Lane
Wokingham, Berkshire RG11 2PY, England

Van Nostrand Reinhold
480 La Trobe Street
Melbourne, Victoria 3000, Australia

Macmillan of Canada
Division of Canada Publishing Corporation
164 Commander Boulevard
Agincourt, Ontario M1S 3C7, Canada

16 15 14 13 12 11 10 9 8 7 6 5 4

Library of Congress Cataloging in Publication Data

Montague, John, 1944–
 Basic perspective drawing.

 Includes index.
 1. Perspective. 2. Drawing—Technique. I. Title.
NC750.M648 1985 742 84-20987
ISBN 0-442-26653-7 (pbk.)

Contents

Preface

The goal of this book is to provide a clear and accessible introduction to the principles and techniques of perspective drawing. Since linear perspective is essentially a mode of interpreting the visual world, a conscious attempt has been made to avoid the tedious verbalization of visual information. Wherever possible, the illustrations have been allowed to speak for themselves and the text reduced to comments, notes, and labels that support the visual images.

The material is organized so that it can either be used as a reference source or studied sequentially. Part One is designed to provide a general orientation and overview. The subsequent sections address specific aspects and problems of perspective drawing but, because perspective is an integrated system, each section draws on and illuminates the others. Individual goals and needs will ultimately dictate the best manner in which the book can be utilized.

Linear perspective is by no means *the* correct or universal way of seeing, yet it relies on assumptions and principles that provide a consistent, unified system of visual representation. Perspective drawing is a skill, which can be acquired, like other skills, through the mundane processes of observation and practice. Once understood, even on the most superficial level, the principles and techniques of perspective representation can become an indispensable tool in both the conceptualization and expression of visual ideas.

For every advantage gained from a particular system of representation, other possibilities are lost. Thus, linear perspective is only one of many representational systems and is certainly not always the most useful or appropriate technique.

In normal experience, our eyes are constantly in motion, roving over and around objects and through ever-changing environments.

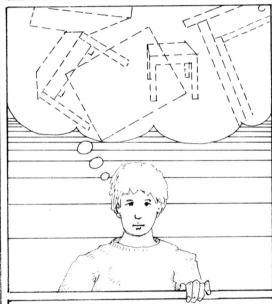

Through this constant scanning, we build up experience data, which is manipulated and processed by our minds to form our understanding or perception of the visual world.

Overview

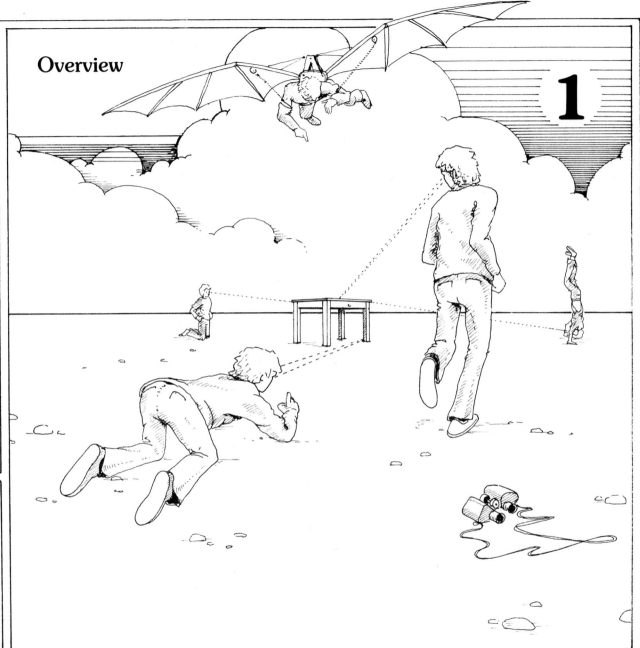

These mental images of the visual world can never be in an exact one-to-one correspondence with what is experienced. Our perceptions are holistic; they are made up of all the information we possess about the phenomena, not just the visual appearance of a particular view.

As we gaze at the object or view, we sense this perceptual information all at once—colors, associations, symbolic values, essential forms, and an infinity of meanings.

Thus, our perception of even such a simple object as a table is impossible to express completely. Any expression of our experience must be limited and partial.

Our choice of what can or will be expressed is greatly affected by the various limits we self-impose or that are imposed upon us by our culture.

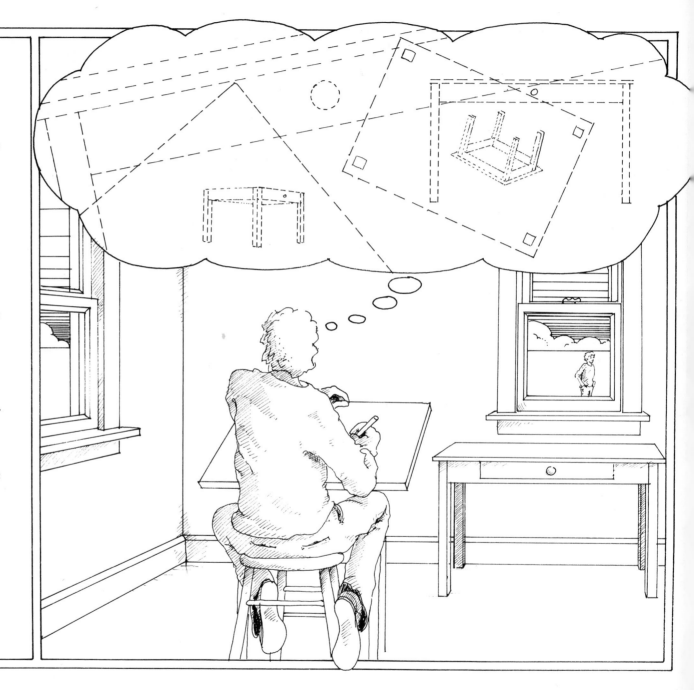

In expressing visual data, individuals and cultures as a whole make choices—some conscious, some unconscious—as to what aspects of their experience of a phenomenon can or should be expressed.

Consider the different images on the right.

Each of these drawings of a table is expressing different sets of information about the table—each is "correct."

A. Several views are presented simultaneously.

B. Parts are separated into measured plans and elevations.

C. Parts are arranged to express feeling, emotions, weight.

D. A single point of view is selected to produce an optical appearance.

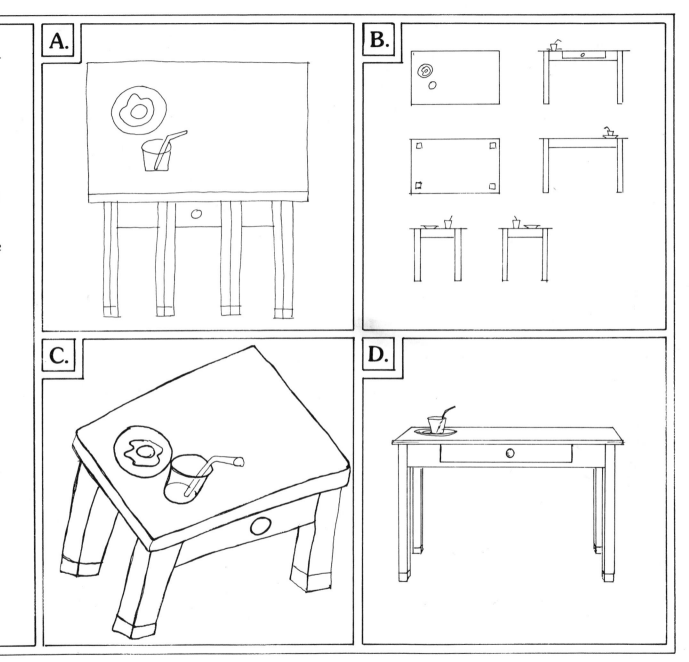

11

For every advantage gained from a particular system of representation, other possibilities are lost. Thus, linear perspective is only one of many representational systems and is certainly not always the most useful or appropriate technique.

Several Points of View

This system of representation has dominated art of the Middle Ages, nonwestern cultures, primitive art, the art of children, and much of the art of the twentieth century. This system represents what is important or what is known about the subject, not just the way the subject appears optically from a single point of view.

One Point of View

This system of representation was established at the time of the European Renaissance (c. 1450). It represents the appearance of reality; that is, appearance from a single point of view, as if traced on a window. Note that this "realistic" view prevents us from seeing the apples and the second cup.

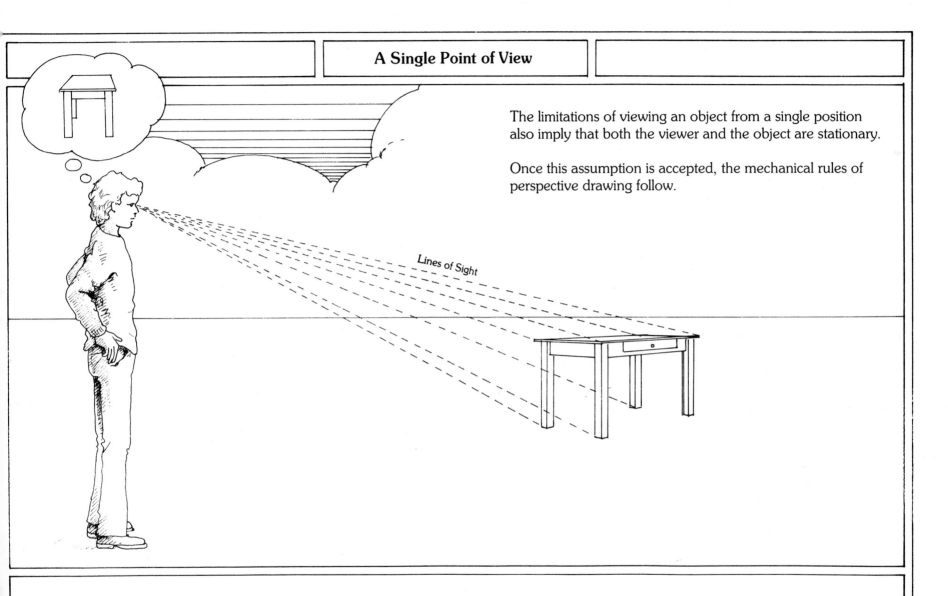

The limitations of viewing an object from a single position also imply that both the viewer and the object are stationary.

Once this assumption is accepted, the mechanical rules of perspective drawing follow.

Lines of Sight

The object reflects light (visual information) in all directions. Only light that is reflected in the direction of the observer's eyes conveys the visual information for the viewer's image of the object.

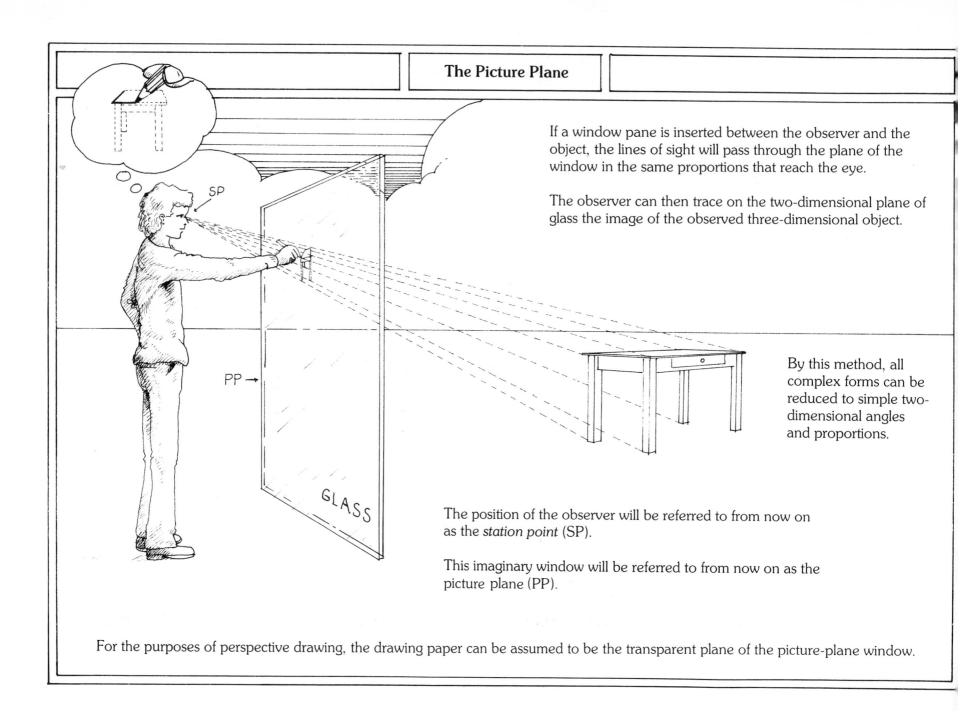

If a window pane is inserted between the observer and the object, the lines of sight will pass through the plane of the window in the same proportions that reach the eye.

The observer can then trace on the two-dimensional plane of glass the image of the observed three-dimensional object.

By this method, all complex forms can be reduced to simple two-dimensional angles and proportions.

SP

PP →

GLASS

The position of the observer will be referred to from now on as the *station point* (SP).

This imaginary window will be referred to from now on as the picture plane (PP).

For the purposes of perspective drawing, the drawing paper can be assumed to be the transparent plane of the picture-plane window.

The illusion of depth in linear perspective is suggested by the relative size, position, and shape of lines on the picture plane. The most obvious of these cues is size. The further away an object, the smaller it appears. This is demonstrated below.

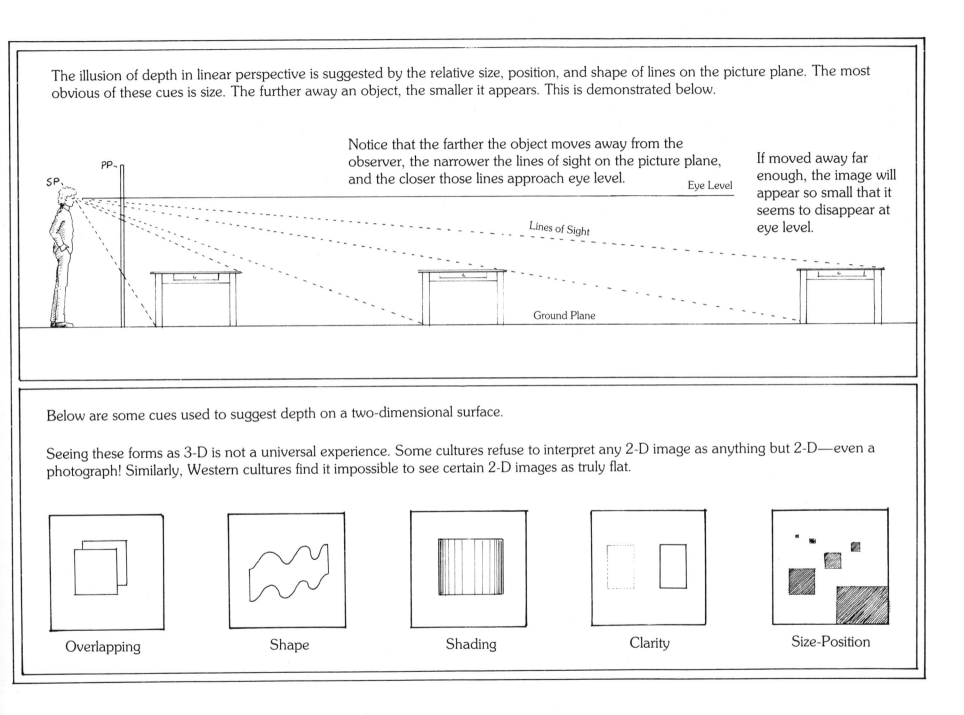

Notice that the farther the object moves away from the observer, the narrower the lines of sight on the picture plane, and the closer those lines approach *eye level*.

If moved away far enough, the image will appear so small that it seems to disappear at *eye level*.

SP

PP

Eye Level

Lines of Sight

Ground Plane

Below are some cues used to suggest depth on a two-dimensional surface.

Seeing these forms as 3-D is not a universal experience. Some cultures refuse to interpret any 2-D image as anything but 2-D—even a photograph! Similarly, Western cultures find it impossible to see certain 2-D images as truly flat.

Overlapping

Shape

Shading

Clarity

Size-Position

15

In relation to the picture plane, all objects moving away from the viewer gravitate toward the viewer's eye level while getting smaller at the same time.

Note that lines parallel to each other in the scene converge toward a common point at eye level, where the distance between them becomes so small, it *seems* to disappear.

The point at which lines converge is called the *vanishing point* (VP).

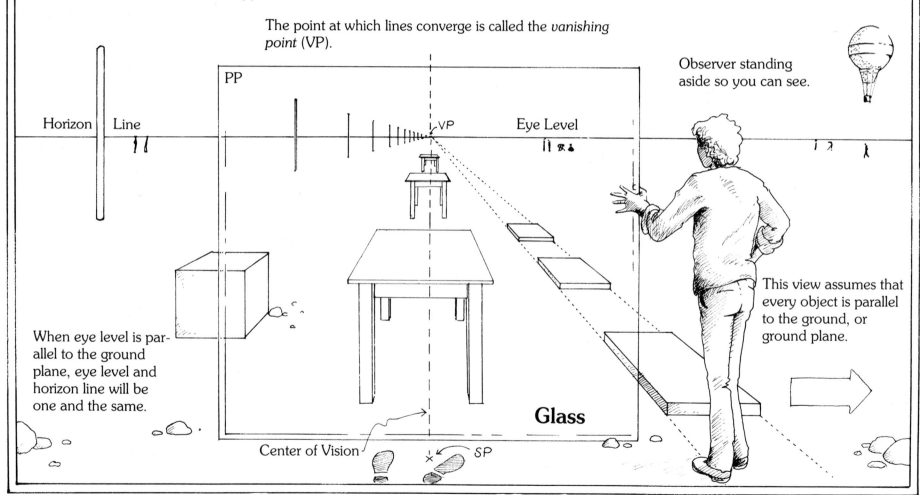

Observer standing aside so you can see.

Horizon | Line

PP

Eye Level

VP

This view assumes that every object is parallel to the ground, or ground plane.

When *eye level* is parallel to the ground plane, eye level and horizon line will be one and the same.

Glass

Center of Vision

SP

16

From the observer's position in space, objects can recede in any direction, not just along lines parallel to the ground.

Therefore, for each observable object, there exists a *sphere of disappearance* encompassing the observer. An object receding in any direction from the observer's point of view (station point) will appear to decrease in size until it reaches the outer limits of its own sphere, vanishing completely.

The size and brightness of the object determine the magnitude of its sphere, if all other factors are equal.

There are as many concentric spheres of disappearance as there are objects observed.

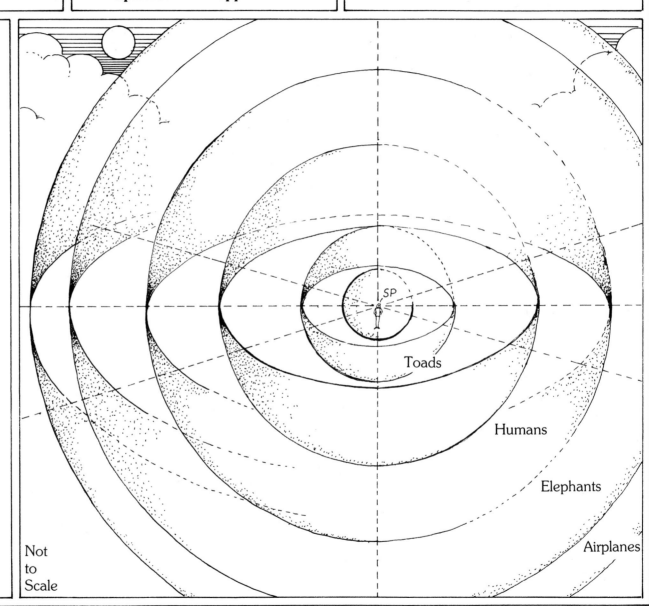

SP

Toads

Humans

Elephants

Airplanes

Not
to
Scale

17

Most of the time, people observe things while their feet are firmly planted on the ground. As a result, spheres of disappearance can be reduced, for practical purposes, to the following types:

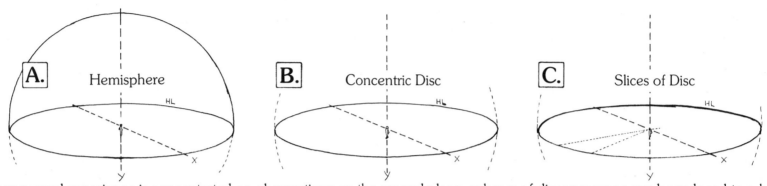

A. Hemisphere **B.** Concentric Disc **C.** Slices of Disc

Since our normal experience is concentrated on observations on the ground plane, spheres of disappearance can be reduced to a horizon line surrounding a disc, analogous to the ground plane (B). Because we can look in only one direction at a time, the disc is reduced to a slice and the horizon line to a segment (C).

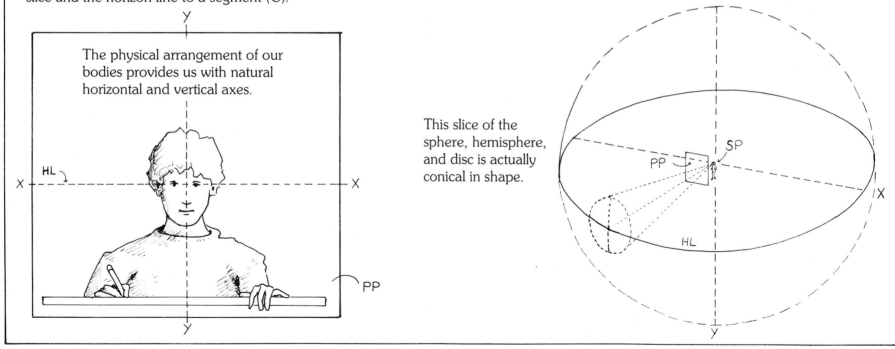

The physical arrangement of our bodies provides us with natural horizontal and vertical axes.

This slice of the sphere, hemisphere, and disc is actually conical in shape.

The parts of our eyes that receive light are hemispherical, each gathering light from a cone of about 150 degrees. When these two cones overlap, we gather light from almost 180 degrees.

Only in the area where the fields from both eyes overlap does binocular vision occur.

Within this broad field of vision, we actually focus clearly through cones of about 30–60 degrees. When objects are outside of these standard cones of vision, we generally consider them to be distorted, as images appear through a wide-angle lens.

Vertically, our vision is limited to about 140 degrees, our sight being cut off by eyebrows, eyelids, and cheeks.

When we use both eyes, our cone of vision is a combination of two overlapping cones, one from each eye.

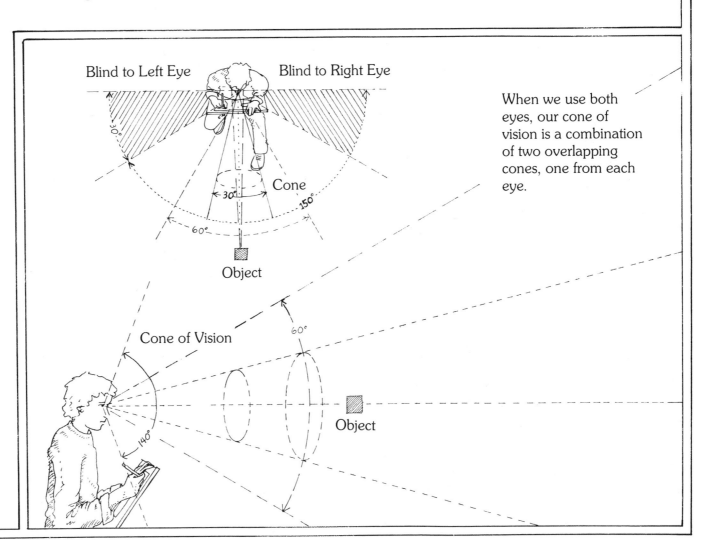

19

Optics of the Eye Relative to the Cone of Vision

Each eye perceives the object from a slightly different angle. This gives the brain a strong cue as to the depth of the object.

The brain harmonizes both two-dimensional views and creates a three-dimensional image.

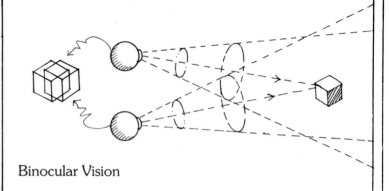

Binocular Vision

In perspective drawing, it is necessary to use only one eye. Remember that the perspective system is based on one point of view.

In other words, the two-dimensional drawing is based upon the two-dimensional view from a single eye.

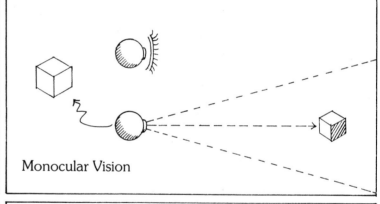

Monocular Vision

Our eyes remain at a constant distance from one another as they angle toward the object of focus. Thus, through a kind of intuitive triangulation, we are aided in estimating the distance to the object. This intuitive aid is lost when only one eye is used; as a result, there will always be a marked difference between the drawn image and the observed world. Stereoscopes and stereo cameras attempt to put this vision back together by showing slightly different views to each eye, thereby creating a sense of depth artificially.

With geometry, one can find distance DC if angles CAD and CBD and length AB are known.

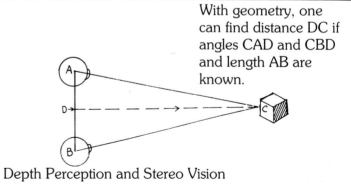

Depth Perception and Stereo Vision

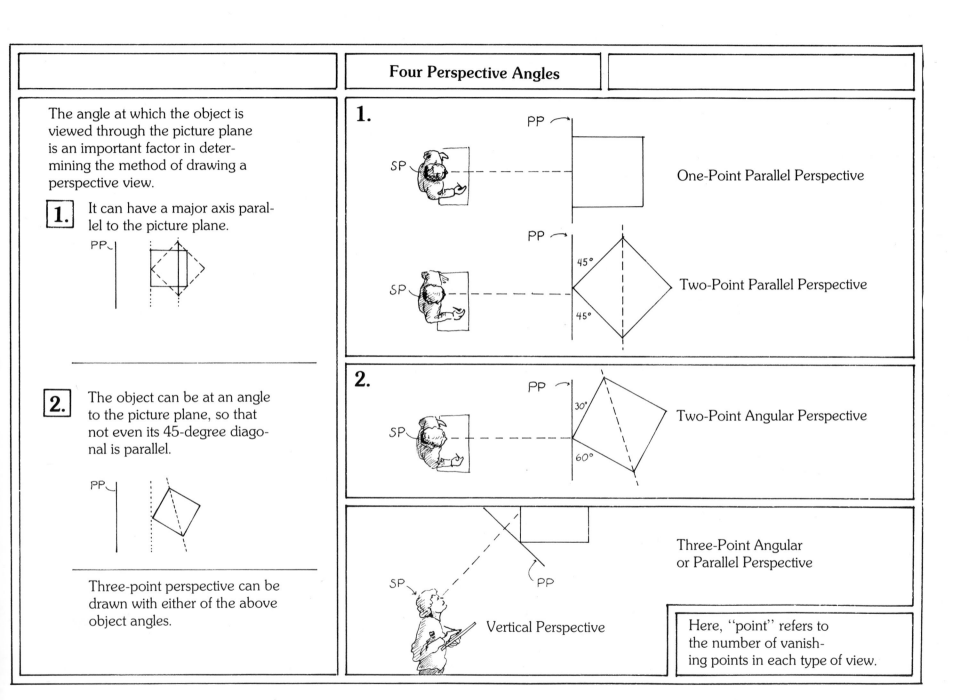

Four Perspective Angles

The angle at which the object is viewed through the picture plane is an important factor in determining the method of drawing a perspective view.

1. It can have a major axis parallel to the picture plane.

2. The object can be at an angle to the picture plane, so that not even its 45-degree diagonal is parallel.

Three-point perspective can be drawn with either of the above object angles.

1.

One-Point Parallel Perspective

Two-Point Parallel Perspective

2.

Two-Point Angular Perspective

Three-Point Angular or Parallel Perspective

Vertical Perspective

Here, "point" refers to the number of vanishing points in each type of view.

21

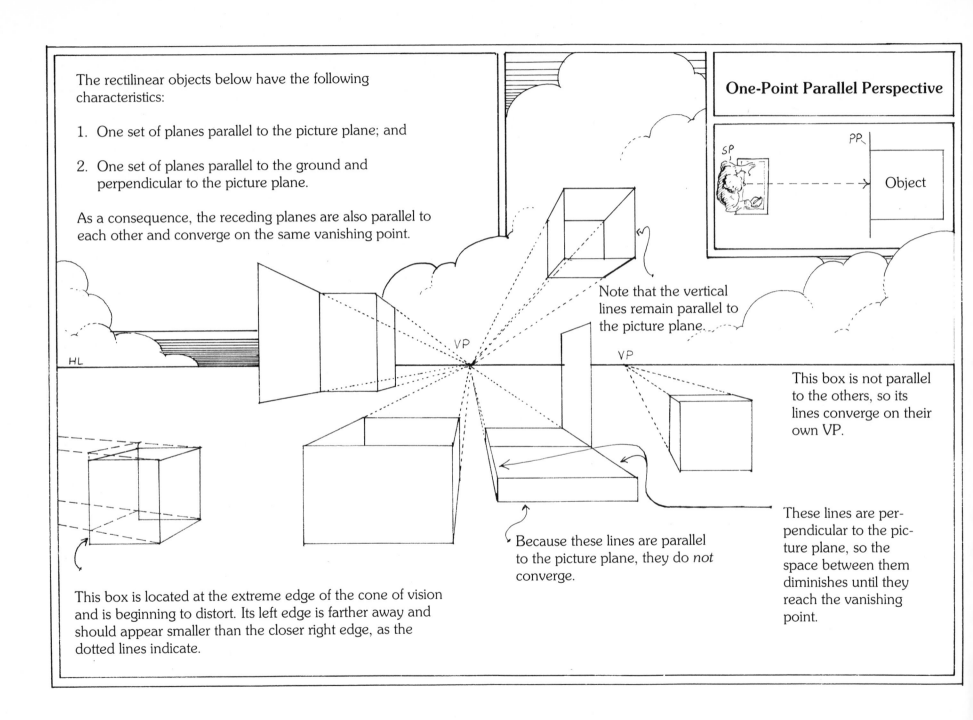

The rectilinear objects below have the following characteristics:

1. One set of planes parallel to the picture plane; and

2. One set of planes parallel to the ground and perpendicular to the picture plane.

As a consequence, the receding planes are also parallel to each other and converge on the same vanishing point.

One-Point Parallel Perspective

SP PP
Object

Note that the vertical lines remain parallel to the picture plane.

VP

VP

This box is not parallel to the others, so its lines converge on their own VP.

HL

This box is located at the extreme edge of the cone of vision and is beginning to distort. Its left edge is farther away and should appear smaller than the closer right edge, as the dotted lines indicate.

Because these lines are parallel to the picture plane, they do *not* converge.

These lines are perpendicular to the picture plane, so the space between them diminishes until they reach the vanishing point.

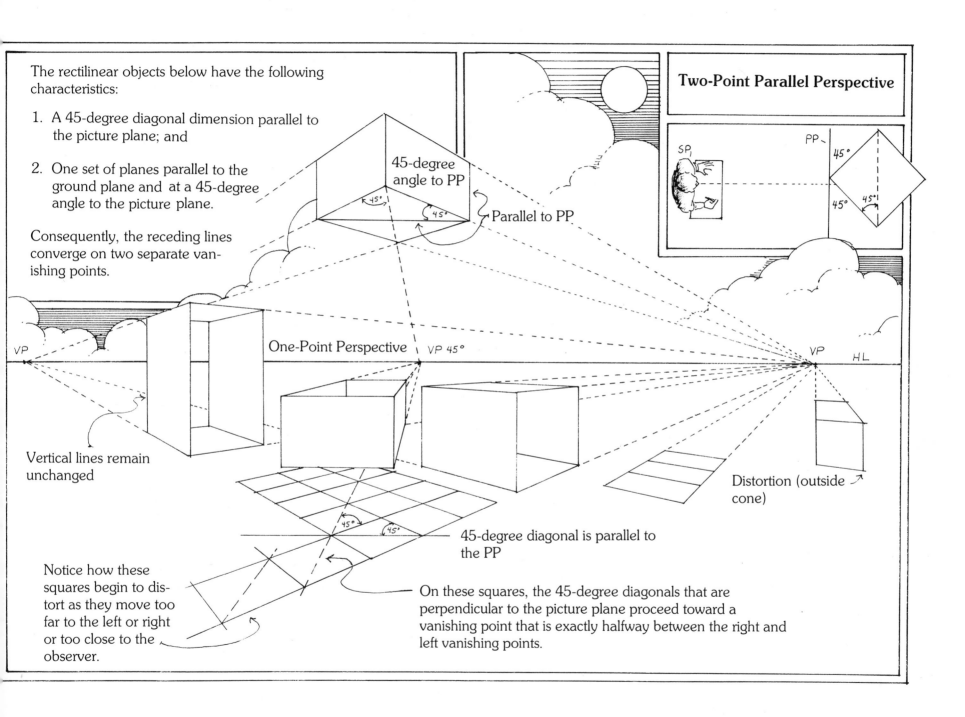

The rectilinear objects below have the following characteristics:

1. A 45-degree diagonal dimension parallel to the picture plane; and

2. One set of planes parallel to the ground plane and at a 45-degree angle to the picture plane.

Consequently, the receding lines converge on two separate vanishing points.

45-degree angle to PP

Parallel to PP

Two-Point Parallel Perspective

One-Point Perspective

VP 45°

VP

HL

Vertical lines remain unchanged

Distortion (outside cone)

45-degree diagonal is parallel to the PP

Notice how these squares begin to distort as they move too far to the left or right or too close to the observer.

On these squares, the 45-degree diagonals that are perpendicular to the picture plane proceed toward a vanishing point that is exactly halfway between the right and left vanishing points.

23

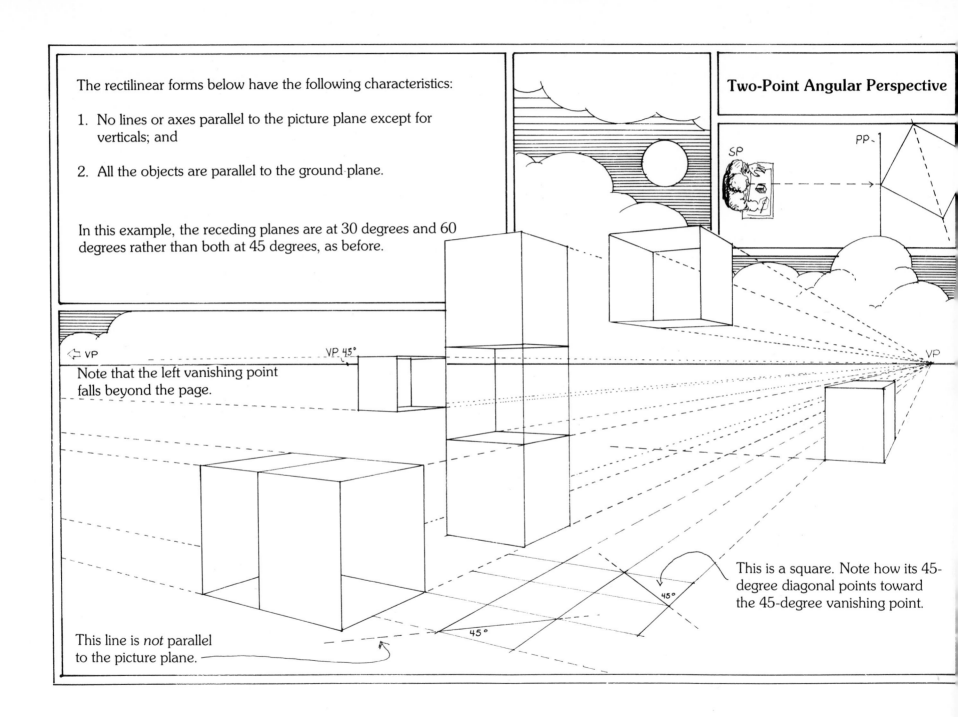

The rectilinear forms below have the following characteristics:

1. No lines or axes parallel to the picture plane except for verticals; and

2. All the objects are parallel to the ground plane.

In this example, the receding planes are at 30 degrees and 60 degrees rather than both at 45 degrees, as before.

Two-Point Angular Perspective

SP

PP

Note that the left vanishing point falls beyond the page.

VP

VP 45°

VP

This is a square. Note how its 45-degree diagonal points toward the 45-degree vanishing point.

45°

45°

This line is *not* parallel to the picture plane.

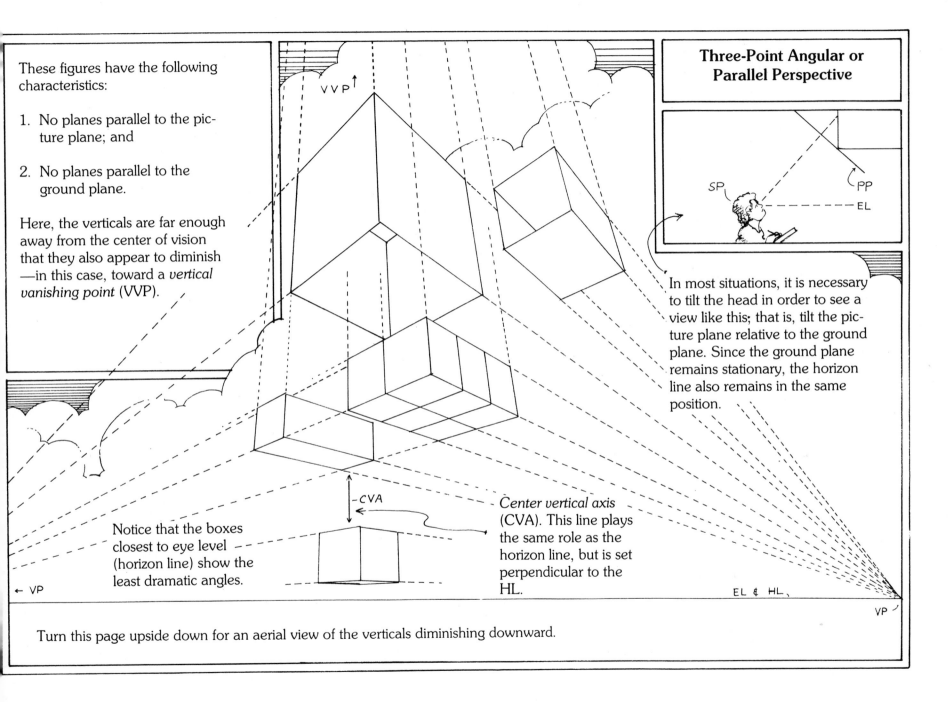

These figures have the following characteristics:

1. No planes parallel to the picture plane; and

2. No planes parallel to the ground plane.

Here, the verticals are far enough away from the center of vision that they also appear to diminish —in this case, toward a *vertical vanishing point* (VVP).

VVP↑

Three-Point Angular or Parallel Perspective

SP PP
 EL

In most situations, it is necessary to tilt the head in order to see a view like this; that is, tilt the picture plane relative to the ground plane. Since the ground plane remains stationary, the horizon line also remains in the same position.

-CVA

Notice that the boxes closest to eye level (horizon line) show the least dramatic angles.

Center vertical axis (CVA). This line plays the same role as the horizon line, but is set perpendicular to the HL.

← VP

EL & HL

VP

Turn this page upside down for an aerial view of the verticals diminishing downward.

25

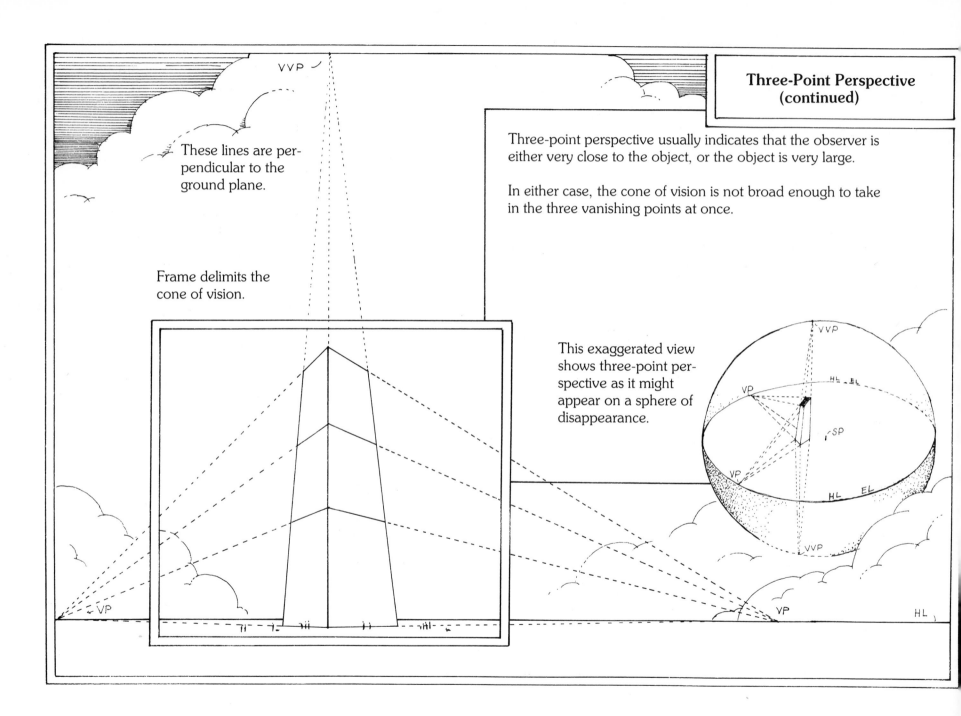

VVP

These lines are per-
pendicular to the
ground plane.

Frame delimits the
cone of vision.

Three-point perspective usually indicates that the observer is
either very close to the object, or the object is very large.

In either case, the cone of vision is not broad enough to take
in the three vanishing points at once.

This exaggerated view
shows three-point per-
spective as it might
appear on a sphere of
disappearance.

VVP

HL EL

VP

SP

VP

HL EL

VVP

VP

HL

VP

26

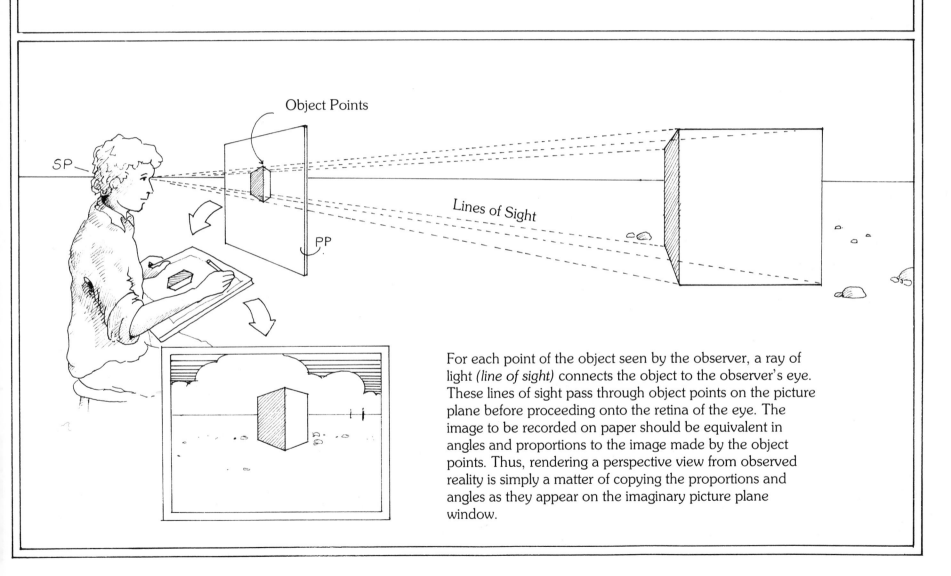

For each point of the object seen by the observer, a ray of light *(line of sight)* connects the object to the observer's eye. These lines of sight pass through object points on the picture plane before proceeding onto the retina of the eye. The image to be recorded on paper should be equivalent in angles and proportions to the image made by the object points. Thus, rendering a perspective view from observed reality is simply a matter of copying the proportions and angles as they appear on the imaginary picture plane window.

Finding Proportions

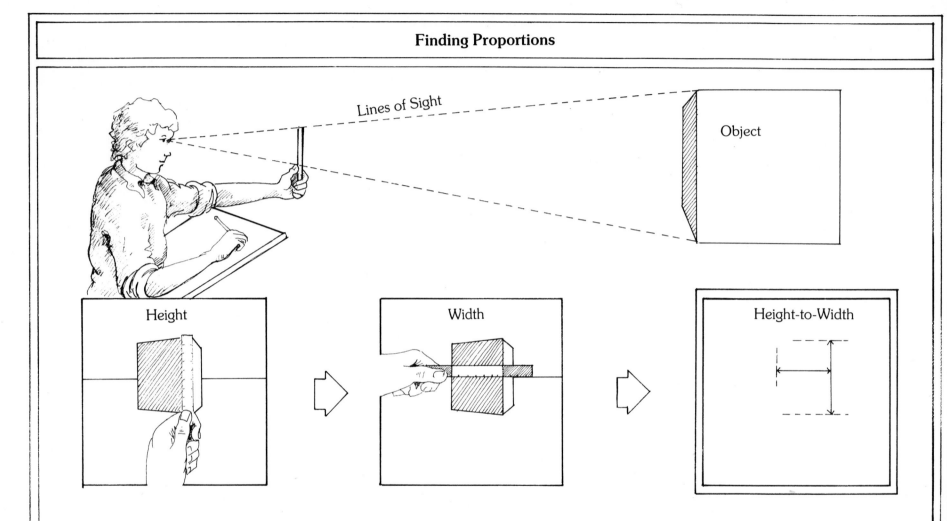

The proportions of an object can be taken from the picture plane window simply by viewing the object over a straightedge held at arm's length. By marking the lengths on the straightedge with the thumb, the height and width can be compared and transferred to the drawing at whatever scale is desired.

Hold the measuring arm straight so that it will always be the same distance from the eye. Remember that the straightedge represents the picture plane.

Finding Angles

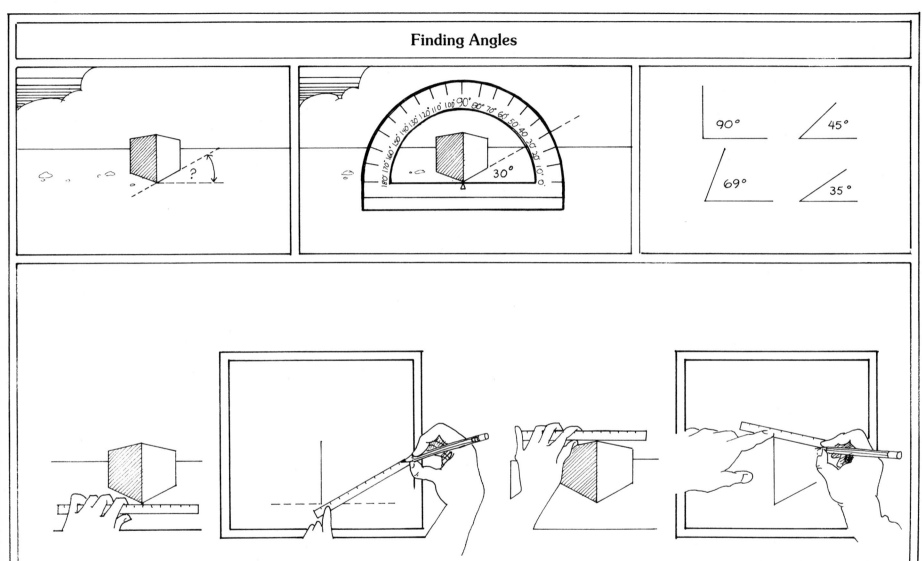

Objects diminishing in size as they recede from the observer appear to form angles relative to the picture plane. In order to determine these angles, one might, ideally, sight them through a transparent protractor and note the degrees of the angles. Since this is usually impractical, align a straightedge with a vertical and/or horizontal line to estimate the angle's shape. If it is not at first obvious what shape a particular angle takes, try comparing it to common angles, such as 90-degree and 45-degree angles, and then note the difference.

Finding the Angles of an Observed Object

If you can copy the angles and proportions of an object or scene, as discussed on the previous page, you can render a correct perspective of any object or space even without knowing the rules of linear perspective. Rendering the images from a view is really nothing more than making a one-to-one match of angles and proportions, as they appear on the imaginary picture plane.

A knowledge of perspective, however, has a twofold value:

1. It saves time, by minimizing the number of measures of proportions and angles that must be taken; and

2. The perspective system is self-correcting. Even if you misread one angle, the completed perspective will point out the error or, at worst, shift the viewpoint slightly.

The following three pages offer some simple steps for rendering perspective views from reality. Note that the basic procedure is to move from the simple to the complex—from essentials to incidentals.

It is critical in any view to establish the horizon line (viewer's eye level) first.

1. Find a vertical line on the object, preferably near you and your center of vision.

2. Find the angle of the receding plane off the vertical line. The farther above or below eye level, the better, since the angle will be more extreme and easier to estimate.

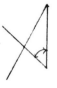

3. Find a second angle on the same side of the vertical line.

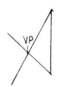

4. The point at which these two lines cross is the vanishing point.

5. Draw a line through this vanishing point parallel to the bottom of the paper (that is, parallel to the bottom of the picture plane). This is the horizon line (eye level).

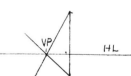

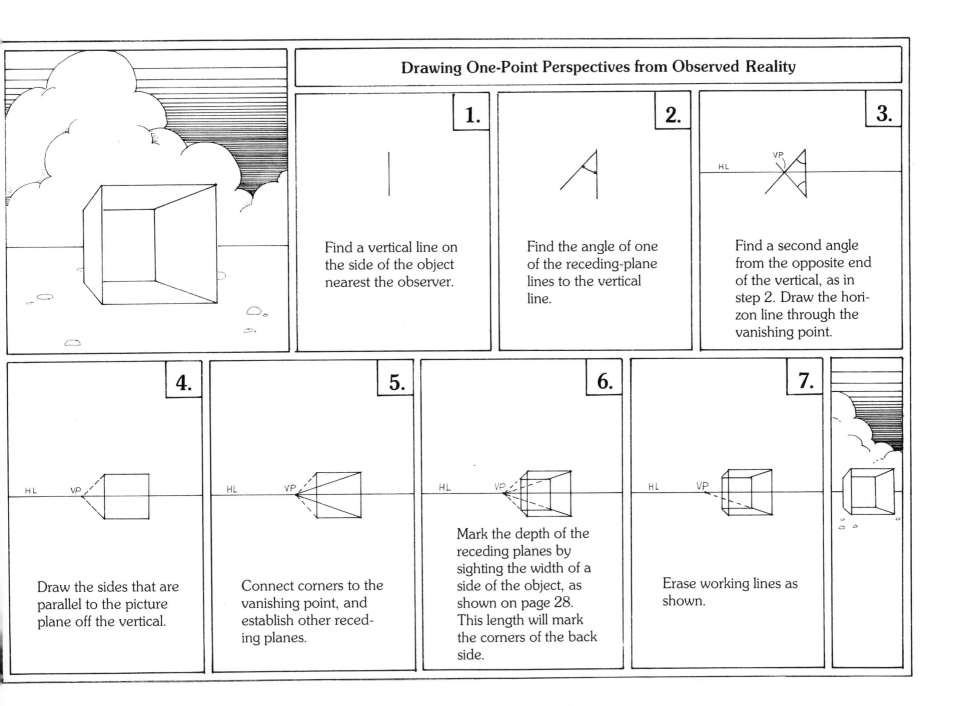

Drawing One-Point Perspectives from Observed Reality

1. Find a vertical line on the side of the object nearest the observer.

2. Find the angle of one of the receding-plane lines to the vertical line.

3. Find a second angle from the opposite end of the vertical, as in step 2. Draw the horizon line through the vanishing point.

4. Draw the sides that are parallel to the picture plane off the vertical.

5. Connect corners to the vanishing point, and establish other receding planes.

6. Mark the depth of the receding planes by sighting the width of a side of the object, as shown on page 28. This length will mark the corners of the back side.

7. Erase working lines as shown.

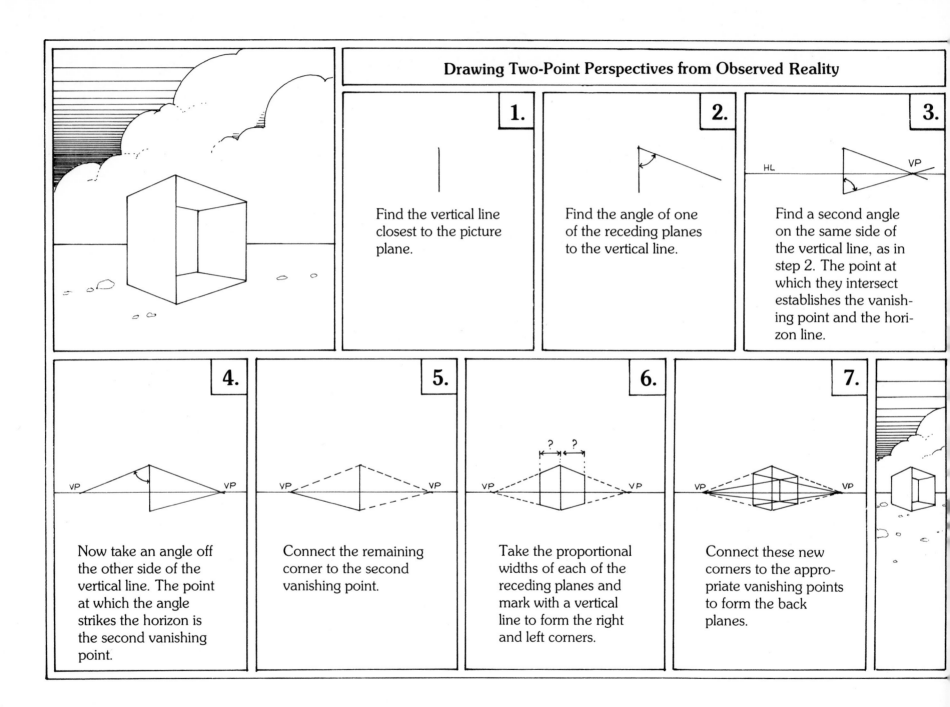

Drawing Two-Point Perspectives from Observed Reality

1. Find the vertical line closest to the picture plane.

2. Find the angle of one of the receding planes to the vertical line.

3. Find a second angle on the same side of the vertical line, as in step 2. The point at which they intersect establishes the vanishing point and the horizon line.

4. Now take an angle off the other side of the vertical line. The point at which the angle strikes the horizon is the second vanishing point.

5. Connect the remaining corner to the second vanishing point.

6. Take the proportional widths of each of the receding planes and mark with a vertical line to form the right and left corners.

7. Connect these new corners to the appropriate vanishing points to form the back planes.

32

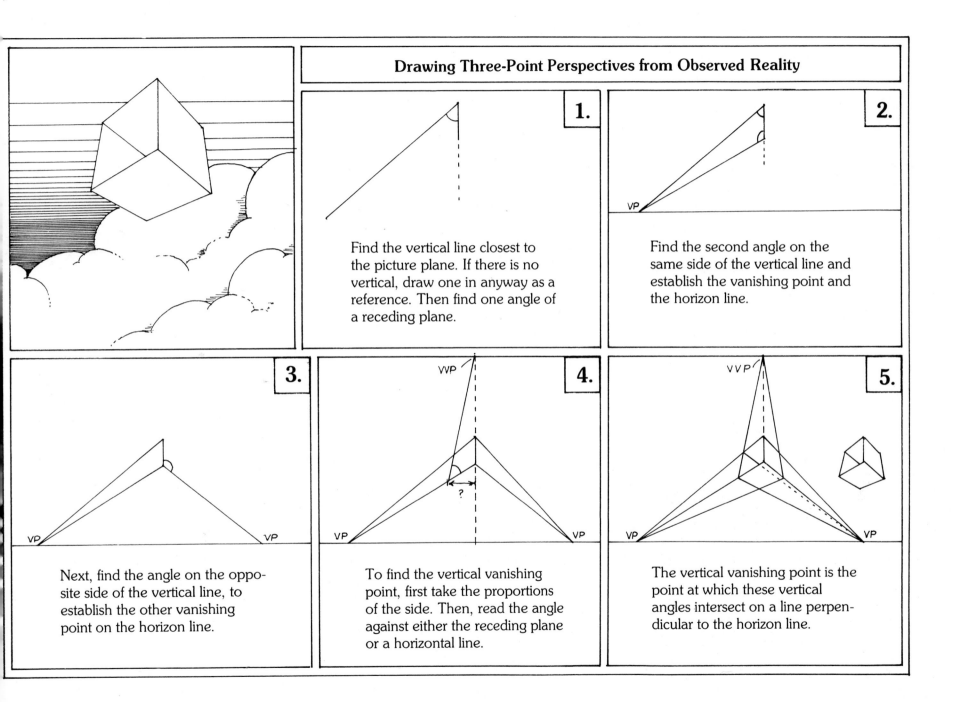

Drawing Three-Point Perspectives from Observed Reality

1. Find the vertical line closest to the picture plane. If there is no vertical, draw one in anyway as a reference. Then find one angle of a receding plane.

2. Find the second angle on the same side of the vertical line and establish the vanishing point and the horizon line.

3. Next, find the angle on the opposite side of the vertical line, to establish the other vanishing point on the horizon line.

4. To find the vertical vanishing point, first take the proportions of the side. Then, read the angle against either the receding plane or a horizontal line.

5. The vertical vanishing point is the point at which these vertical angles intersect on a line perpendicular to the horizon line.

33

Constructing Perspective Views

When rendering perspective views from real objects or models, the view can be controlled only within certain limitations. The great advantage of constructing or making a perspective is that virtually any view can be represented, even if such a view would be impossible to see in a real situation.

In order to construct perspective views, it is necessary to take into consideration certain interconnected variables that will affect the final image.

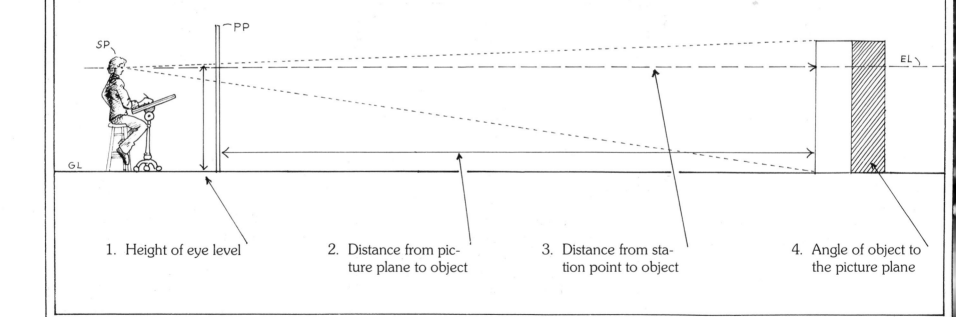

1. Height of eye level

2. Distance from picture plane to object

3. Distance from station point to object

4. Angle of object to the picture plane

On the picture plane, eye level and the horizon are the same.

Thus, if an object is below the horizon line, the top side of the object will be visible.

If the object is divided by the horizon line, neither the top nor the bottom will be visible.

If the object is above eye level, the bottom of the object will be visible.

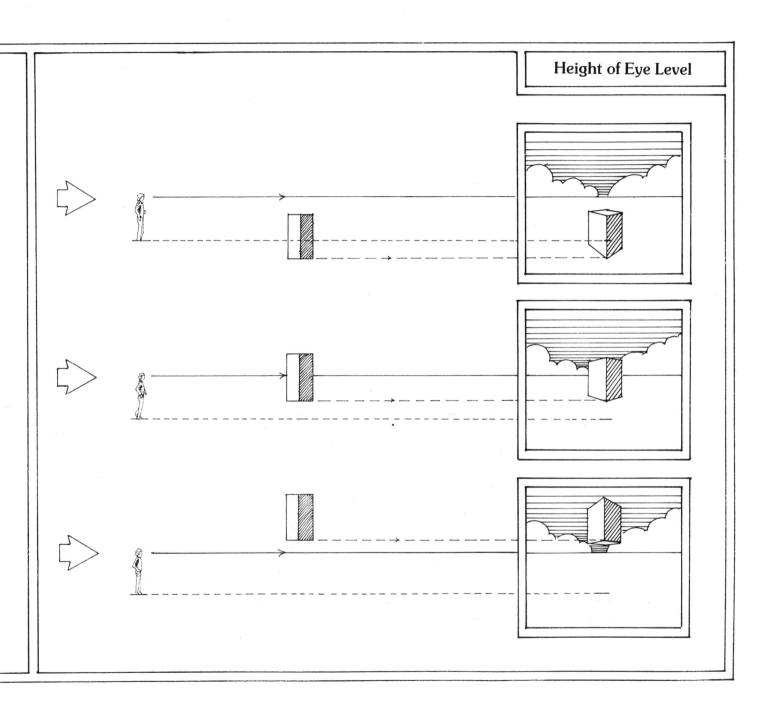

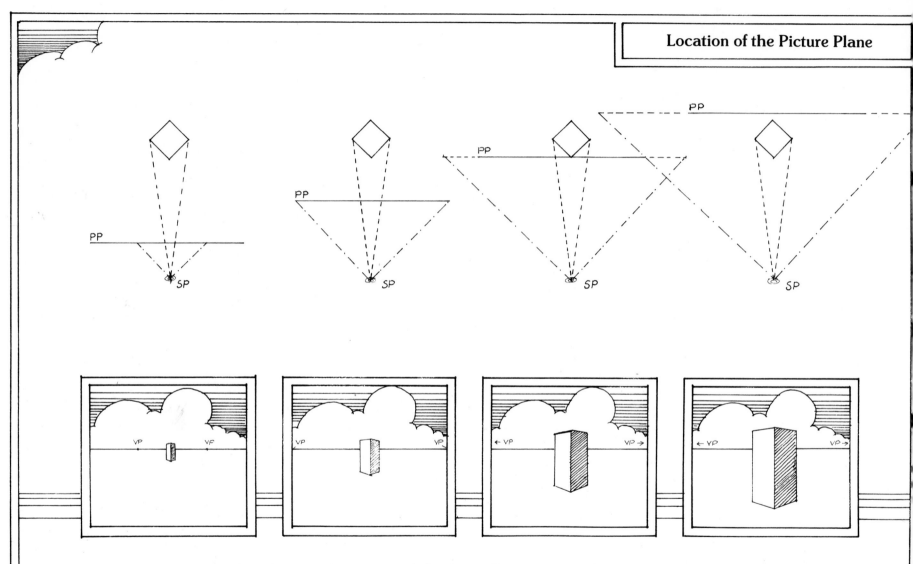

The position of the picture plane in relation to the viewer and the object affects the overall size of the object within the frame, but does not alter the proportions or angles of the image. For the purpose of setting up plans and perspective views, therefore, the picture plane can be assumed to be wherever it is most convenient. Usually, this is at the corner or side of the object closest to the viewer.

A change in the distance between the viewer (station point) and the object directly affects the angles of the receding planes. When the viewer is closer to the object, the angles are more acute; when the viewer is farther away, the angles are more obtuse. Notice also that the farther the viewer moves from the object, the more distant the vanishing points become.

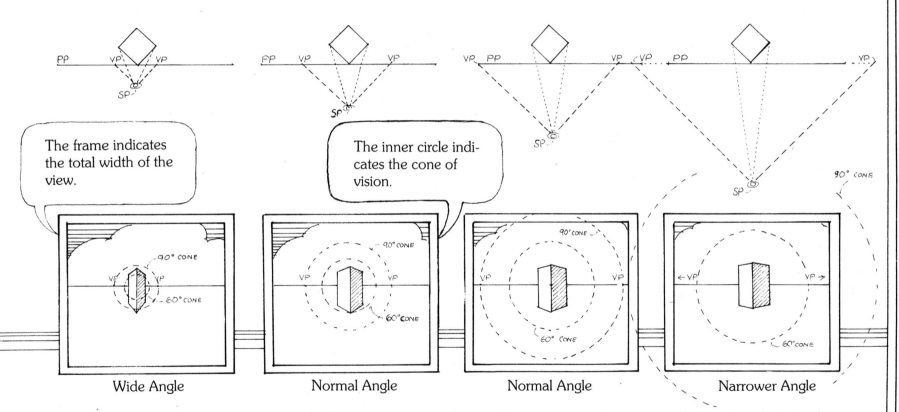

The frame indicates the total width of the view.

The inner circle indicates the cone of vision.

Wide Angle

Normal Angle

Normal Angle

Narrower Angle

The most obvious effect of the distance between the viewer and the object is the relative size of the object. This size is relative to the viewer's cone of vision: when we get close to the object, we focus on a narrower portion of it; when we stand back, we take in a wider view. If we are far off and take in a narrower cone of vision, however, we get the distortions of a narrow-angle view—a telephoto effect.

The angle of the object to the picture plane determines which side or sides of the object will be visible. The angle of the object also determines the position of the vanishing points.

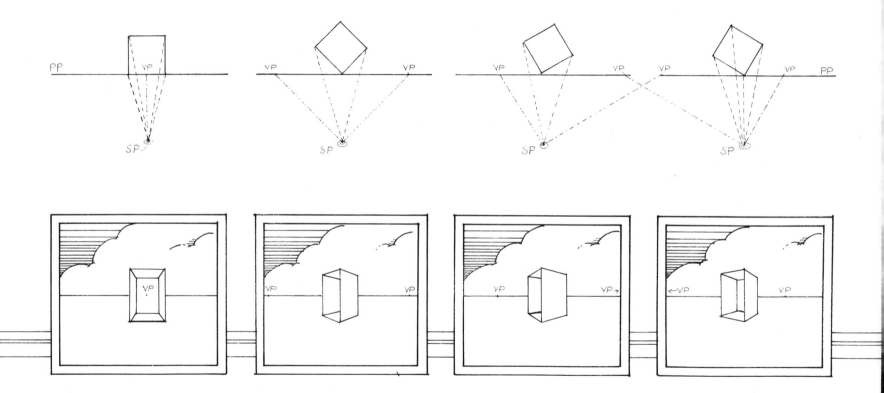

As one vanishing point moves toward the center of the frame, the other moves away, and vice versa. Also note that the vanishing points and station point form a right angle parallel to the right angle of the corner of the object.

Drawing a One-Point-Perspective View from a Plan

By following this simple procedure, you can translate the information contained in the plan of an object into a perspective view.

1.

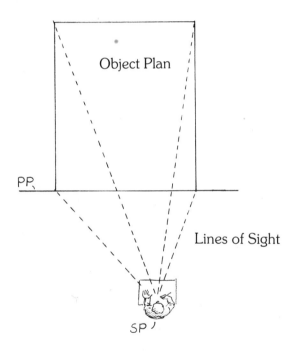

First, draw the object plan. Establish the position of the picture plane and the position of the viewer (station point).

2.

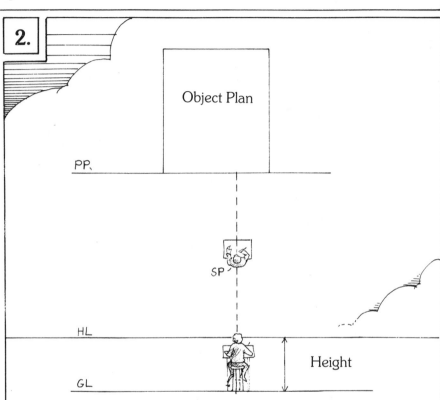

At a convenient distance directly below the station point, draw a horizon line parallel to the picture plane in the plan. (Sometimes the picture-plane line doubles as the horizon line to save space.)

Draw a ground line below the horizon line at a distance equal to the space between eye level and the ground.

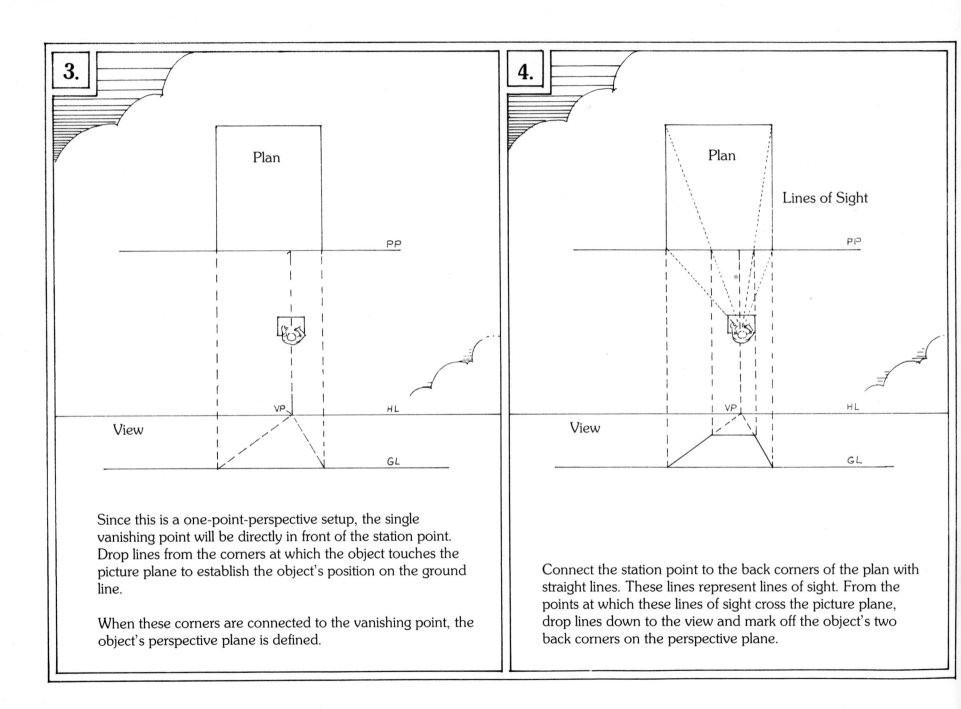

3.

Plan

PP

VP HL

View

GL

Since this is a one-point-perspective setup, the single vanishing point will be directly in front of the station point. Drop lines from the corners at which the object touches the picture plane to establish the object's position on the ground line.

When these corners are connected to the vanishing point, the object's perspective plane is defined.

4.

Plan

Lines of Sight

PP

VP HL

View

GL

Connect the station point to the back corners of the plan with straight lines. These lines represent lines of sight. From the points at which these lines of sight cross the picture plane, drop lines down to the view and mark off the object's two back corners on the perspective plane.

In these more complex examples of one-point perspective, note how the lines of sight passing through the picture plane determine the corresponding position of the object in the view.

Plans

PP

PP

PP

PP

SP

SP

SP

HL

HL

VP

VP

VP

Views

GL

GL

If the object projects beyond the picture plane, as in the image on the right, the lines of sight must be carried back to the picture plane before being dropped down to the view.

Drawing a Two-Point-Perspective View from a Plan

The procedure for constructing a two-point-perspective view is essentially the same as for the one-point perspective, except for the additional step of establishing two vanishing points.

1.

Object Plan

PP

SP

Draw the object plan and establish the picture plane and station point.

2.

Object Plan

Parallel

PP

Right Angle

SP

VP

HL

VP

Height

GL

Draw a horizon line parallel to the picture plane and add a ground line just below it. Now, from the station point, draw lines parallel to the sides of the object until they strike the picture plane. From these two points on the picture plane, drop lines down to the horizon line to establish the two vanishing points for the view.

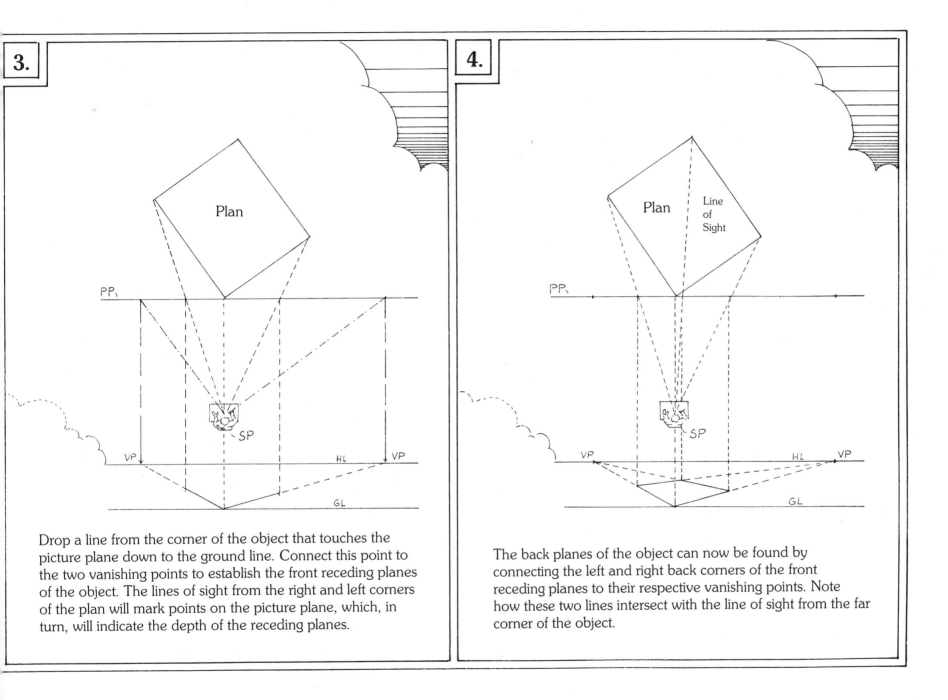

3. Drop a line from the corner of the object that touches the picture plane down to the ground line. Connect this point to the two vanishing points to establish the front receding planes of the object. The lines of sight from the right and left corners of the plan will mark points on the picture plane, which, in turn, will indicate the depth of the receding planes.

4. The back planes of the object can now be found by connecting the left and right back corners of the front receding planes to their respective vanishing points. Note how these two lines intersect with the line of sight from the far corner of the object.

43

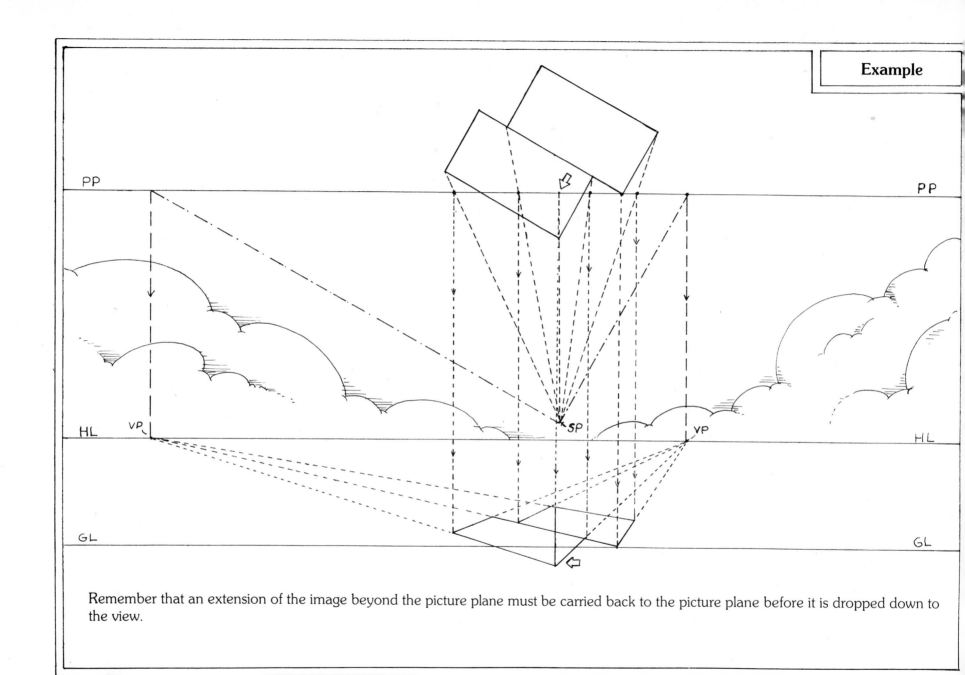

PP

PP

HL

VP

SP

VP

HL

GL

GL

Remember that an extension of the image beyond the picture plane must be carried back to the picture plane before it is dropped down to the view.

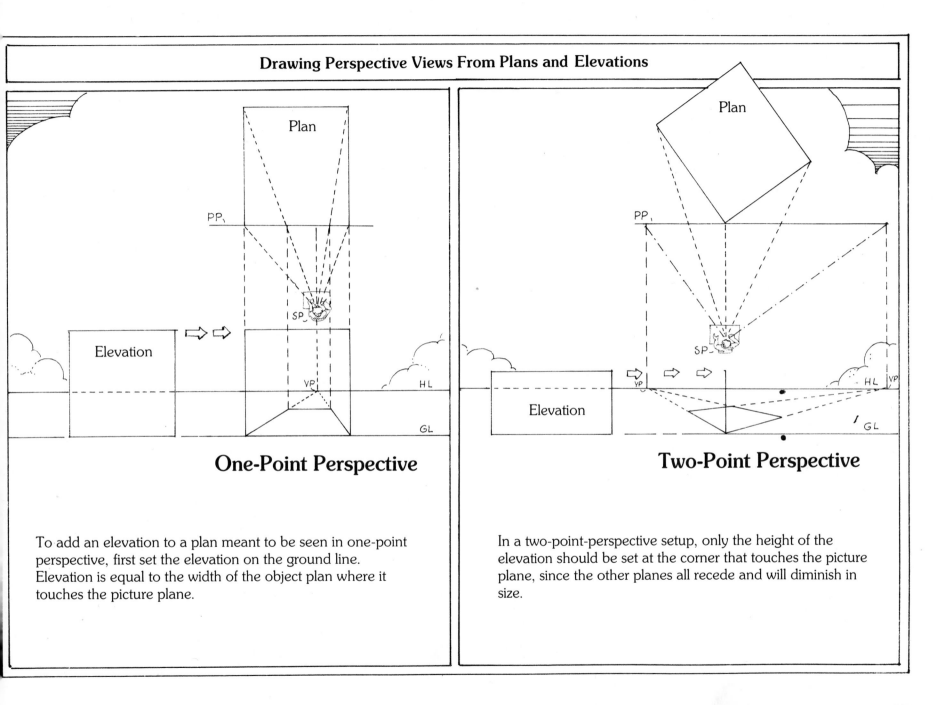

One-Point Perspective

Two-Point Perspective

To add an elevation to a plan meant to be seen in one-point perspective, first set the elevation on the ground line. Elevation is equal to the width of the object plan where it touches the picture plane.

In a two-point-perspective setup, only the height of the elevation should be set at the corner that touches the picture plane, since the other planes all recede and will diminish in size.

45

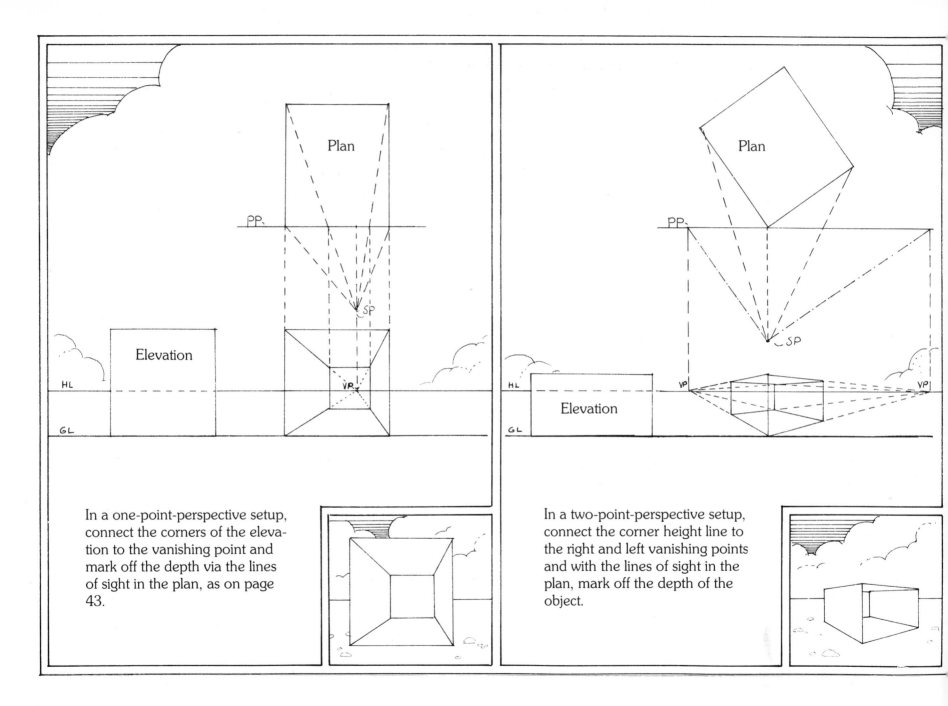

Plan

PP.

Elevation

HL

SP

VP

GL

In a one-point-perspective setup, connect the corners of the elevation to the vanishing point and mark off the depth via the lines of sight in the plan, as on page 43.

Plan

PP.

HL

Elevation

SP

VP

VP

GL

In a two-point-perspective setup, connect the corner height line to the right and left vanishing points and with the lines of sight in the plan, mark off the depth of the object.

46

In some situations, a single plan and elevation will be sufficient to reproduce a complete perspective of the object.

As the object becomes more and more complex, it becomes necessary to incorporate additional plans and elevations to convey the information.

By laying out plans and elevations separately, it is possible to position variations and details with great accuracy in the perspective view.

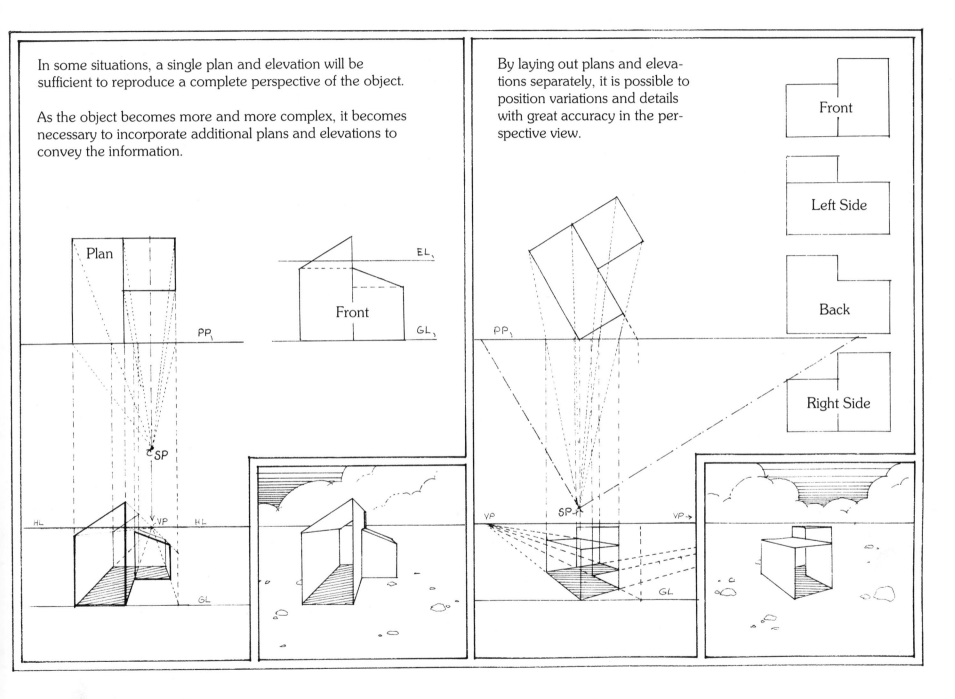

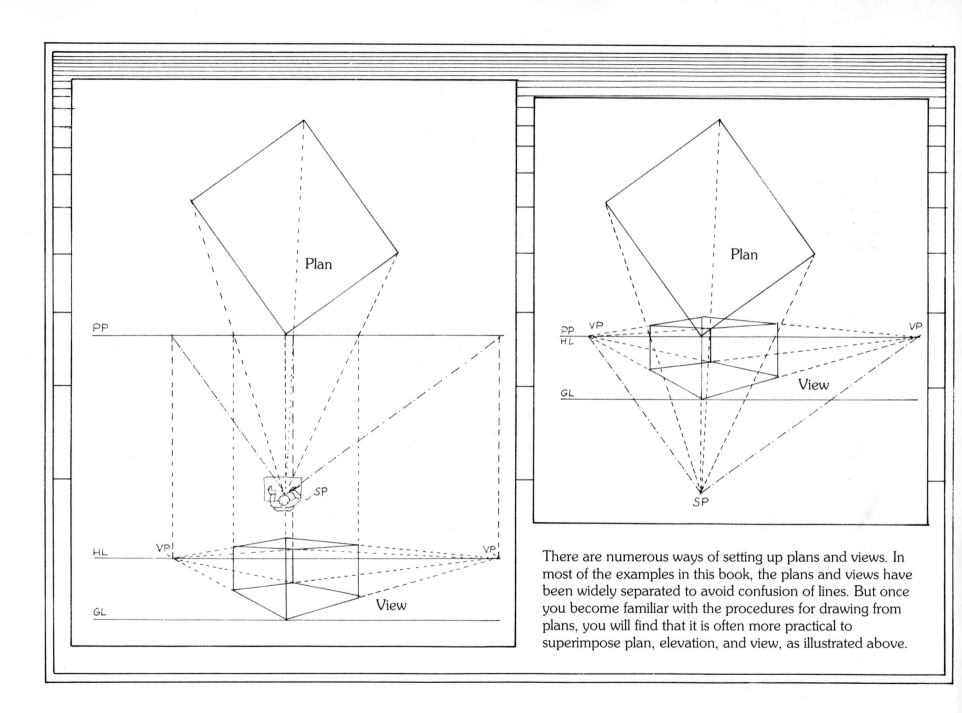

There are numerous ways of setting up plans and views. In most of the examples in this book, the plans and views have been widely separated to avoid confusion of lines. But once you become familiar with the procedures for drawing from plans, you will find that it is often more practical to superimpose plan, elevation, and view, as illustrated above.

Constructing Perspective-Grid Systems

Perspective grids are extremely useful tools, particularly when objects and/or spaces to be drawn are complex. A grid is a series of lines perpendicular to one another that mark off units of uniform size, usually squares. When set in perspective, these units provide a ready reference for the size, angles, and proportions of objects within the same view. Using grid systems is a standard method in drawing objects to scale. In the following examples, techniques will be demonstrated for the construction of one-point and two-point grids.

Once a perspective grid is drawn, it can be enlarged, subdivided, and used again and again in other projects. In many cases, only a portion of a grid will be necessary to work out a particular detail or special problem; the whole system need not be drawn out every time. Grid systems in various scales and points of view are also commercially available.

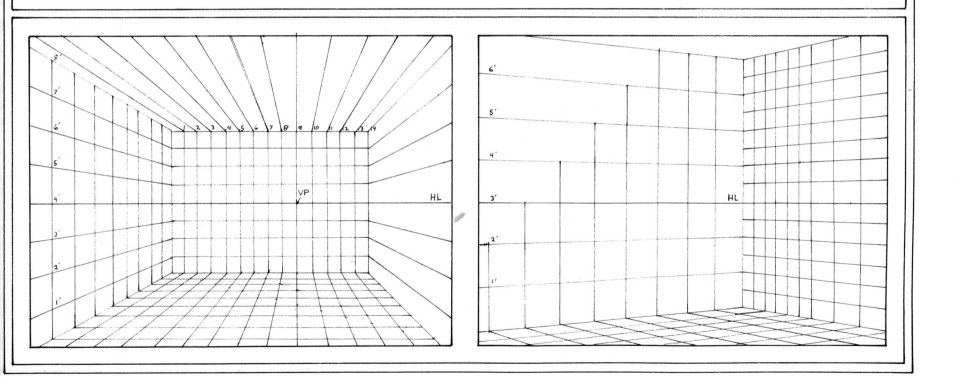

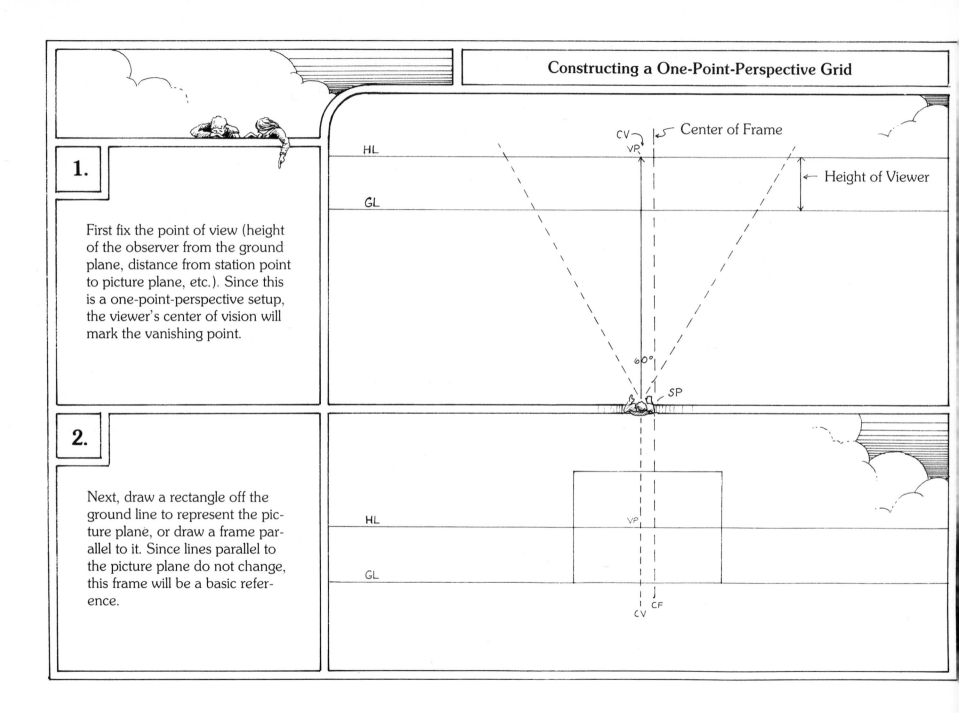

1.

First fix the point of view (height of the observer from the ground plane, distance from station point to picture plane, etc.). Since this is a one-point-perspective setup, the viewer's center of vision will mark the vanishing point.

CV
VP
Center of Frame

HL

GL

← Height of Viewer

60°

SP

2.

Next, draw a rectangle off the ground line to represent the picture plane, or draw a frame parallel to it. Since lines parallel to the picture plane do not change, this frame will be a basic reference.

HL

GL

VP

CV CF

3.

Mark the perimeter of the rectangle in equal units. Here the space will be 8 feet high and 12 feet wide. The observer is sitting slightly off to the left, with eye level at 4 feet off the ground.

4.

Draw lines through the equally spaced marks and connect them to the vanishing point. The space has now been divided into equal sized strips diminishing toward the vanishing point.

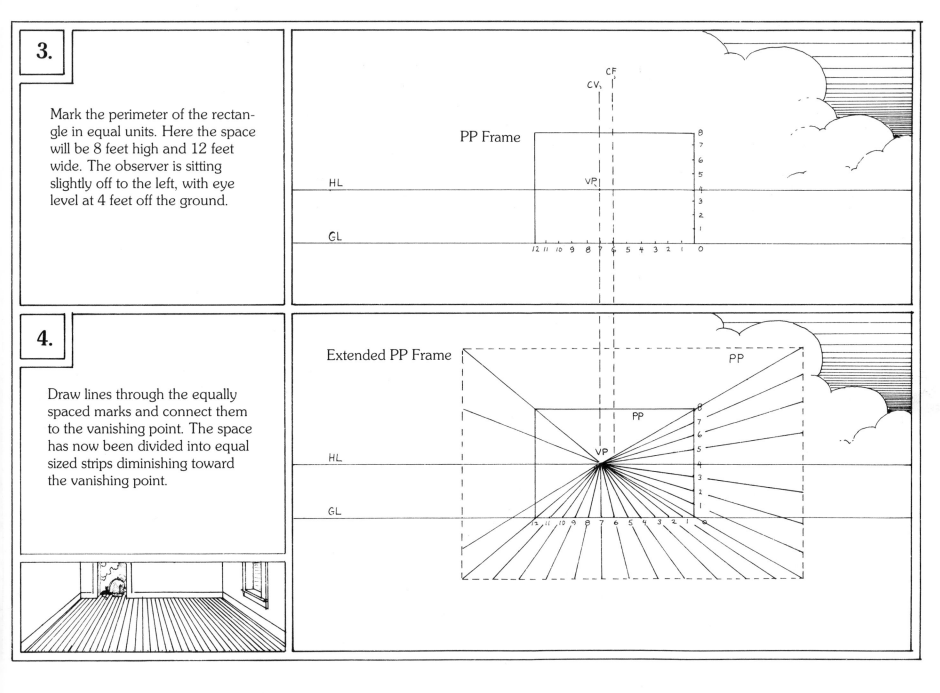

5.

In order to divide these parallel strips into square units, it is necessary to know the location of the 45-degree vanishing point. A line extended from this point across the receding lines at any given point will mark the positions for the lateral lines of the grid. Here, the 45-degree line was run through the corner of the frame.

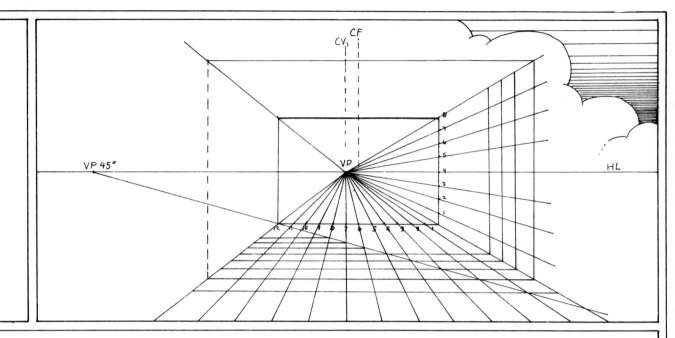

The diagonal of a square is 45 degrees—half the 90-degree corner. Therefore, any 45-degree diagonal will mark parallel lines into squares.

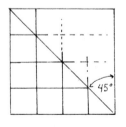

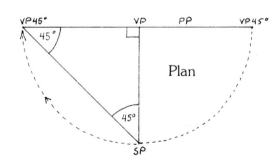

Plan

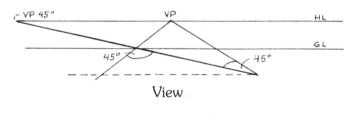

View

The 45-degree vanishing point can be found in this setup by taking the distance from the station point to the picture plane and measuring it on the horizon line in either direction from the center vanishing point.

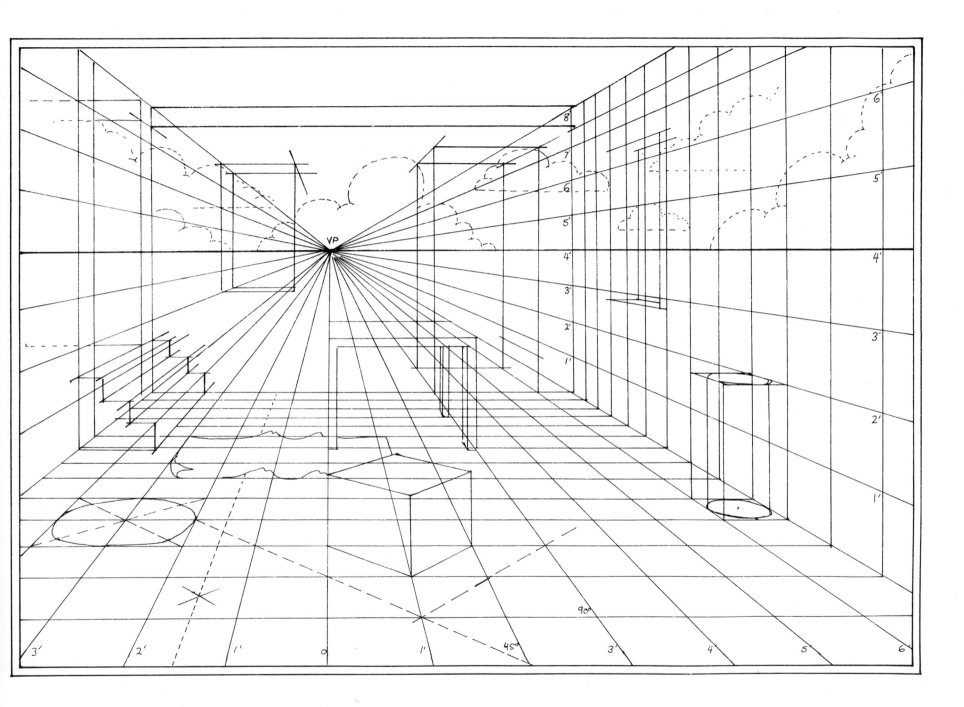

VP

8
7
6
5'
4'
3'
2'
1'

6
5'
4'
3'
2'
1'

90°

45°

3' 2' 1' 0 1' 3' 4 5' 6

53

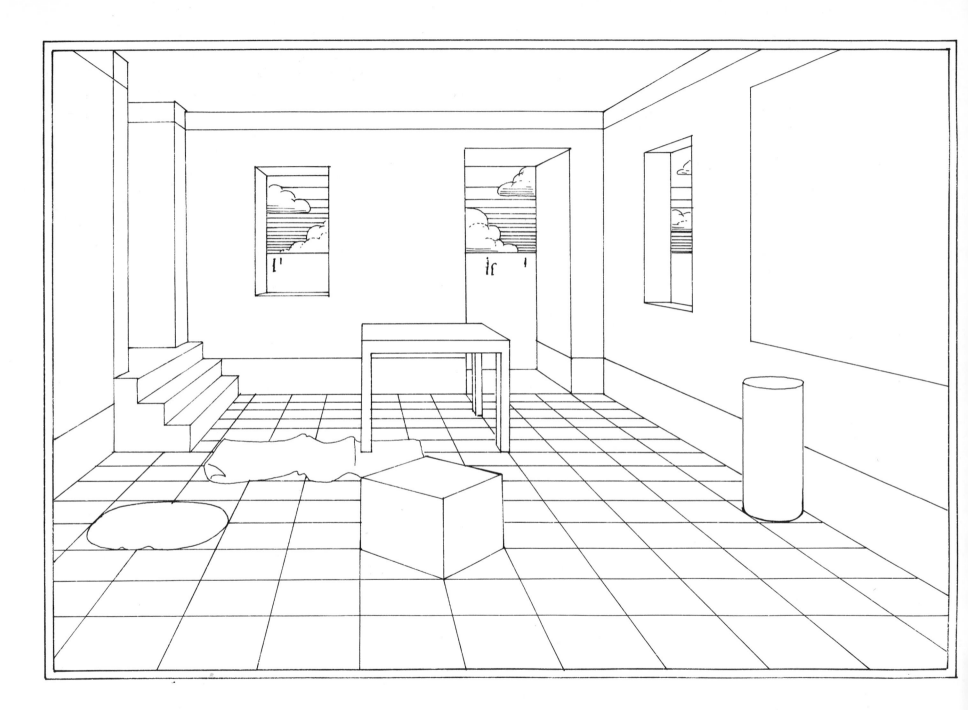

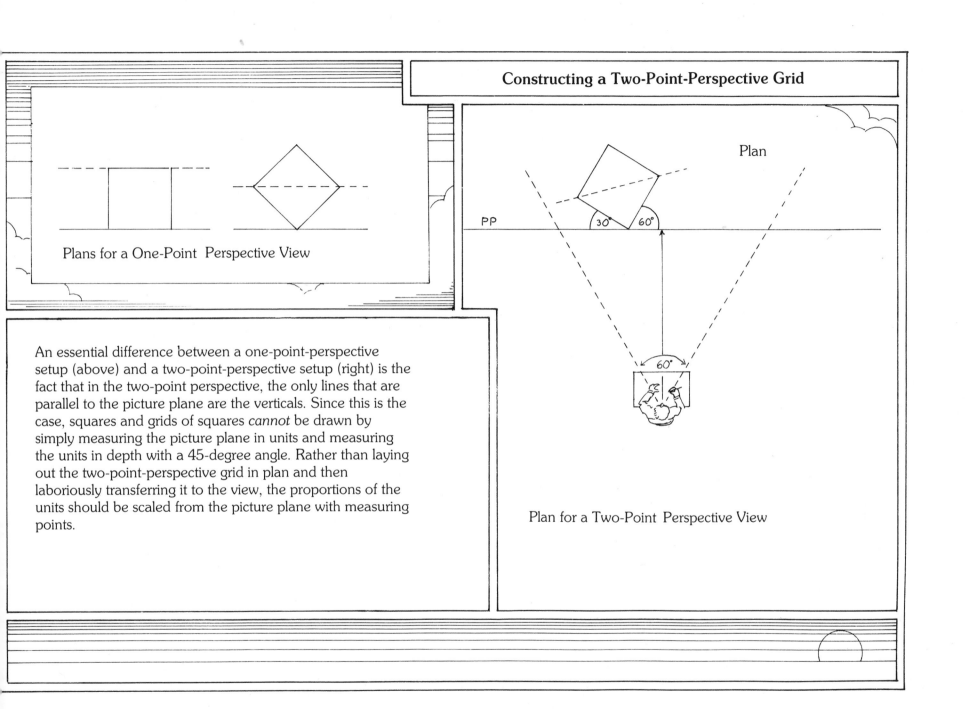

Plans for a One-Point Perspective View

Plan

PP

Plan for a Two-Point Perspective View

An essential difference between a one-point-perspective setup (above) and a two-point-perspective setup (right) is the fact that in the two-point perspective, the only lines that are parallel to the picture plane are the verticals. Since this is the case, squares and grids of squares *cannot* be drawn by simply measuring the picture plane in units and measuring the units in depth with a 45-degree angle. Rather than laying out the two-point-perspective grid in plan and then laboriously transferring it to the view, the proportions of the units should be scaled from the picture plane with measuring points.

55

1.

Set up the point of view, as described earlier, and establish the vanishing points for the angle at which the grid is to be seen.

Note in this example that the viewer's center of vision is to the right of the point where the angle touches the picture plane.

2.

Measuring points must now be found for each vanishing point. To find a measuring point, first measure the distance from the vanishing point to the station point with a compass. Next, measure and note this same distance from the vanishing point toward the other vanishing point on the picture plane. This noted length will be the measuring point for that vanishing point. In other words, the VP-SP line is equal to the VP-MP line. The left vanishing point's MP will be to the right of the center of vision, while the right VP's measuring point will be located at the left of the center of vision.

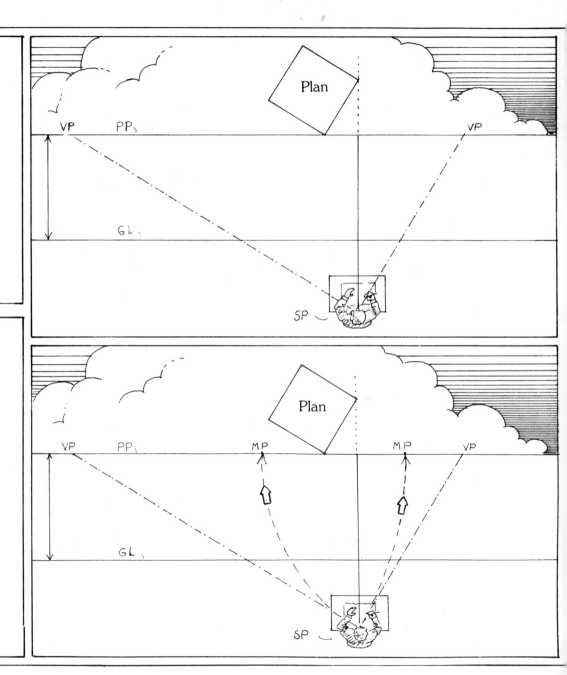

3. Drop a vertical line down to the ground line from the point where the object touches the picture plane (horizon line). Mark this point with a zero and then mark off the ground line in equal units. This will be the measured scale for the perspective grid.

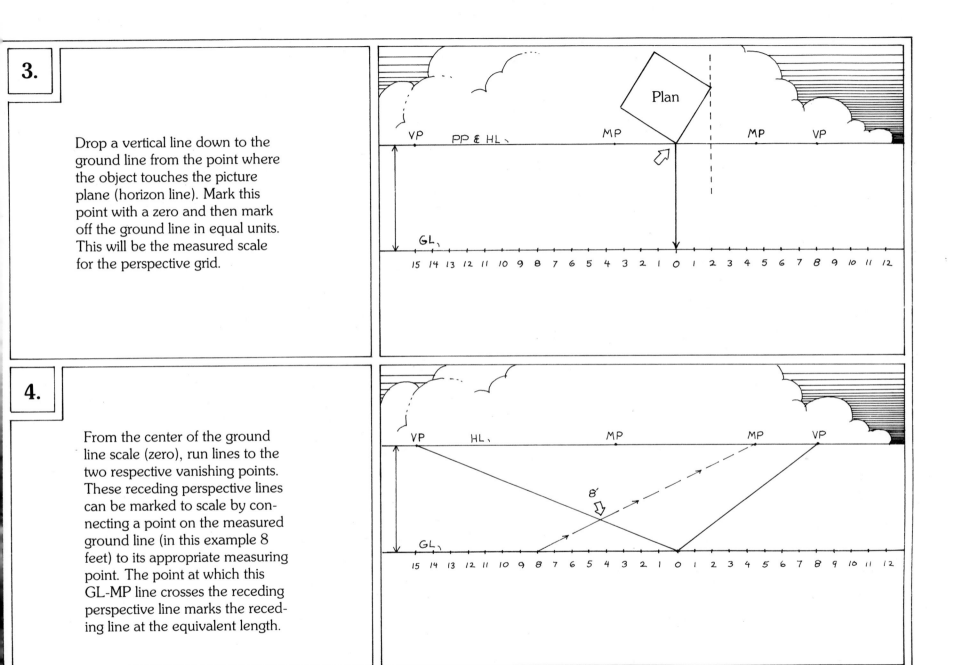

4. From the center of the ground line scale (zero), run lines to the two respective vanishing points. These receding perspective lines can be marked to scale by connecting a point on the measured ground line (in this example 8 feet) to its appropriate measuring point. The point at which this GL-MP line crosses the receding perspective line marks the receding line at the equivalent length.

57

5.

Using the procedure shown on the previous page, mark the other receding line at an equal length (8 feet). Connect these receding-line points to their respective vanishing points, to form a two-point-perspective square. In this example, the square is 8 feet by 8 feet.

Draw a diagonal of the square to establish a 45-degree vanishing point. Forty-five degree vanishing points can be helpful in both checking and expanding the grid system.

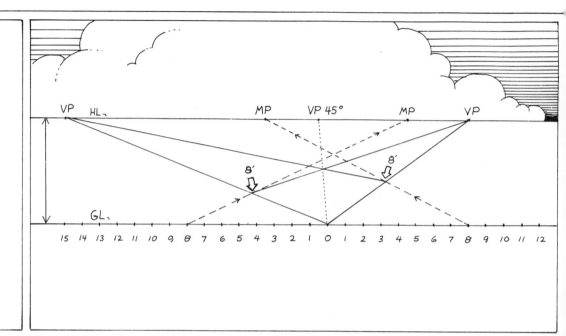

6.

Additional evenly spaced points can be marked off on the receding perspective lines (now the two front sides of a square). When these points are connected to their vanishing points, they form a scaled grid.

Here, the grid squares are 2 feet by 2 feet.

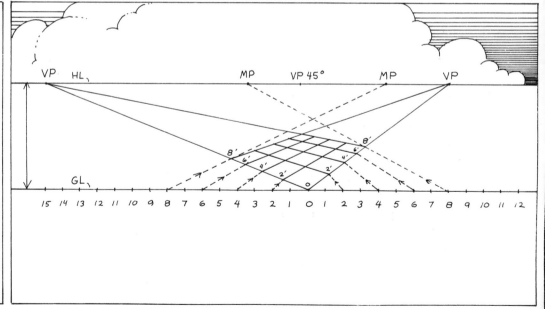

7. The vertical dimensions of the two-point-perspective grid can be drawn with the aid of a *vertical measuring line* (VML). To make a vertical measuring line, simply set a vertical at the zero point on the scaled ground line and mark it to the same scale. The points of this vertical scale can be transferred to any point over the base grid by connecting a given point to its correct vanishing point. In this example, the 10-foot height has been carried 8 feet toward the left vanishing point.

8. By transferring the points on the vertical measuring line to other verticals, vertical grids can be easily set up in coordination with the lines of the base grid. Note in this illustration how the 8 foot by 10 foot vertical grid plane is related to the base grid and the vertical measuring line.

The entire three-dimensional space can be gridded in two-point perspective by expanding this system.

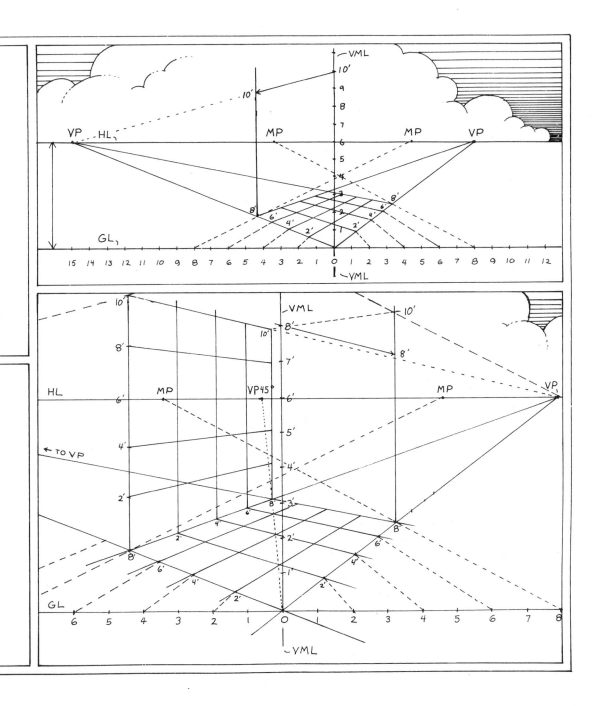

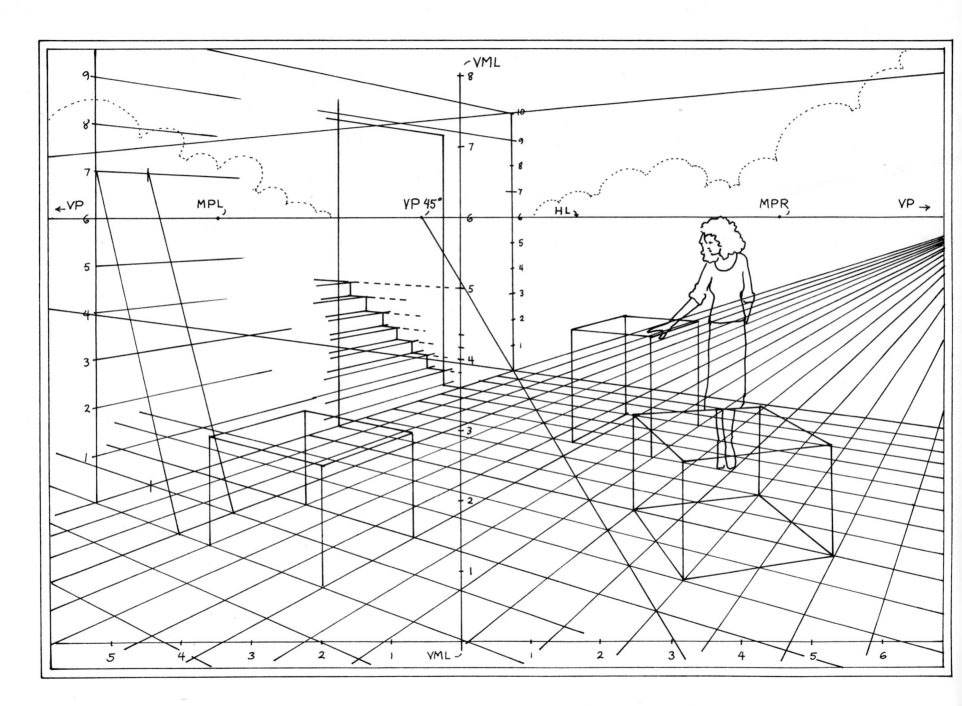

Diagonals

In addition to their use in constructing perspective grids, diagonals serve several useful functions in the drawing of perspective views.

One basic rule is that diagonals of any rectangle will cross at the center of that rectangle; this is also true of rectangles viewed in perspective.

Finding the center automatically means that rectangles can be subdivided and multiplied geometrically in the perspective system.

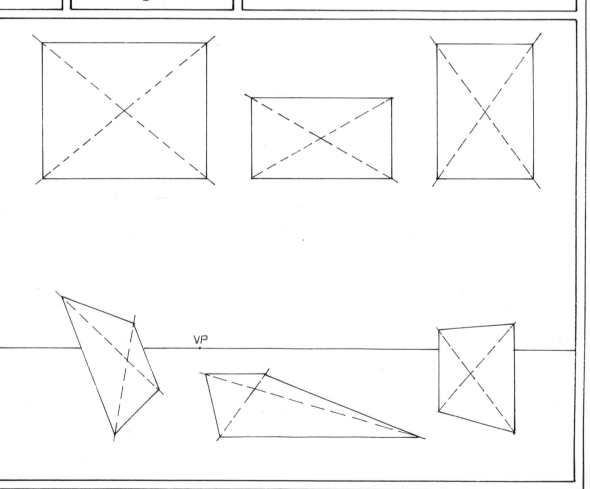

Dividing a Rectangle with Diagonals

Cross two diagonal lines to find the center.

Pass a line, parallel to the axis to be divided, through the center.

Pass a line through the center perpendicular to the first center line, to quarter the rectangle.

Repeat the above procedure in the newly divided axis to continue the subdivisions.

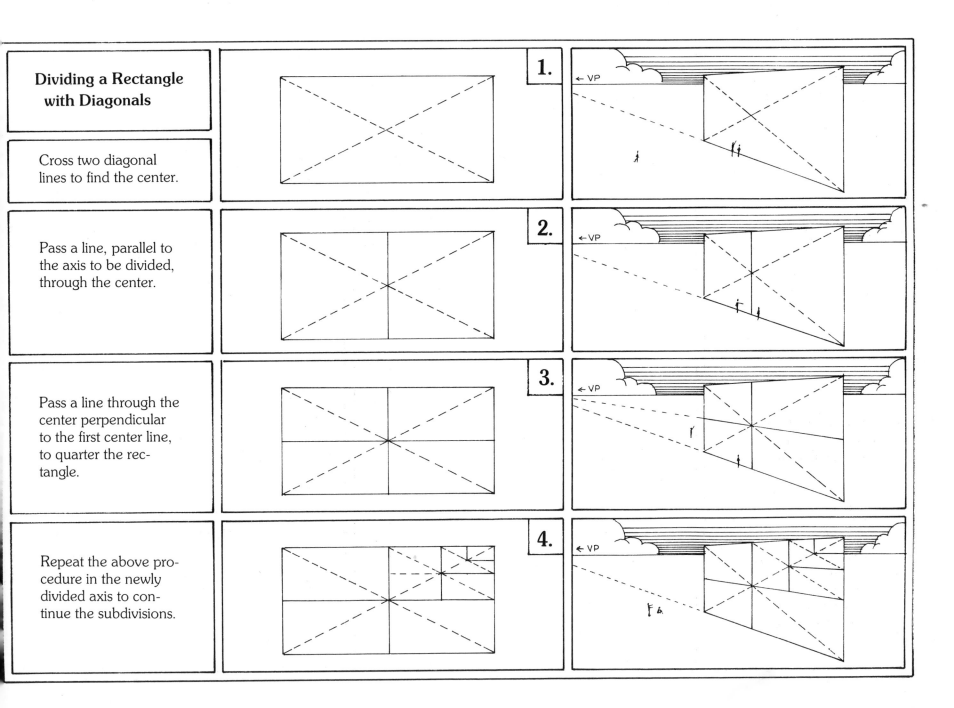

Adding Rectangles with Diagonals

Divide the rectangle in half, using diagonals.

1.

Draw a diagonal from one corner through the halfway point of one side, to double the side of the original rectangle.

2.

Using this new line as a gauge, construct the new equal rectangle.

3.

From these two equal rectangles, more rectangles can be added by taking diagonals from the originals.

4.

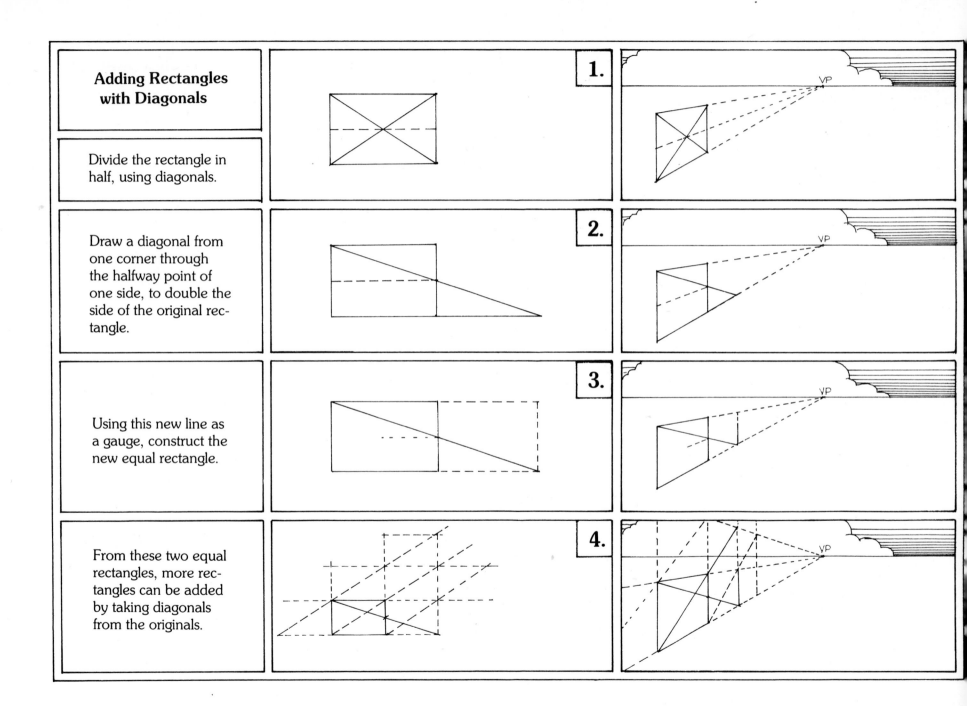

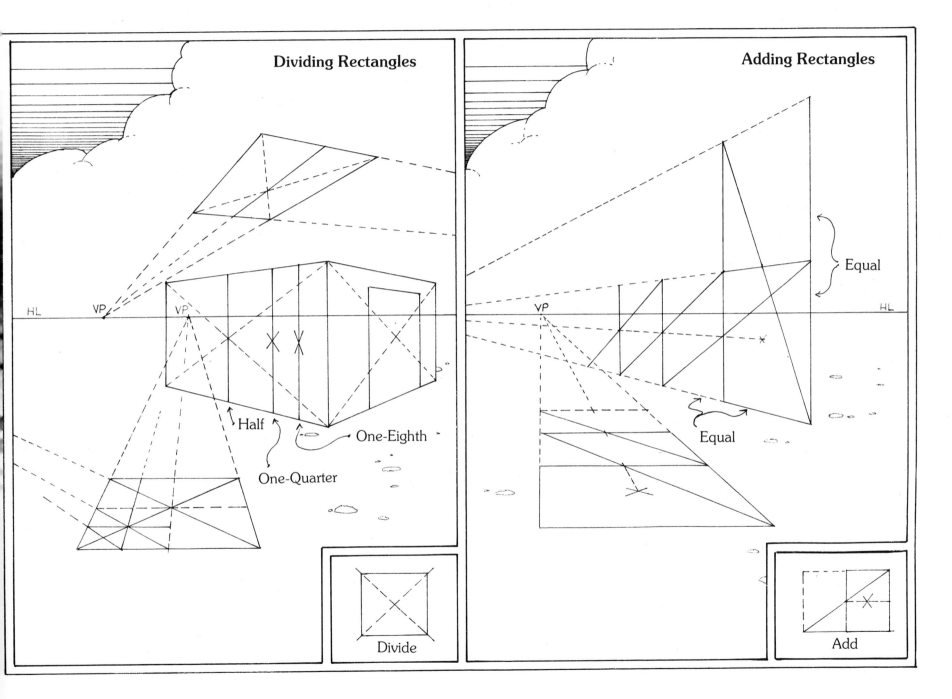

Dividing Rectangles

HL

VP

VP

Half

One-Eighth

One-Quarter

Divide

Adding Rectangles

Equal

HL

VP

Equal

Add

65

Squares

Squares are the simplest, most convenient device for building scaled drawings. They are also valuable as conceptual tools for imagining and creating perspective structures, and for estimating and deriving perspective images from observed objects and spaces. A working familiarity with square characteristics is, therefore, essential.

Characteristics of Squares

1. All four sides of a square are equal.

2. All sides of a square are at right angles to one another.

3. The diagonals of squares are always at 45 degrees.

A square can be drawn in any perspective setup if the right-angle vanishing points are known and the 45-degree vanishing point is known.

VP VP 45° VP
HL

There are numerous ways in which to draw squares in perspective views. The following are some of the most basic and common.

A.

Draw the square or combination of squares in the plan and bring the dimensions down into the view. (See pages 39–43.)

B.

In a one-point-perspective setup, find the 45-degree vanishing point or estimate its position, and then mark off the receding plane at the point where the diagonal crosses.

Drawing Squares in Perspective

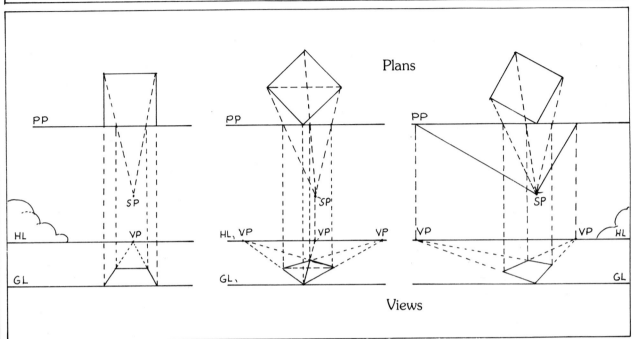

Plans

Views

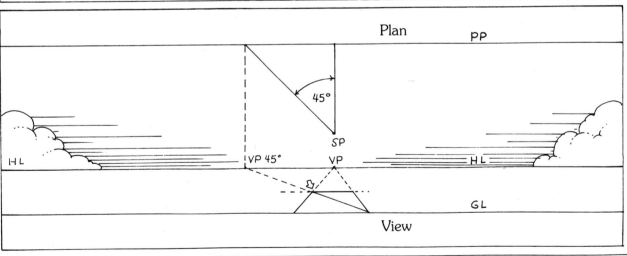

Plan

View

67

C.

For two-point-perspective setups, find the measuring points and connect them to equal lengths on the ground line (the bottom of a scaled picture plane).

D.

With practice and experience, you will develop a sensitivity to the shapes and proportions of drawn perspective squares, so that you can recognize or correct them.

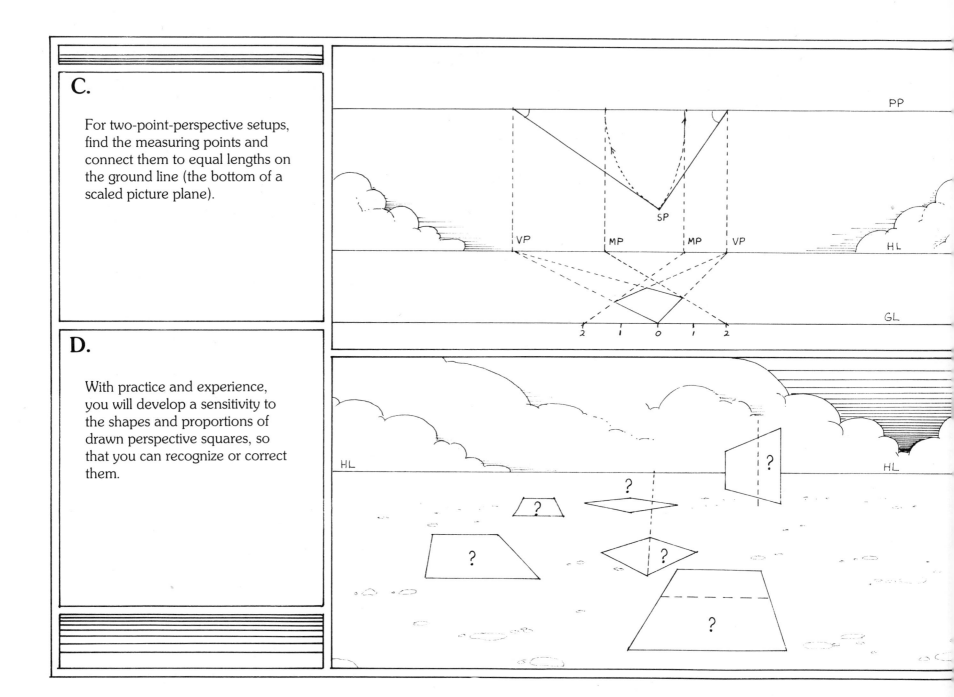

Cubes are a combination of six squares. The methods of constructing them in perspective views, then, are essentially the same as the methods used for squares.

Characteristics of Cubes

1. All six sides of a cube are equal square planes.

2. All six side planes are joined at right angles.

3. The diagonals of the sides (squares) are always at 45 degrees.

As with squares, a cube can be drawn in any perspective setup if the right-angle vanishing points are known and the 45-degree vanishing point is known.

69

The basic methods for drawing cubes in perspective are virtually the same as those for squares, except for the addition of an elevation.

A.

Draw the cube in plan and elevation. After the plan has been brought down into the view as described earlier (see pages 39–44), set the whole elevation over the view to coincide with the ground plane (for a one-point perspective) or set the corner elevation at the corner of the view (for a two-point perspective).

B.

For a one-point-perspective setup, draw a base square, add the elevation, and complete the cube as illustrated.

Drawing Cubes in Perspective

Plan

PP, PP

SP SP

VP VP VP

HL HL

GL GL

View

Plan

PP PP

45°

SP

HL. VP 45° VP HL

GL GL'

View

C.

To establish the base square for a two-point-perspective cube, find the measuring points and connect them to the scaled ground line. Where a corner of the cube touches the ground line, draw a vertical measuring line and mark it off at the height of the elevation.

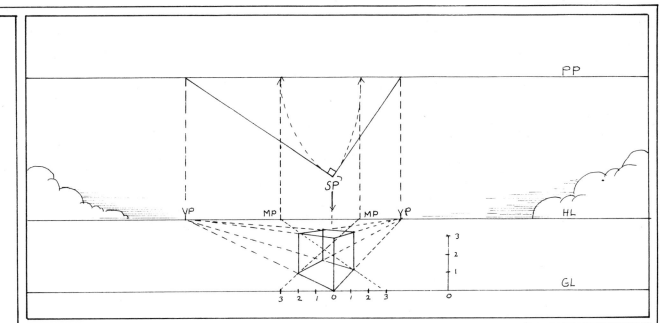

D.

As with squares, try to develop the ability to recognize and estimate the proportions and angles of perspective cubes. Try adding and subtracting from various planes until the shape seems correct.

E.

In three-point perspective, none of the planes of the cube are parallel to the picture plane. Therefore, even the elevation of the cube will diminish toward a vanishing point.

Since the viewer is in the center of the view, all the vanishing points will be an equal distance apart, forming an equilateral triangle connecting three horizons. The three 45-degree vanishing points will also be equidistant and in the centers of their respective horizons.

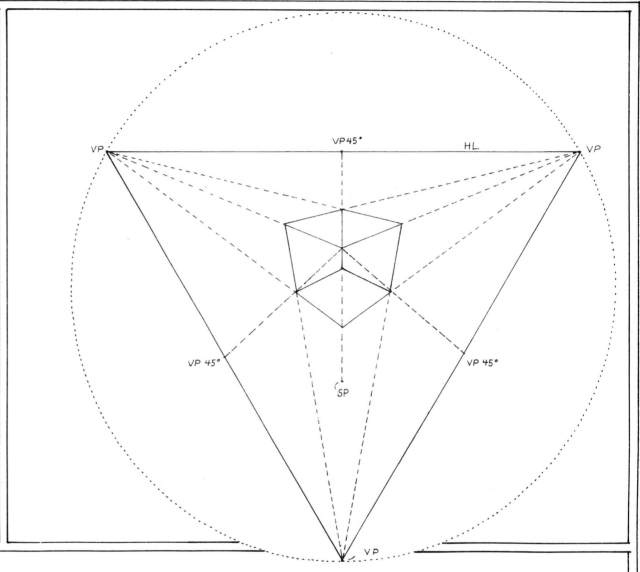

Movement of the object toward any one of the vanishing points will tend to turn the view into a one-point perspective, while movement of the object toward any of the horizons will have the effect of turning the view into a two-point perspective.

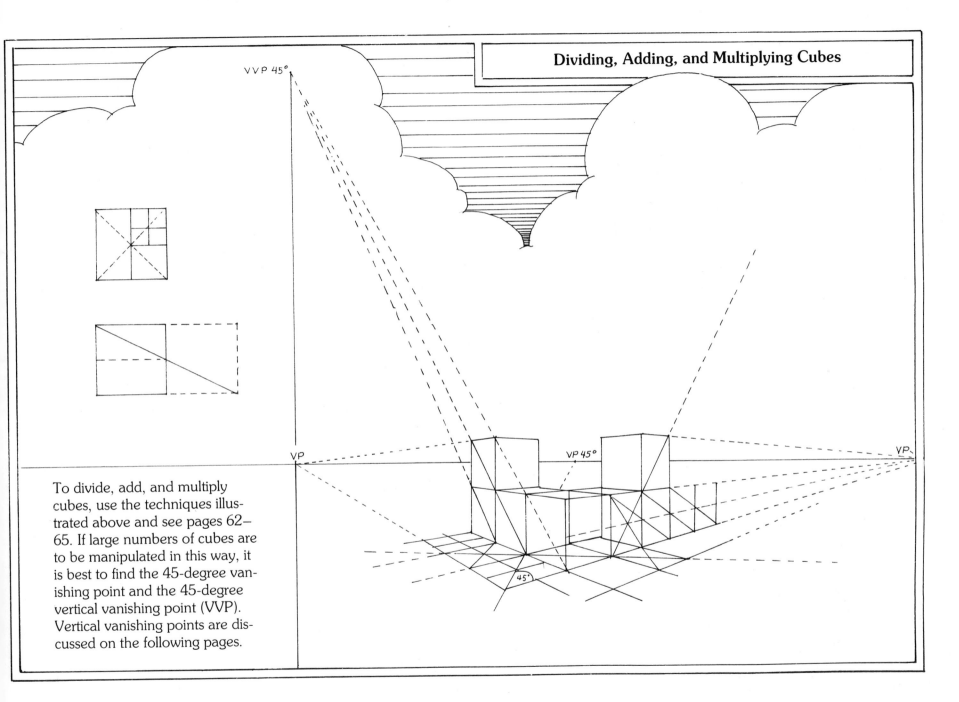

VVP 45°

VP

VP 45°

VP

45°

To divide, add, and multiply cubes, use the techniques illustrated above and see pages 62–65. If large numbers of cubes are to be manipulated in this way, it is best to find the 45-degree vanishing point and the 45-degree vertical vanishing point (VVP). Vertical vanishing points are discussed on the following pages.

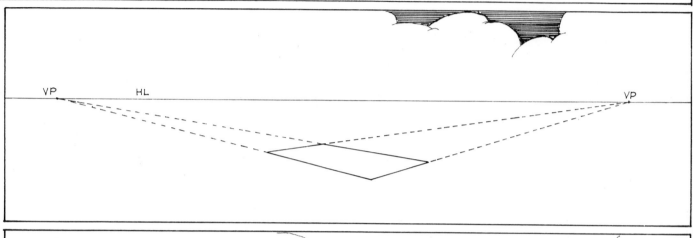

Rectilinear planes that are parallel to the ground plane will have vanishing points that fall on the horizon line.

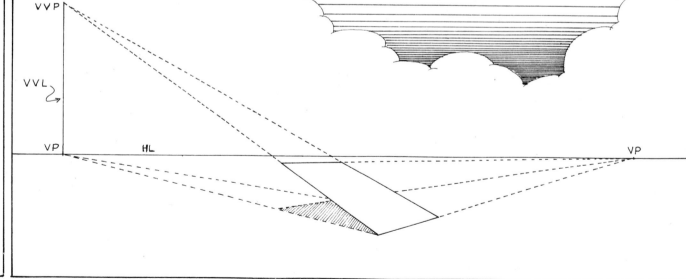

If one axis of a receding plane is *not* parallel to the ground plane, its vanishing point will *not* fall on the horizon line. Instead, it will fall on a line perpendicular to the horizon line that runs through the original vanishing point. This line is called the *vertical vanishing line* (VVL). Vanishing points that fall on this line are called *vertical vanishing points* (VVP).

The steeper the angle of a plane's ascent or descent from the ground plane, the further up or down on the vertical vanishing line the points will fall.

It is important to realize that the vertical vanishing line operates just like the horizon line, except that it is perpendicular to the horizon.

Turn the page on end and note that the image becomes a three-point-perspective setup.

Note how the sloping planes diminish toward vanishing points below the horizon line after they have passed an angle 90 degrees to the ground plane.

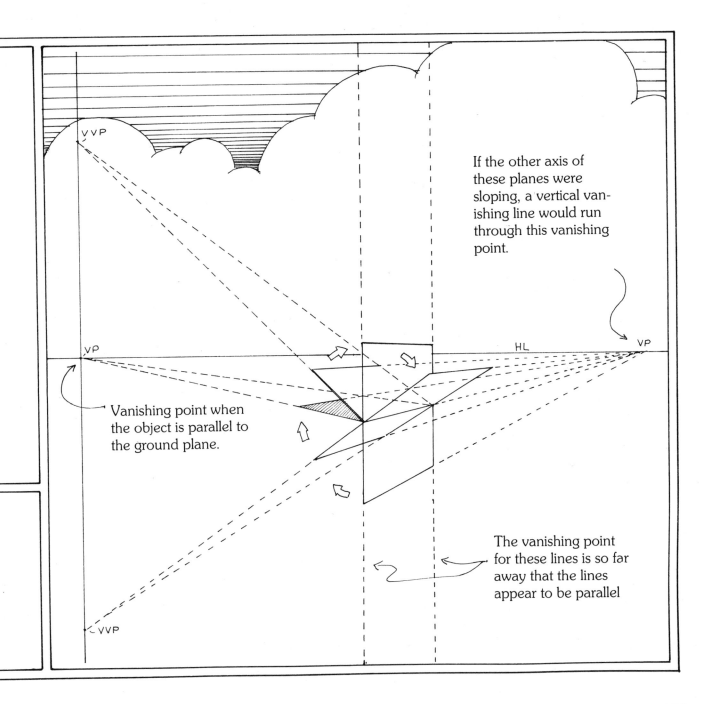

If the other axis of these planes were sloping, a vertical vanishing line would run through this vanishing point.

Vanishing point when the object is parallel to the ground plane.

The vanishing point for these lines is so far away that the lines appear to be parallel

VVP

VP

HL

VP

VVP

75

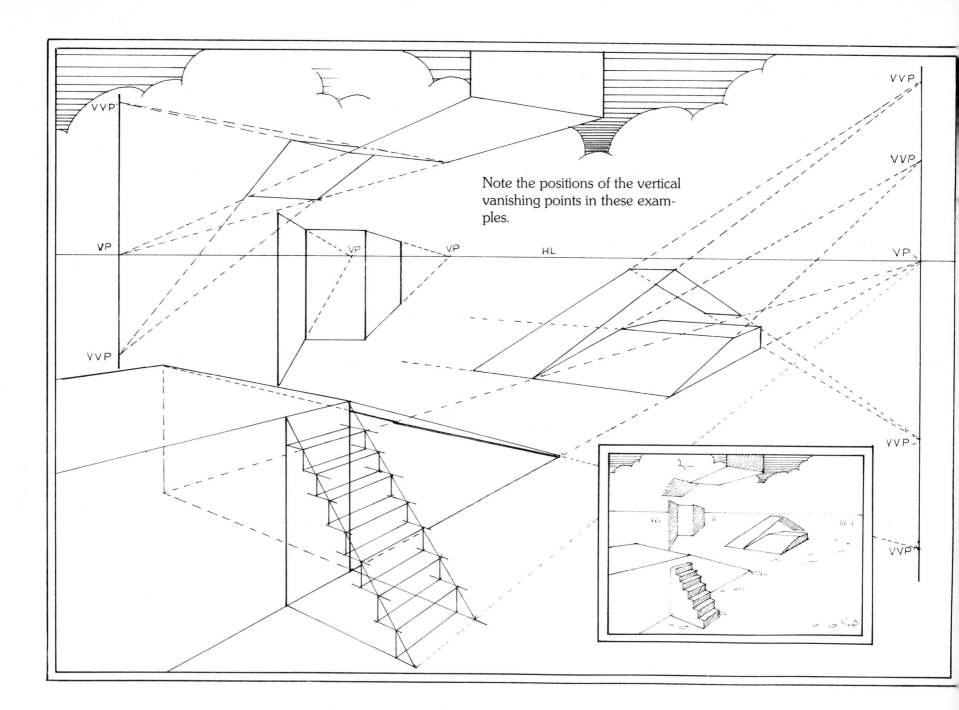

Note the positions of the vertical vanishing points in these examples.

It is not always convenient or necessary to find the vanishing points for a sloped plane or angle.

If the base and the height of an angle are known, the angle can be drawn by connecting the two extremes with a diagonal line.

If the base is drawn in perspective, the sloping plane will automatically converge toward its vertical vanishing point. Thus, it is possible to plot complex angles and slopes by determining their base length and height.

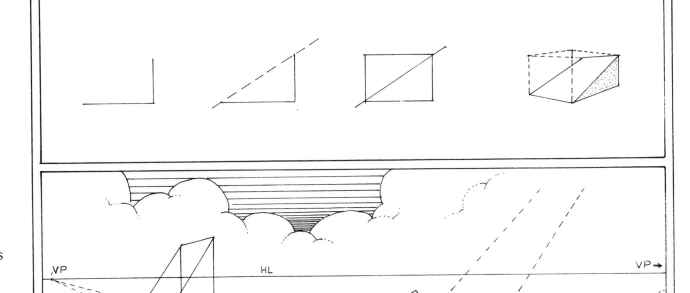

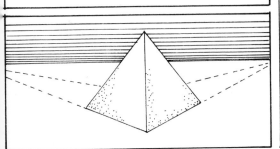

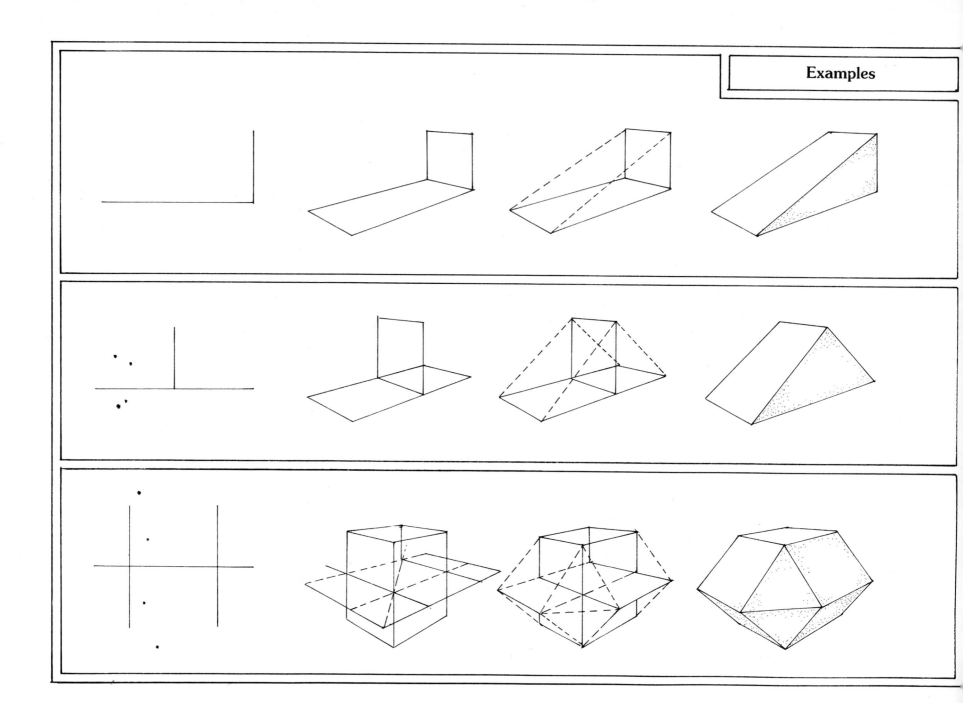

78

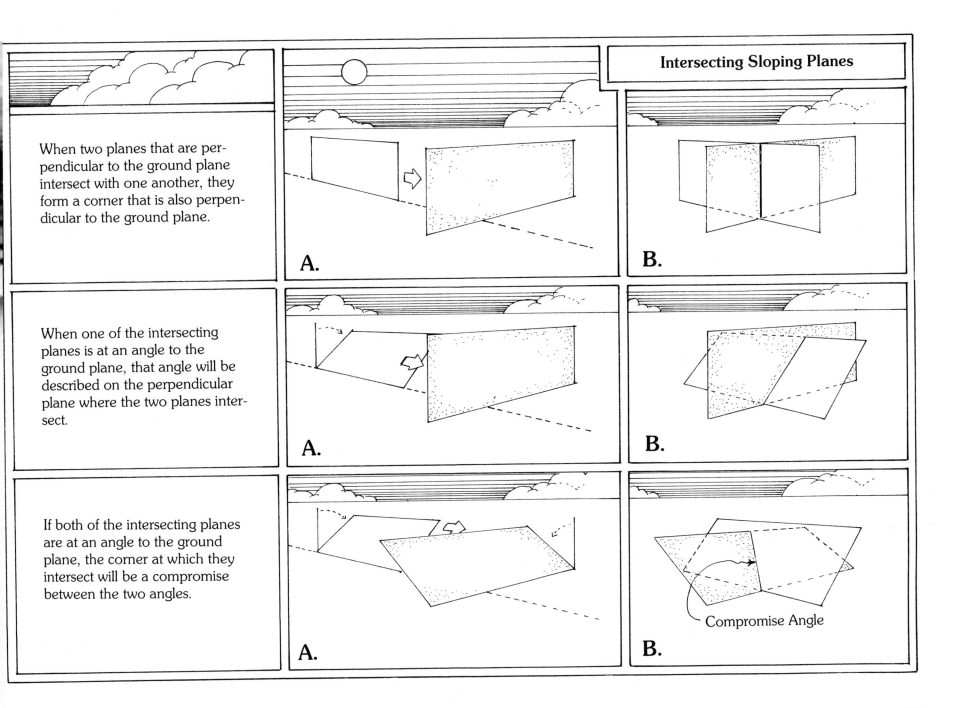

When two planes that are perpendicular to the ground plane intersect with one another, they form a corner that is also perpendicular to the ground plane.

A.

B.

When one of the intersecting planes is at an angle to the ground plane, that angle will be described on the perpendicular plane where the two planes intersect.

A.

B.

If both of the intersecting planes are at an angle to the ground plane, the corner at which they intersect will be a compromise between the two angles.

A.

B.

Compromise Angle

79

If the tops of intersecting planes are the same height off the ground plane, the angle of the intersecting corner can be found by drawing a line between the points where the *edges* of the two planes meet.

However, if the intersecting planes are of different heights, it is necessary to find the point where the smaller plane enters the larger one before the position and angle of the corner can be drawn. (Directions follow.)

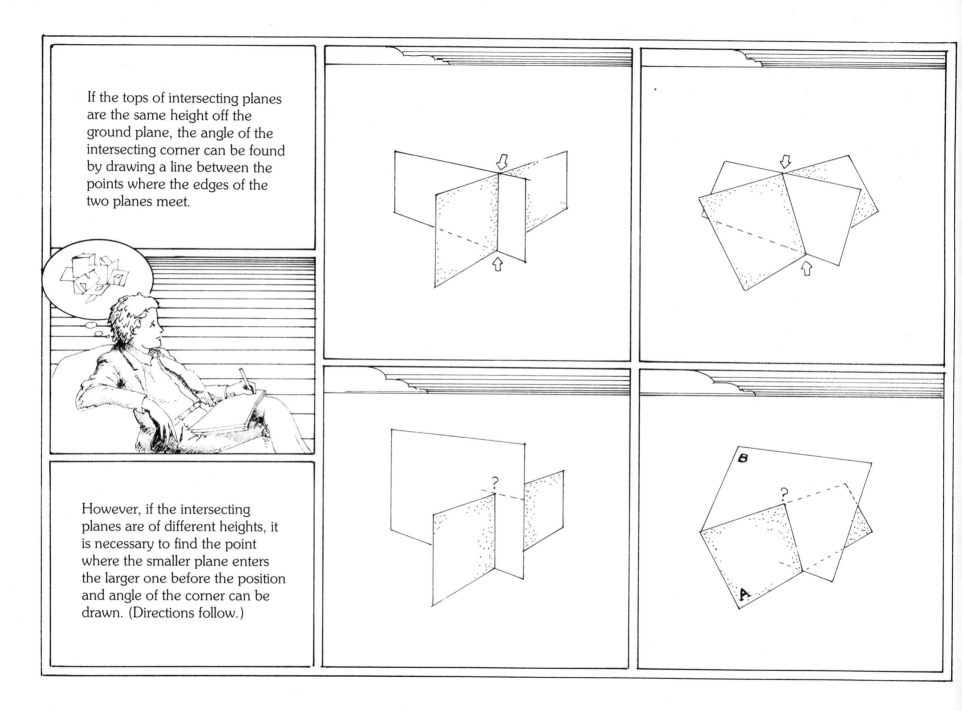

To find the point on the larger plane where the smaller one intersects it, mark the height of the smaller plane on the larger plane. This point marks the top of the intersecting corner.

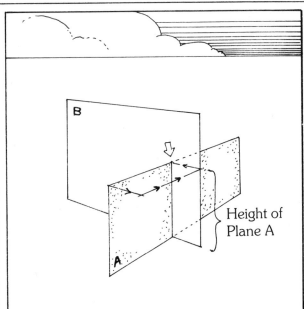

Height of Plane A

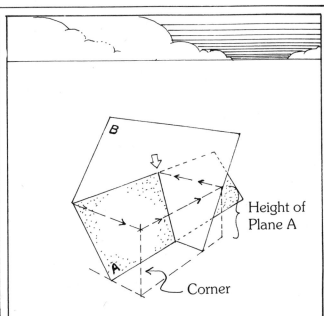

Height of Plane A

Corner

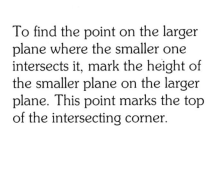

If the vertical vanishing point for the larger slope is known, a line can be extended from the top of the smaller plane perpendicular to the ground, across toward its own vanishing point, and then up to the larger slope's vertical vanishing point.

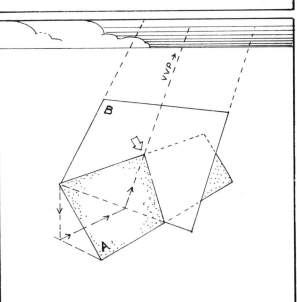

Fortunately, the more complex the design, the more cross-references there are for determining angles.

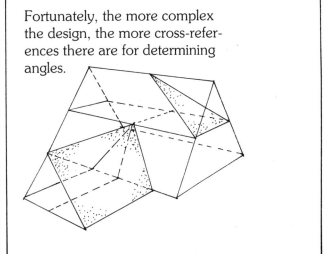

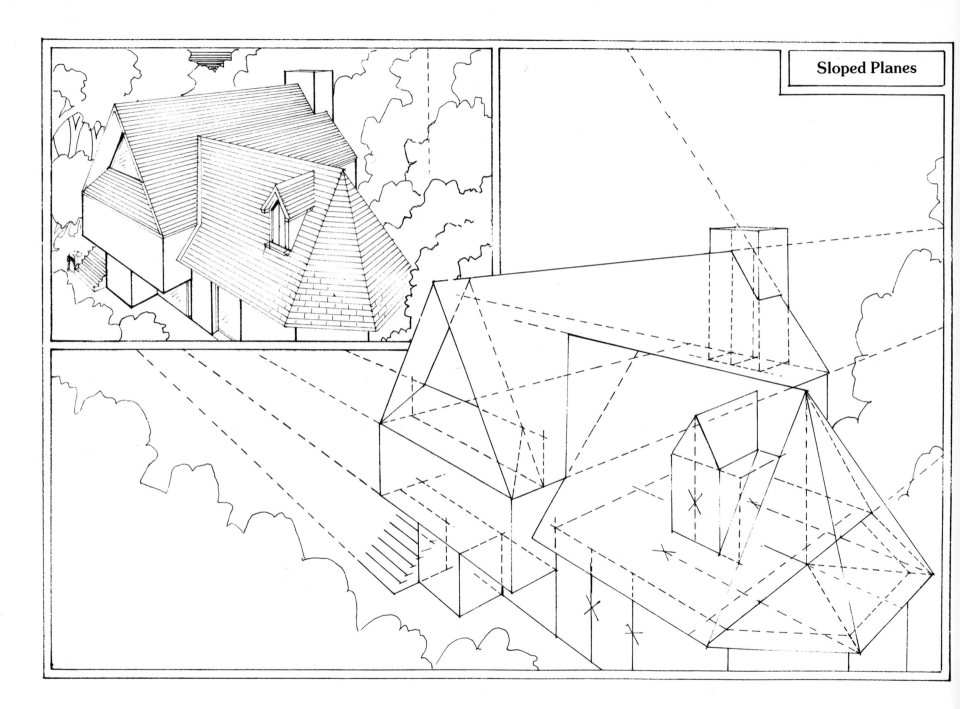

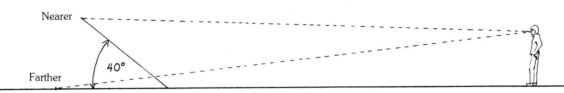

When viewed in perspective, a plane that is at an angle to the ground plane will have proportions different from its horizontal counterpart because of the change in distance between the observer and the object.

The geometric consistency of linear perspective makes it possible to determine the following slope characteristics:

1. The angle of the slope in degrees; and

2. The length and proportions of the receding slope, to scale.

In order to accomplish this, it is necessary to find and use measuring points (see page 56).

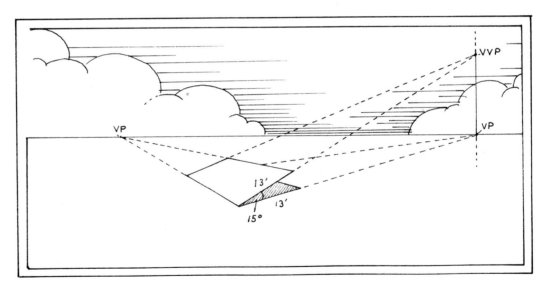

1.

Begin by finding the measuring point for the axis on which the angle will ascend and descend.

You will recall that the vanishing point to station point line is the same distance on the picture plane as the vanishing point to measuring point line. See page 56.

2.

Once you have transferred the vanishing points and measuring points to the horizon line, lay down a ground line and connect the base lines of the angle to their respective vanishing points.

With the measuring point as the axis, draw a line from the horizon line. The point at which this line strikes the vertical vanishing line marks the vertical vanishing point for the desired angle.

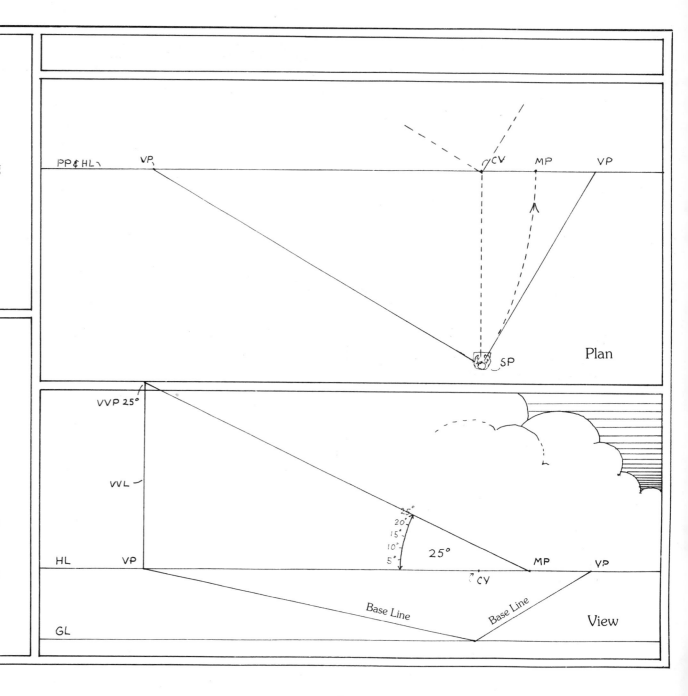

Plan

View

3.

The measuring point provides a side view (elevation) of the angle, so the angle can be scaled and measured with a protractor. Here, the angle is 25 degrees.

Note that all angled lines that strike the 25-degree vertical vanishing point are 25 degrees off the ground plane, no matter where they fall on the ground plane.

Since any angle can become the diagonal of a rectangle, the vanishing point of an angle can serve as a guide for multiplying and dividing rectangles of given proportions.

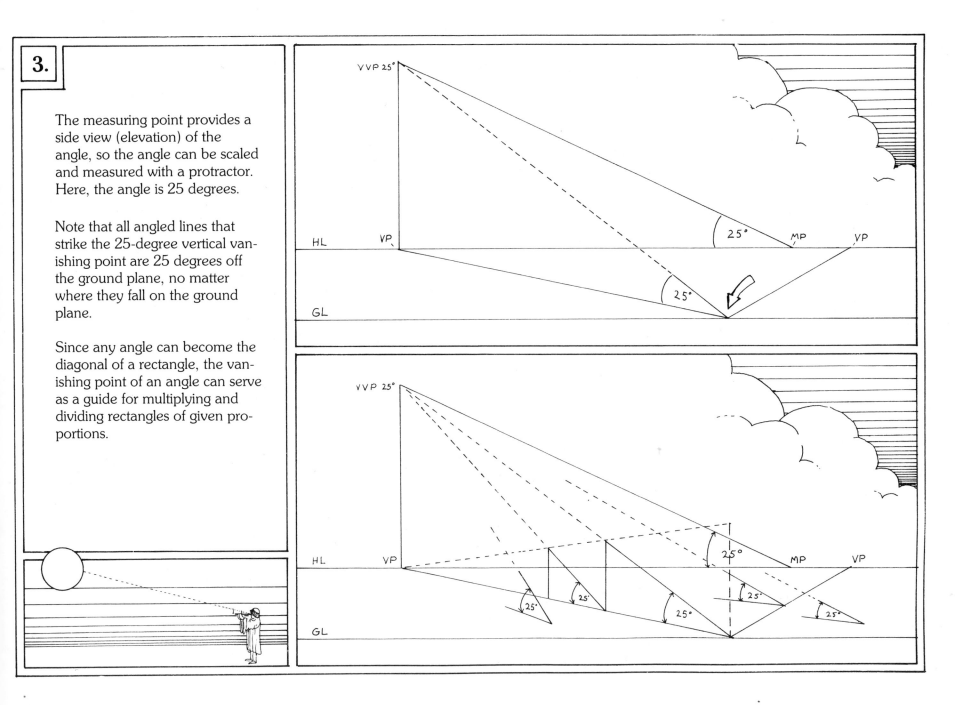

1.

Draw a rectangle to scale by using a scaled ground line and appropriate measuring points, as shown on pages 57 and 58.

Here, the rectangle is 10 feet by 10 feet; the desired angle is 25 degrees.

Drawing a Measured Sloped Plane in Perspective

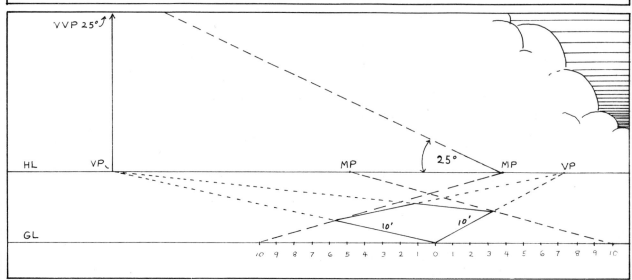

2.

The angle of the slant will be 25 degrees above the horizon, so a vertical measuring line should be drawn perpendicular to the ground line where the two base lines meet. Mark this line with the same scale increments as the ground line.

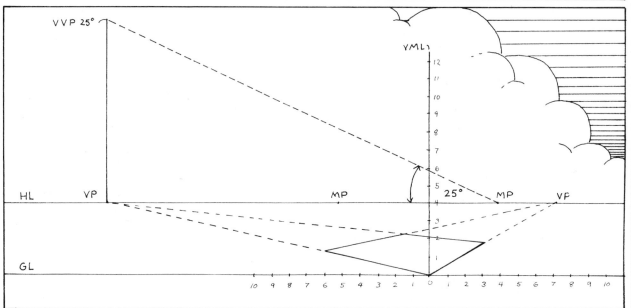

3.

Establish the sloping plane by connecting the right-hand corners of the rectangle to the 25-degree vertical vanishing point.

4.

In order to mark this slope to scale, you must find a measuring point on the vertical vanishing line. Draw a line from this point to the scaled vertical measuring line (VML) to mark the limit of the sloping plane.

Note that the vertical measuring point (VMP) is found by swinging an arc down from the measuring point on the horizon line, which has its axis at the 25-degree vanishing point.

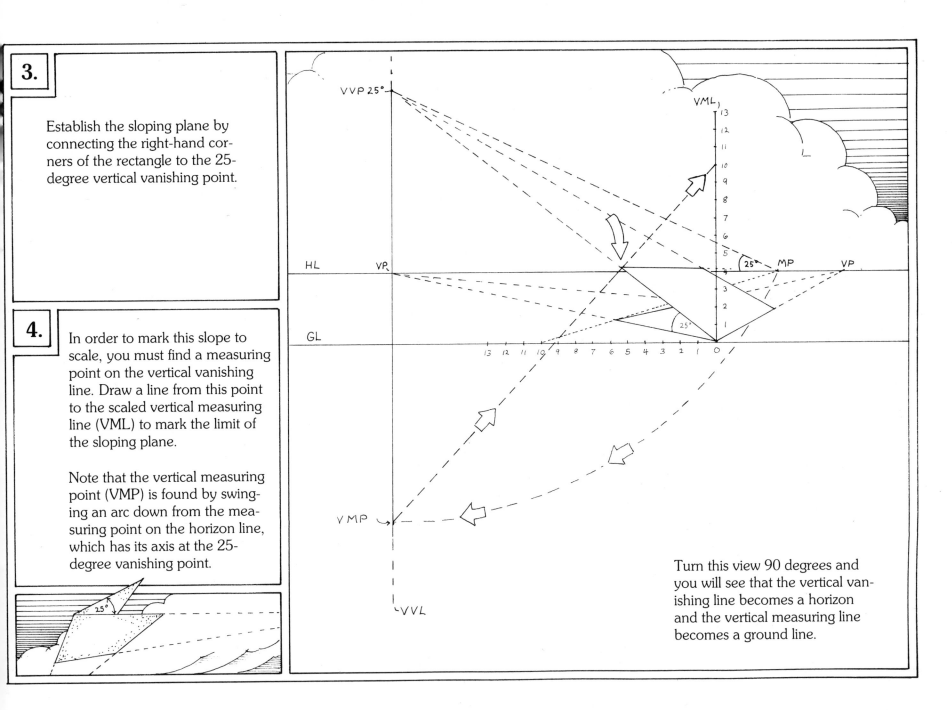

Turn this view 90 degrees and you will see that the vertical vanishing line becomes a horizon and the vertical measuring line becomes a ground line.

Circles and Curved Surfaces

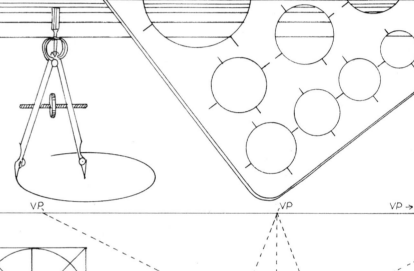

When circles and curves are drawn in plan, you may use compasses, templates, and other mechanical devices to ensure accuracy. When drawn in perspective views, you must approximate circles and other curved forms from reference points based on straight lines and from angles that can be measured accurately.

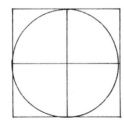

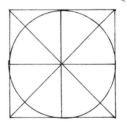
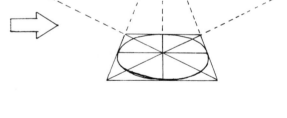

When drawing a curve, it is ultimately necessary to sense its shape in much the same manner that you sense a curve when driving a car, for example. Even mathematicians must come to terms with this uncertainty; and, like them, you can narrow the range of uncertainty by increasing the number of reference points. The accuracy of circles and curves in perspective is relative. What is "good enough" or "close enough" depends on the requirements of the project.

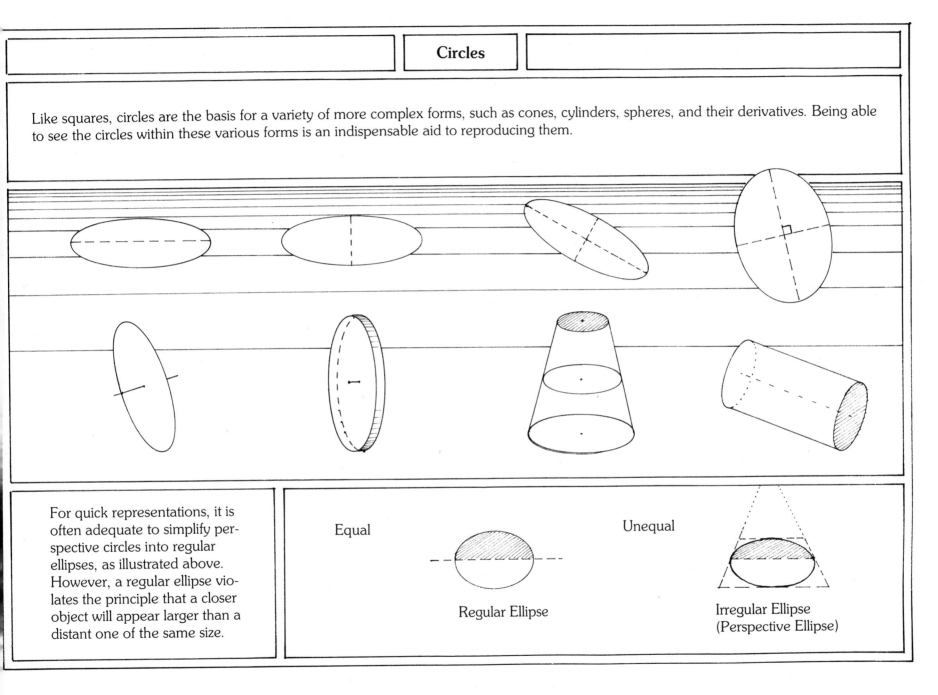

Circles

Like squares, circles are the basis for a variety of more complex forms, such as cones, cylinders, spheres, and their derivatives. Being able to see the circles within these various forms is an indispensable aid to reproducing them.

For quick representations, it is often adequate to simplify perspective circles into regular ellipses, as illustrated above. However, a regular ellipse violates the principle that a closer object will appear larger than a distant one of the same size.

Equal

Regular Ellipse

Unequal

Irregular Ellipse
(Perspective Ellipse)

90

Drawing Circles Inside Squares

One of the most practical methods of drawing perspective circles is to draw them inside perspective squares. Perspective squares can be constructed easily and can supply the basic reference points needed for guiding the arcs of the circles.

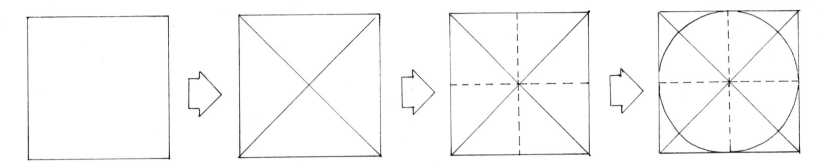

The arc of a circle touches the center of each side of the square that inscribes it. The arc also cuts across the diagonals at a little more than two-thirds distance from the center. By estimating the position of this point of intersection, the curve can be drawn, using three reference points.

Once the position of the arc is found on one quarter, the other three can be found by using the vanishing points and verticals.

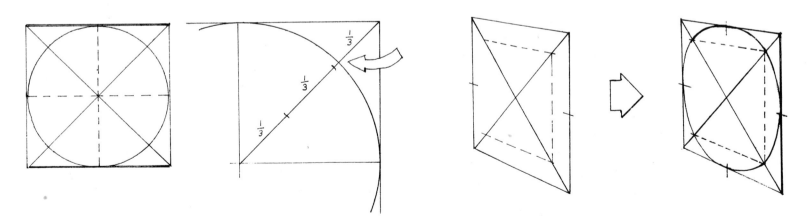

Another method of drawing a circle in perspective, which requires even less guesswork, is to transfer the circle from a plan to a perspective view, as demonstrated earlier with rectangles and squares.

In this method, points on the circle's arcs can be brought down to the ground line via the picture plane and marked off accurately in the view.

In this example, lines have been drawn through the points of intersection between the diagonals and the arc. When these same lines are taken back from the ground line to the vanishing point, they mark the diagonals in the view at the correct point.

Actually, only one such intersection need be found in the plan, since the others could be derived from the view.

If even greater accuracy is desired (that is, more reference points), additional lines can be dropped from the arc. The circle could even be gridded.

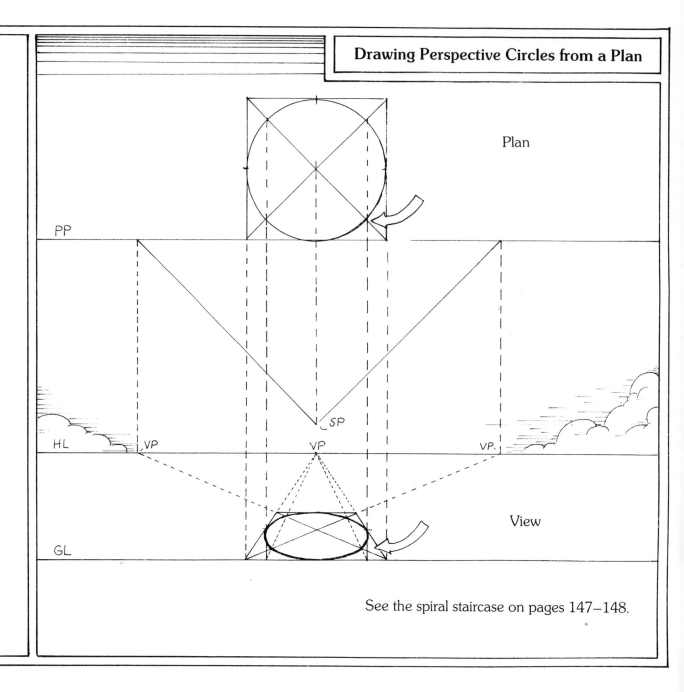

Drawing Perspective Circles from a Plan

Plan

PP

SP

HL VP VP VP.

GL

View

See the spiral staircase on pages 147–148.

A third method of deriving a circle from a square again involves the identification of the point at which the diagonals of the square cross the arcs of the circle.

1. Draw the square.

2. Use diagonals to find the center of the square.

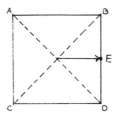

3. Extend a horizontal line from this center to find the center of one side (E).

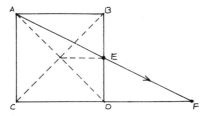

4. Extend lines AE and CD until they intersect (F). Line CD equals line DF.

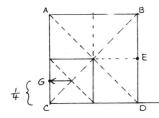

5. Using diagonals, find the center of one quarter of the square (G).

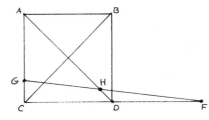

6. Connect G to F to find the point at which the arc of the circle will cross the diagonal (H).

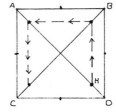

7. From point H, other points of the circle's intersection can be found, as shown.

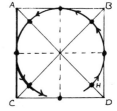

8. Last, connect the diagonal reference points and the points in the center of each side to draw the circle.

This method can be used in a perspective view. Extend either the side parallel to the picture plane or the side or sides receding towards the vanishing point.

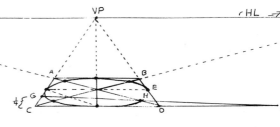

93

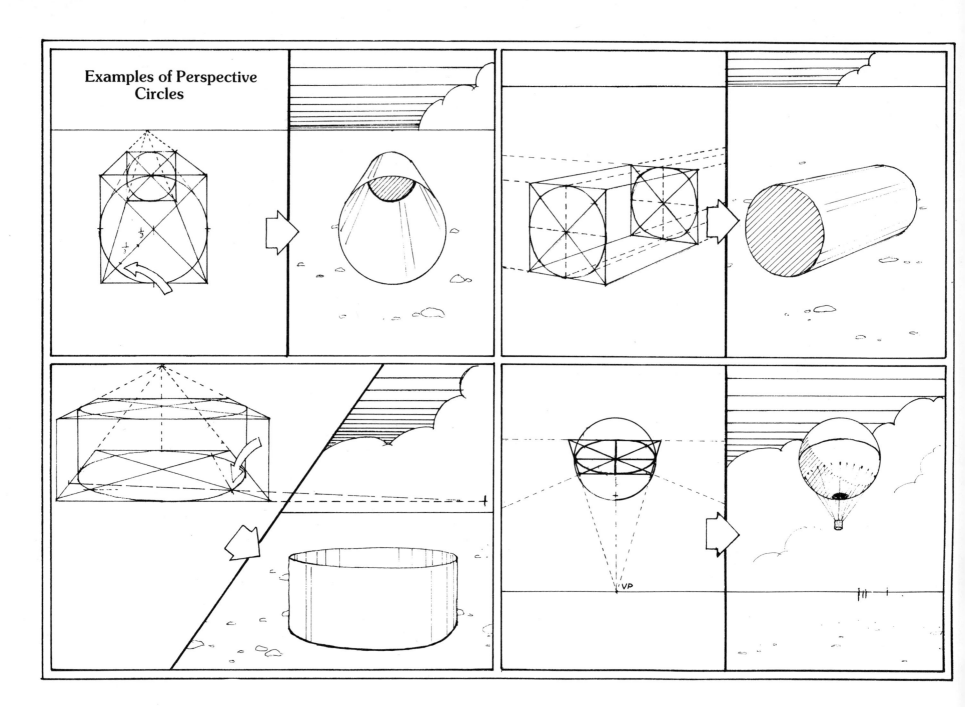

Examples of Perspective Circles

94

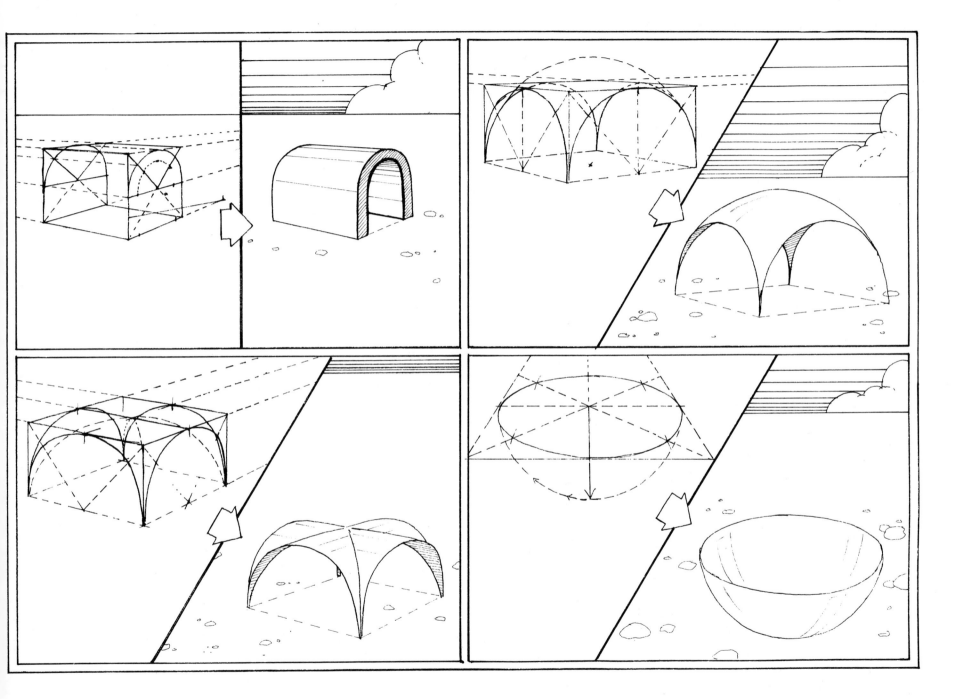

The key to drawing curved lines and surfaces in perspective is to plot significant apexes and other reference points by means of right-angle coordinates, which can be measured easily.

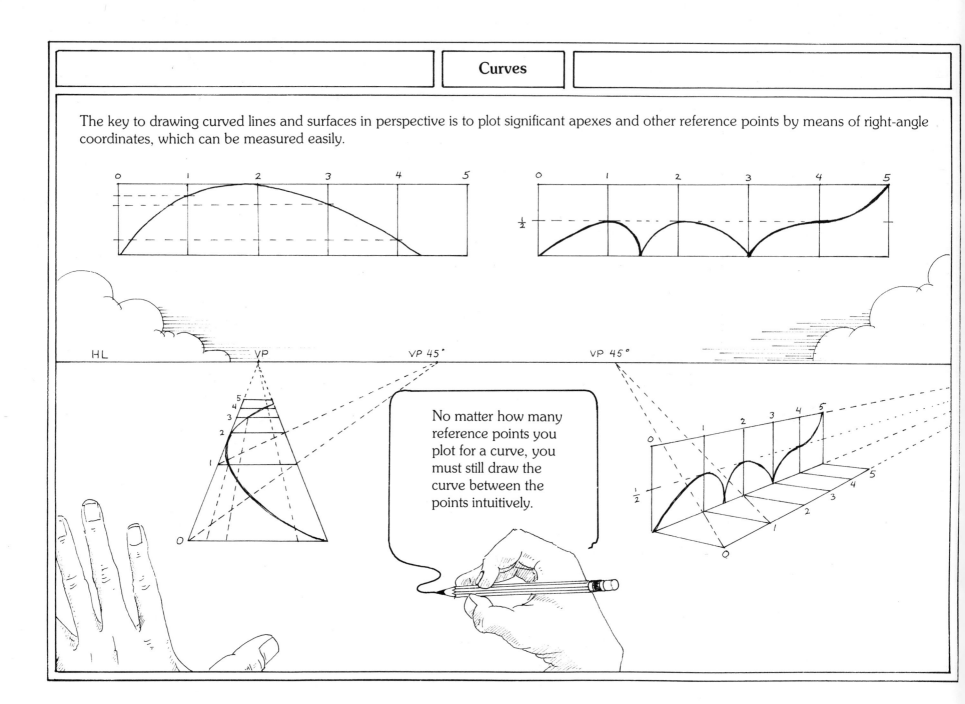

No matter how many reference points you plot for a curve, you must still draw the curve between the points intuitively.

Drawing Curved Planes on One Axis

Lay out a rectangle for a basic reference and mark the apex around which the curve will bend.

Perpendicular to the curved plane, draw a rectangle in perspective with one corner set at the apex of the curve. This rectangle will establish the width of the curved plane.

Form the ends of the curved plane as shown, using the corner of the rectangle as a guide.

Connect these new reference points to form the curve corresponding to the opposite side of the curved plane.

Erase the guide lines and the lines passing behind opaque surfaces.

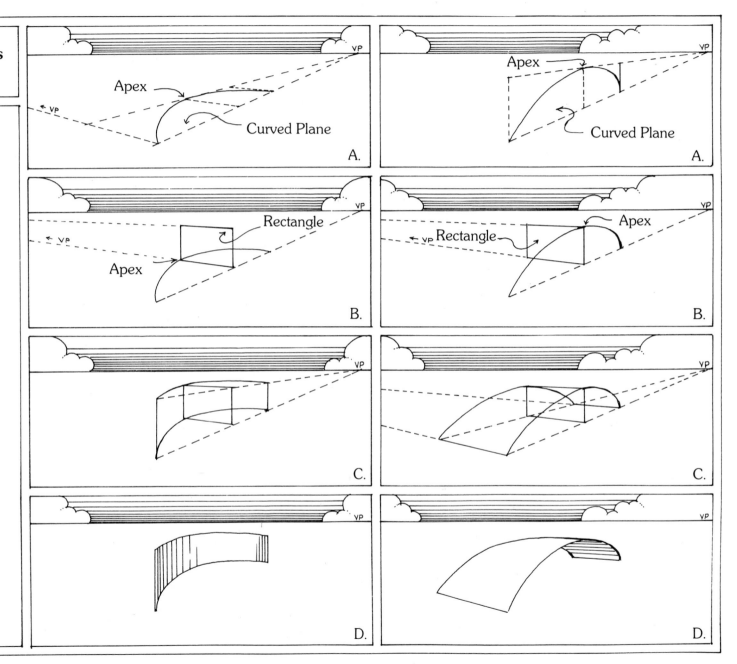

Drawing Curved Planes on Two Axes

Planes that curve along two axes can create additional

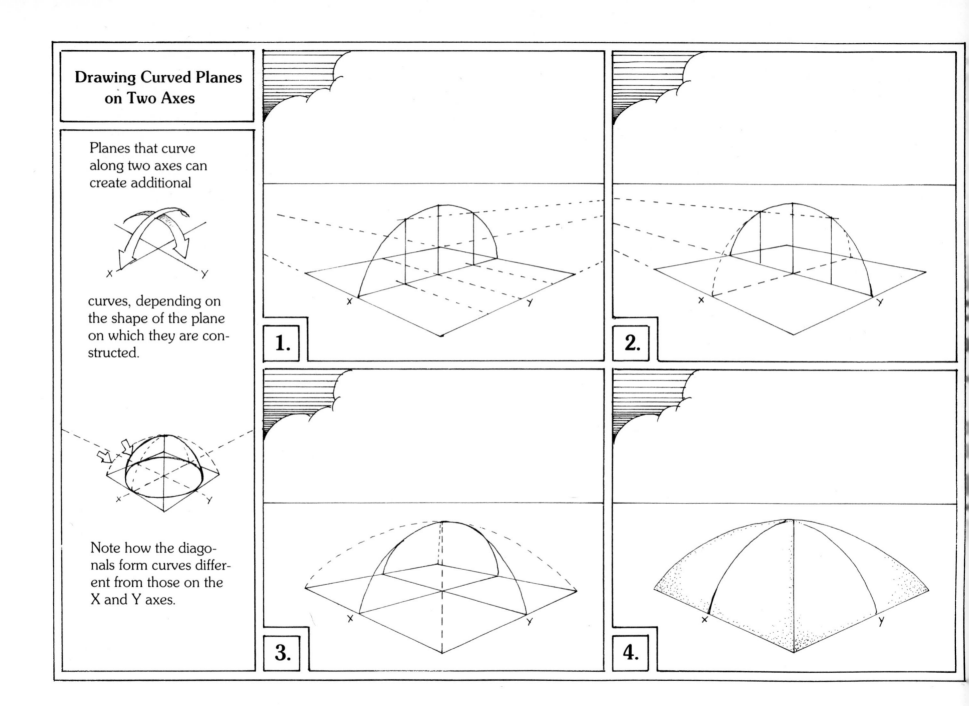

curves, depending on the shape of the plane on which they are constructed.

Note how the diagonals form curves different from those on the X and Y axes.

1.

2.

3.

4.

Drawing Curved Planes on Three Axes

Planes that curve along three perpendicular axes are like double curved forms that rest on a curved base.

If the curves are all the same, the resulting form will be a sphere, or a section of it.

1.

HL VP

2.

HL VP

3.

HL VP

4.

HL

When curved planes intersect, they form curved intersections.

When curved planes intersect, they produce a curve that is a compromise between the two original curved surfaces.

In drawing curves of this sort, it is often sufficient to estimate the shape of the curve by imagining the probable intersection of the flat planes, and trying to adjust a compromise curve over the straight lines.

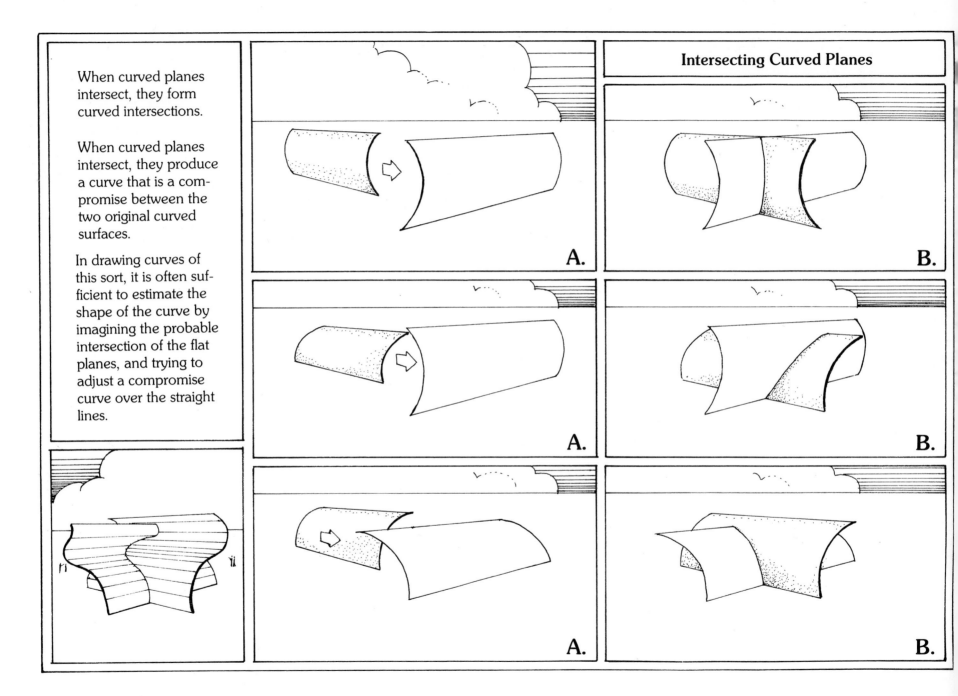

Intersecting Curved Planes

A.

B.

A.

B.

A.

B.

The most accurate way to plot the intersection of curved planes is to follow the method of transferring the height of the smaller plane to the larger one using a corner. See pages 80–84.

By marking reference points along the ends of either of the curves and repeating the process, guide points for the compromise curve can be plotted along the intersection.

Note how each reference point is actually the corner of a separate horizontal plane.

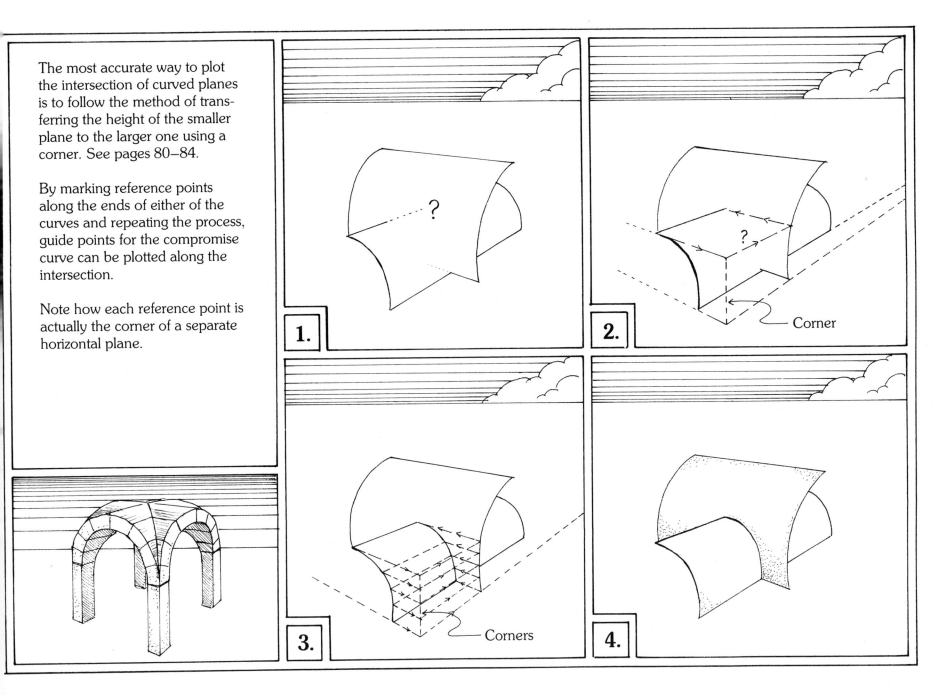

1.

2.

Corner

3.

Corners

4.

The stations that carry the points from one curved surface to the other need not be rectangles, as long as the lines that form them are connected to the proper vanishing points.

Here, for example, the two planes are not intersecting at right angles; thus, the base of each curved plane has its own set of vanishing points.

With complex surfaces like these, more reference points need to be plotted to guide the intersecting curve.

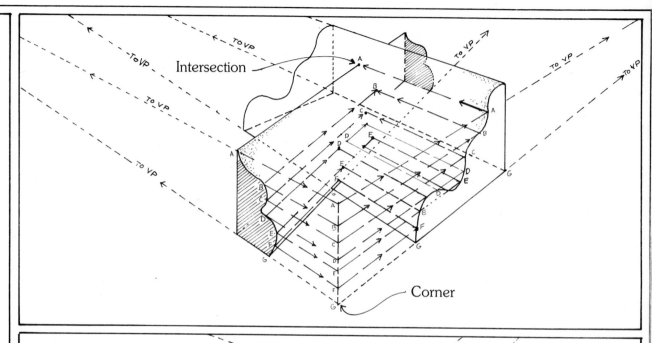

Intersection

Corner

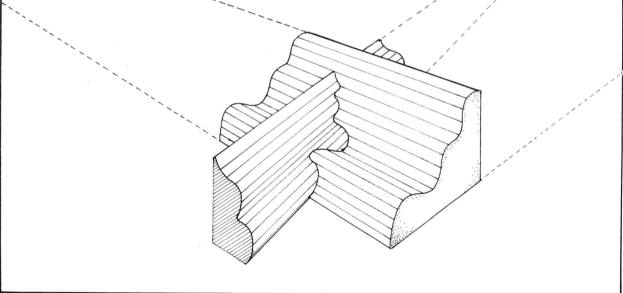

Drawing Complex Curved Shapes in Perspective

There is no one way in which to approach the drawing of complex and multiple curved surfaces in perspective, for each project will present a certain number of unique problems that will require unique solutions. However, whether one is loosely sketching or trying to render an object to scale, the basic principle of progressing from the simple to the complex remains valid. In particular, this means moving from straight lines and right angle coordinates, which can be plotted with certainty in a perspective view, to complex curves, which ultimately must be sensed.

In the example at the lower right, note the way in which the final form, which has few straight lines, is built up from simple coordinates.

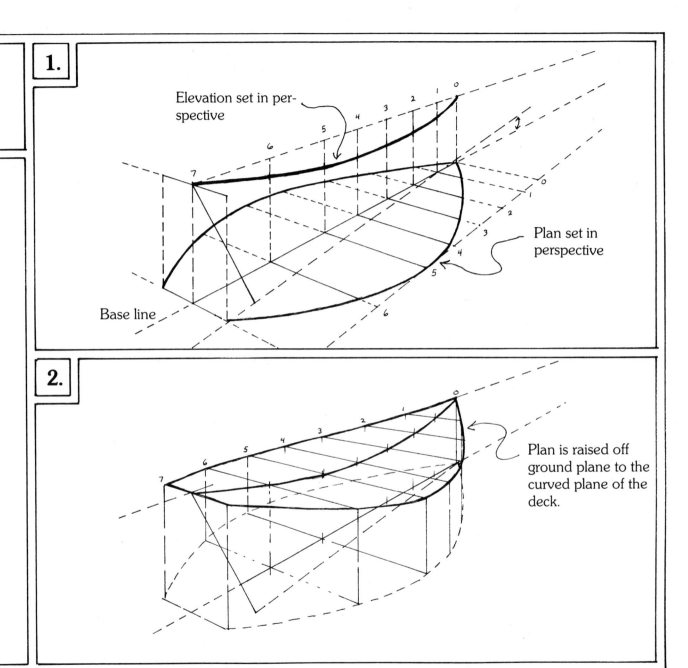

1.

Elevation set in perspective

Plan set in perspective

Base line

2.

Plan is raised off ground plane to the curved plane of the deck.

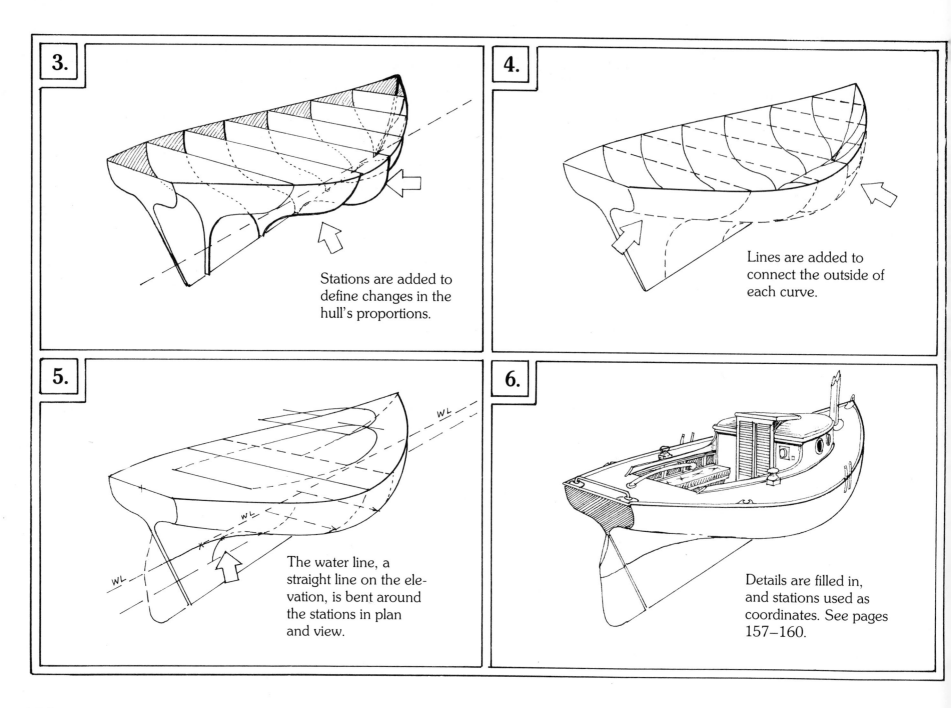

3. Stations are added to define changes in the hull's proportions.

4. Lines are added to connect the outside of each curve.

5. The water line, a straight line on the elevation, is bent around the stations in plan and view.

6. Details are filled in, and stations used as coordinates. See pages 157–160.

Knowing how to construct grids on curved surfaces makes it possible for you to plot complex designs on curves and transfer designs from plans and elevations. For freehand sketching, it is often enough to have a general mental picture of the curving grid plane. For greater accuracy, however, a grid can be drawn in and subdivided.

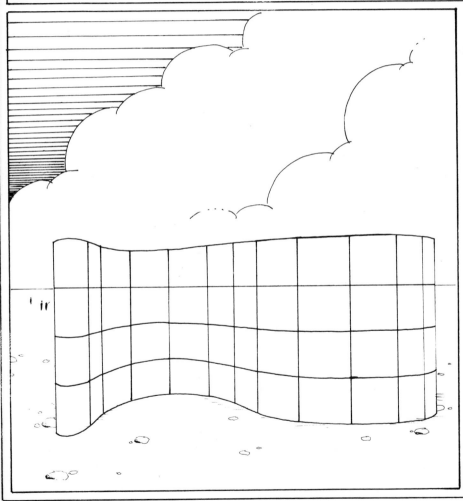

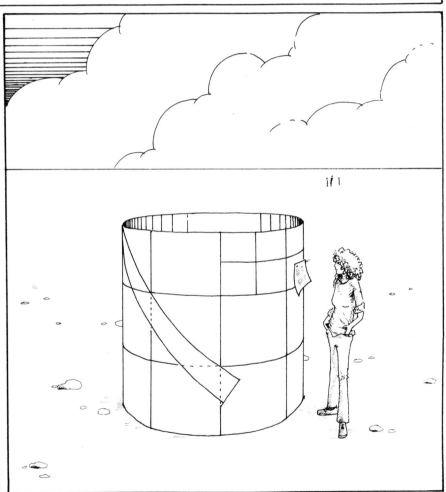

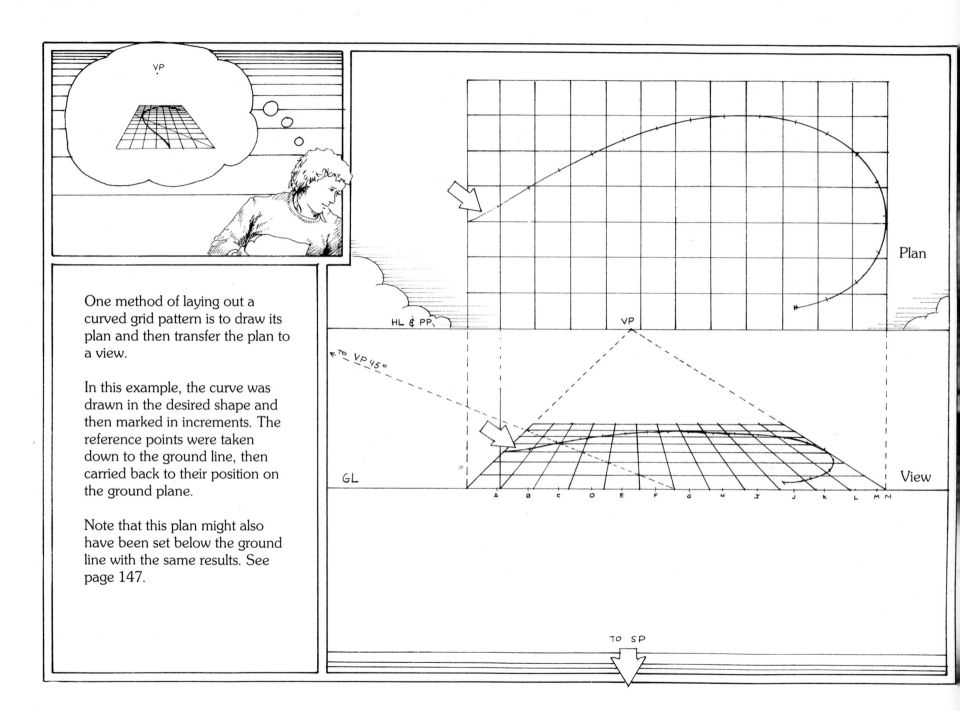

One method of laying out a curved grid pattern is to draw its plan and then transfer the plan to a view.

In this example, the curve was drawn in the desired shape and then marked in increments. The reference points were taken down to the ground line, then carried back to their position on the ground plane.

Note that this plan might also have been set below the ground line with the same results. See page 147.

Once you have laid the base curve out on the ground plane, add verticals perpendicular to the incremental marks on the curve. These are the vertical lines of the grid. Note that the space between them differs, depending on their distance from the picture plane.

Now, on a vertical measuring line, mark the increments of the horizontal lines of the grid and connect them back to the curve. In theory, each vertical of the grid will have to be marked off separately from a line at the picture plane. However, a few judiciously placed marks may be enough to guide the whole line.

Curved diagonals can be set up across the curved squares to check accuracy.

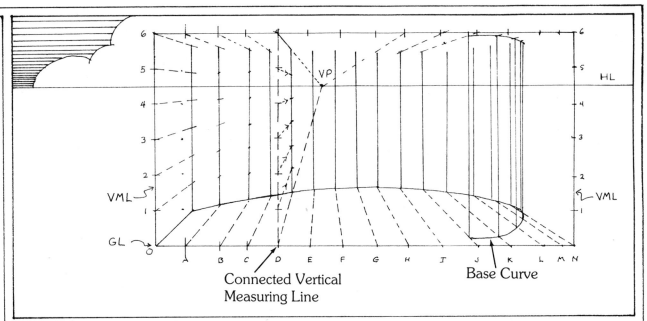

Connected Vertical Measuring Line

Base Curve

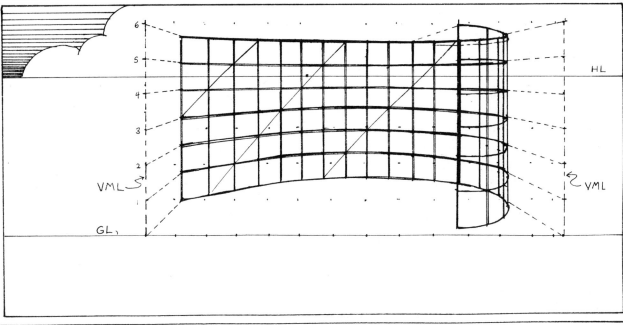

Perspective Grids Based on Circles

Cylinders, cones, and spheres are the primary curved forms based on circles. From these forms, a great variety of shapes and combinations can be derived.

Notice in these examples that the lateral divisions of the grid patterns are circles or, in perspective, ellipses.

When drawing these forms the circles (ellipses) can be treated like stations. Designs can also be drawn on the flattened plan of the form and then "rolled" into perspective view.

In order to move back and forth between plan and view, it is important to understand something about the relationship between the diameter and circumference of a circle.

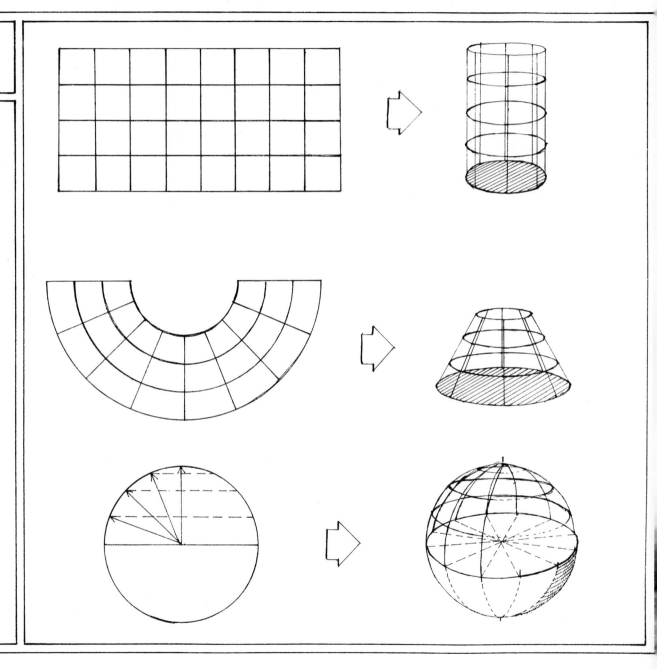

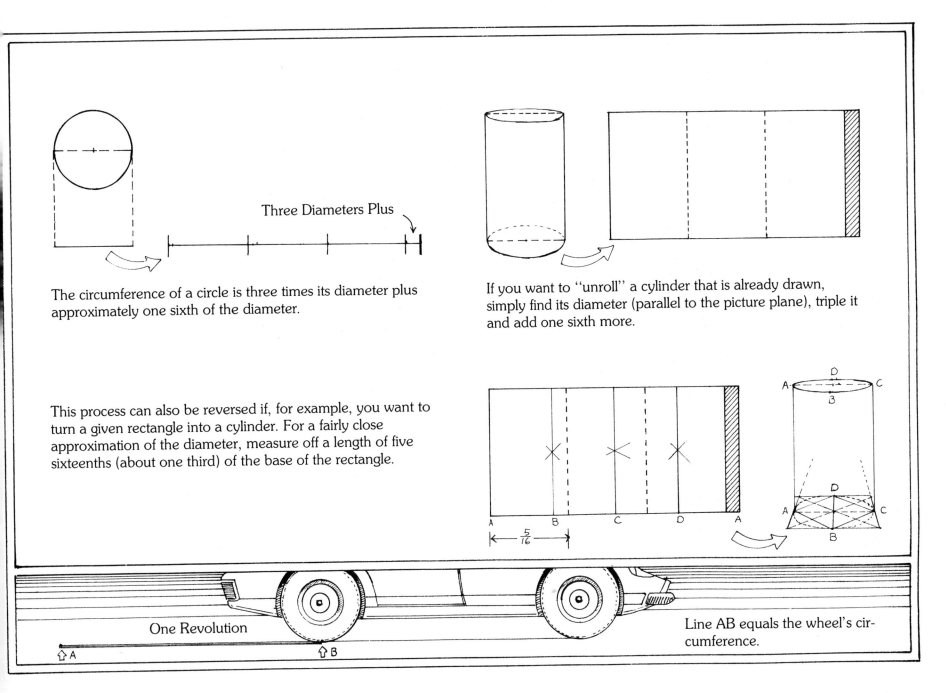

The circumference of a circle is three times its diameter plus approximately one sixth of the diameter.

If you want to "unroll" a cylinder that is already drawn, simply find its diameter (parallel to the picture plane), triple it and add one sixth more.

This process can also be reversed if, for example, you want to turn a given rectangle into a cylinder. For a fairly close approximation of the diameter, measure off a length of five sixteenths (about one third) of the base of the rectangle.

Three Diameters Plus

One Revolution

Line AB equals the wheel's circumference.

 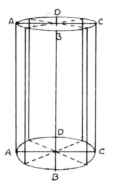 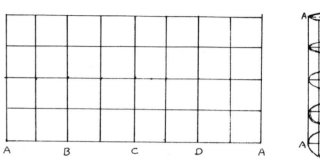 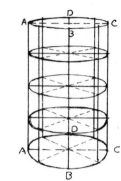

To construct a grid on a cylinder, divide the elevation into four equal parts and draw in perpendicular lines. These lines will mark the major axes of the circle, when set in perspective. Note that line AC is the diameter in perspective.

Draw the grid pattern to scale by adding horizontal lines, as shown. Each horizontal line represents what will be a perspective circle.

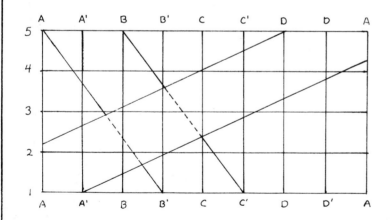 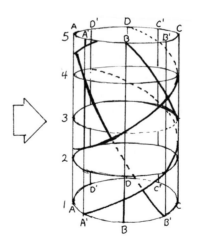 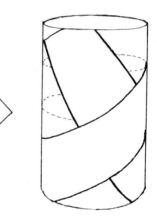

Designs can now be plotted on the flat grid. Use the coordinates as guides, then transfer the design shapes to the curving surface of the cylinder.

There are as many types of spirals as there are geometric shapes. The key to drawing them in perspective is identifying the simpler elements around which the spirals are constructed. In this example, the spirals are based on equidistant circles (cylinders), which act as stations.

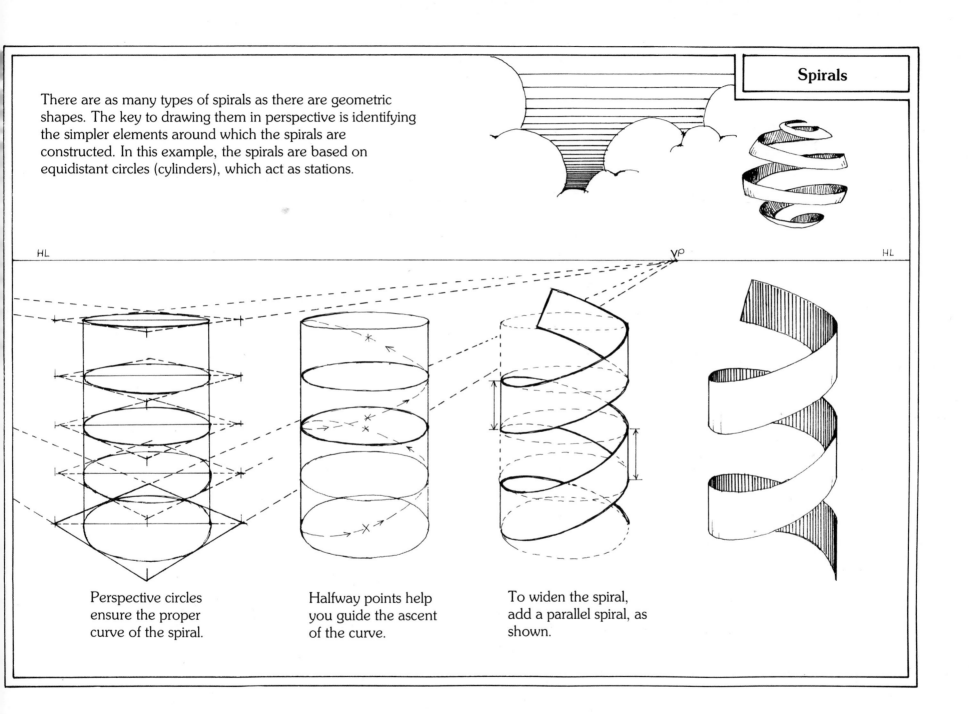

HL

VP

HL

Perspective circles ensure the proper curve of the spiral.

Halfway points help you guide the ascent of the curve.

To widen the spiral, add a parallel spiral, as shown.

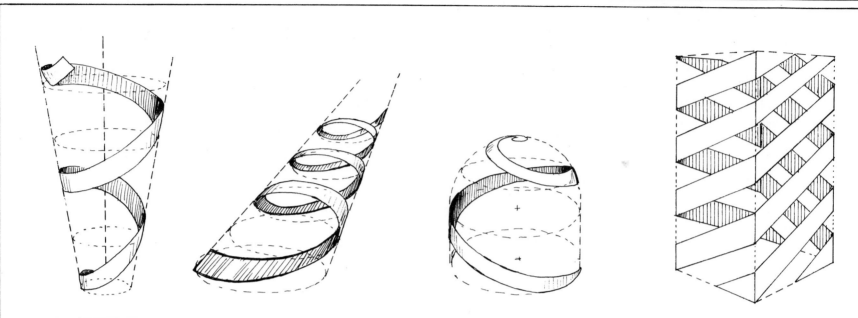

Note the forms in which these spirals are contained and the shape of the stations around which the spirals must be formed.

You can plot spirals with converging, diverging, or irregular sides by determining the points at which the lines cross the stations.

For very complex spirals, a grid can be used. See page 110.

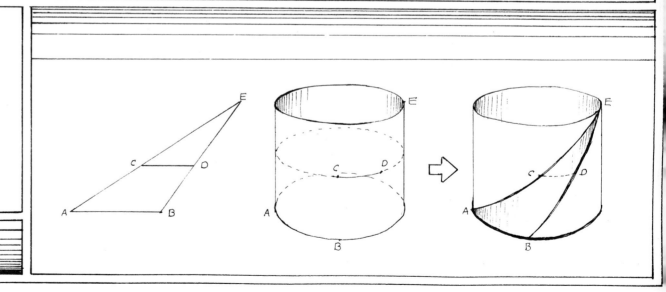

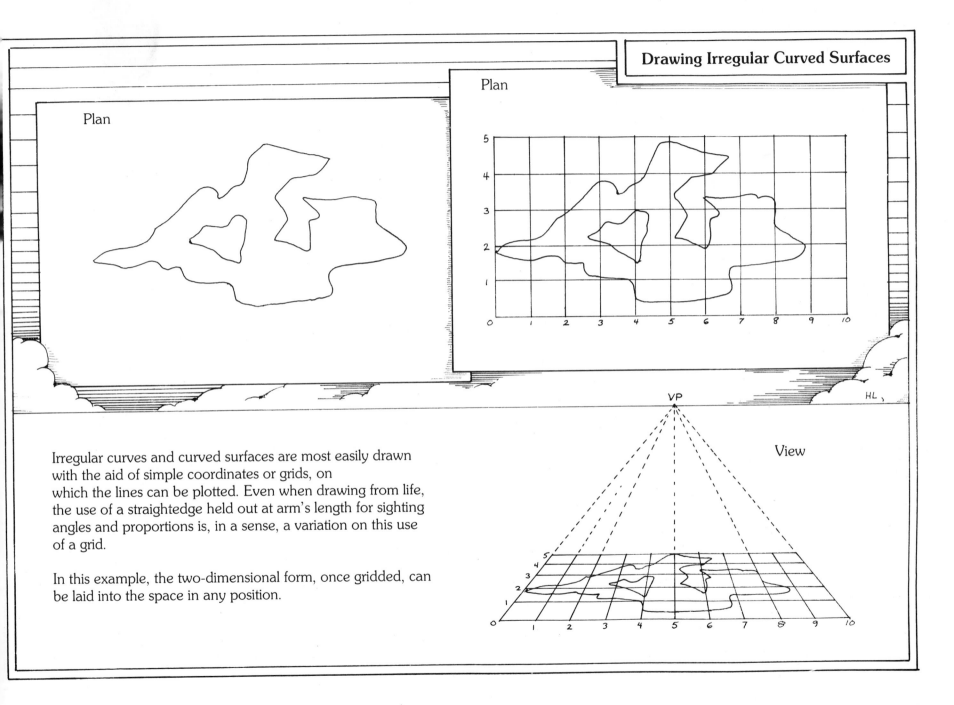

Plan

Plan

View

VP

HL

Irregular curves and curved surfaces are most easily drawn with the aid of simple coordinates or grids, on which the lines can be plotted. Even when drawing from life, the use of a straightedge held out at arm's length for sighting angles and proportions is, in a sense, a variation on this use of a grid.

In this example, the two-dimensional form, once gridded, can be laid into the space in any position.

113

Irregular three-dimensional curved surfaces can be handled in a number of ways, depending on the requirements of the particular project.

One common method involves the use of plans and elevations. Irregular elevations are sliced off into horizontal planes (stations). By this method, for example, you could translate information from a topographical map into a landscape view.

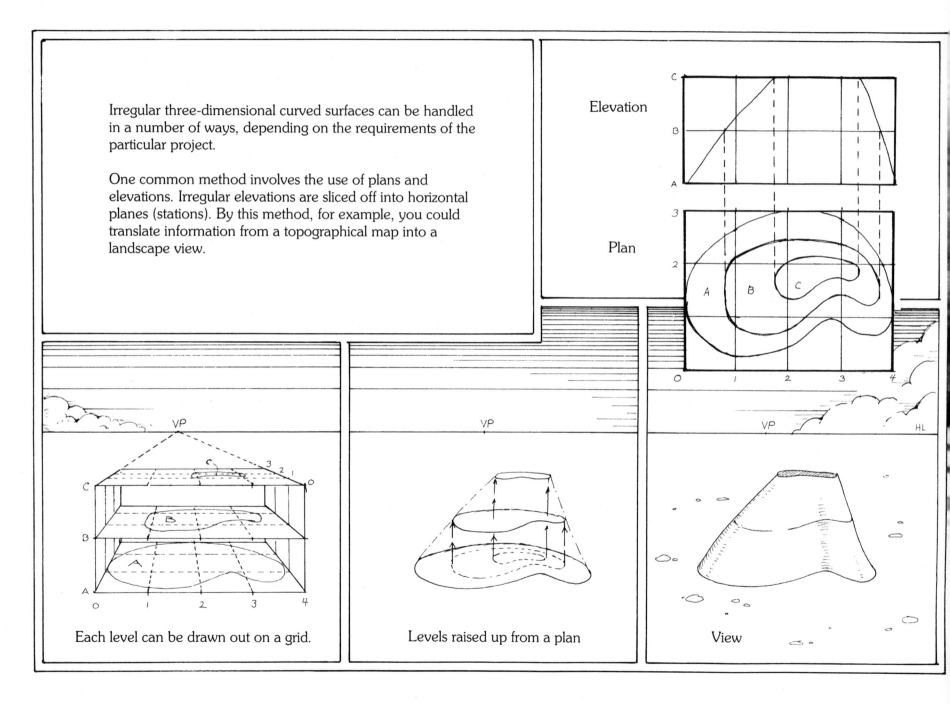

Elevation

Plan

Each level can be drawn out on a grid.

Levels raised up from a plan

View

Another method for plotting irregular curved surfaces is to use a base grid on which perpendicular lines are set at various heights to mark significant coordinates.

This method is really the same as the one described on the previous page, except that here, the information has been sliced vertically rather than horizontally.

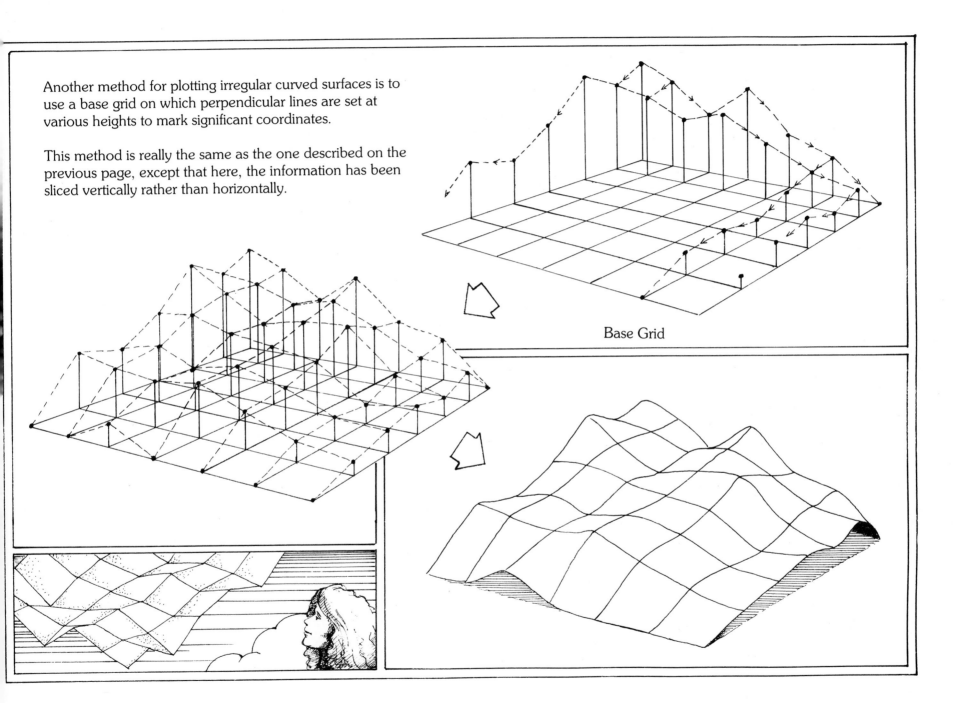

Base Grid

Shadows and Reflections

Despite their initial appearance of complexity, shadows and reflections obey the same immutable rules of perspective illustrated in the preceding sections of this book.

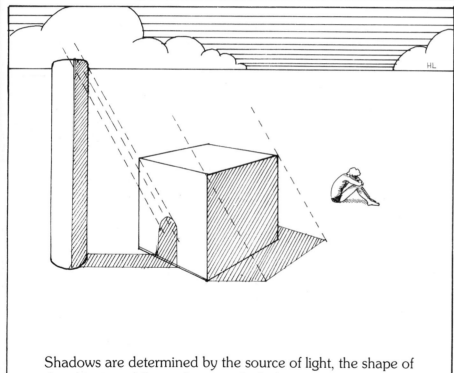

Shadows are determined by the source of light, the shape of the object, and the surface on which they are cast.

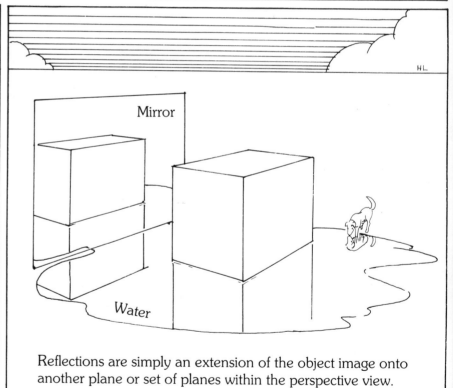

Reflections are simply an extension of the object image onto another plane or set of planes within the perspective view.

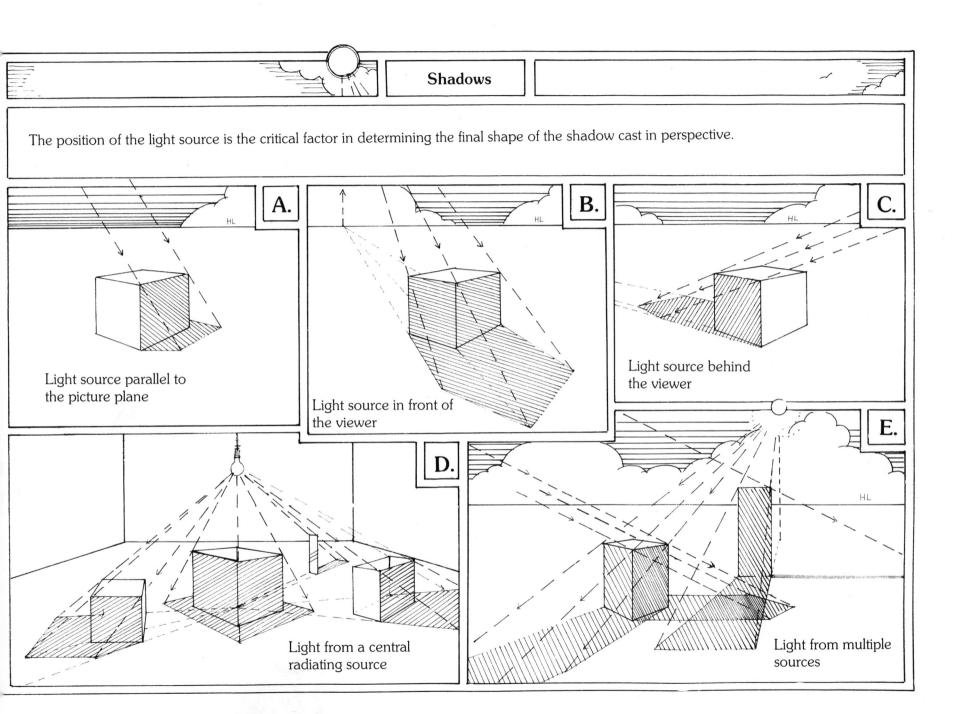

Shadows

The position of the light source is the critical factor in determining the final shape of the shadow cast in perspective.

A.

Light source parallel to the picture plane

B.

Light source in front of the viewer

C.

Light source behind the viewer

D.

Light from a central radiating source

E.

Light from multiple sources

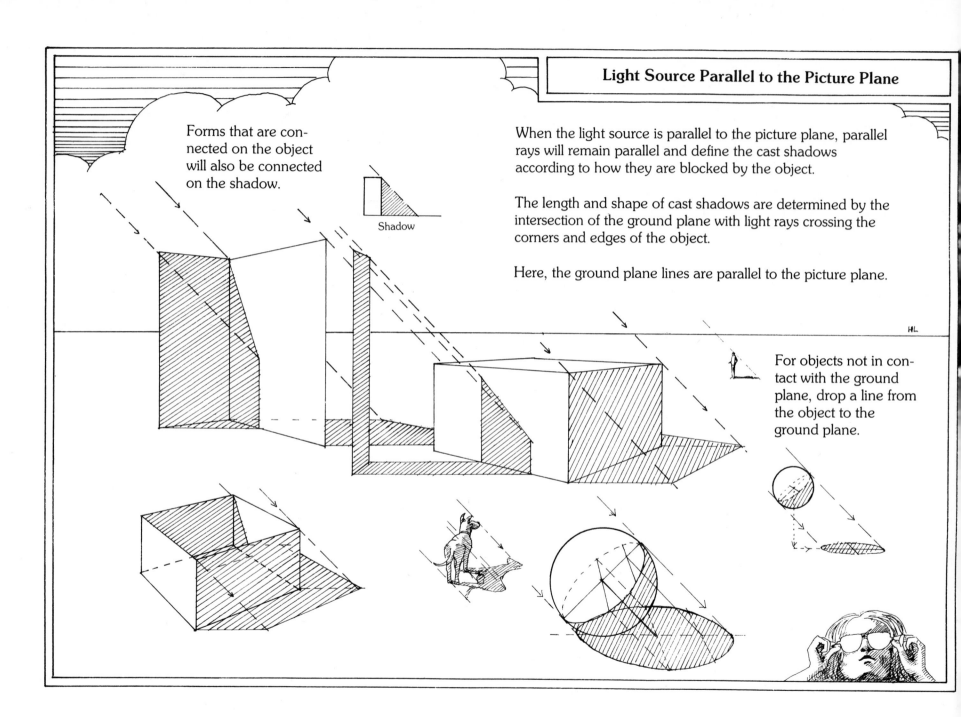

Forms that are connected on the object will also be connected on the shadow.

Shadow

When the light source is parallel to the picture plane, parallel rays will remain parallel and define the cast shadows according to how they are blocked by the object.

The length and shape of cast shadows are determined by the intersection of the ground plane with light rays crossing the corners and edges of the object.

Here, the ground plane lines are parallel to the picture plane.

For objects not in contact with the ground plane, drop a line from the object to the ground plane.

HL

118

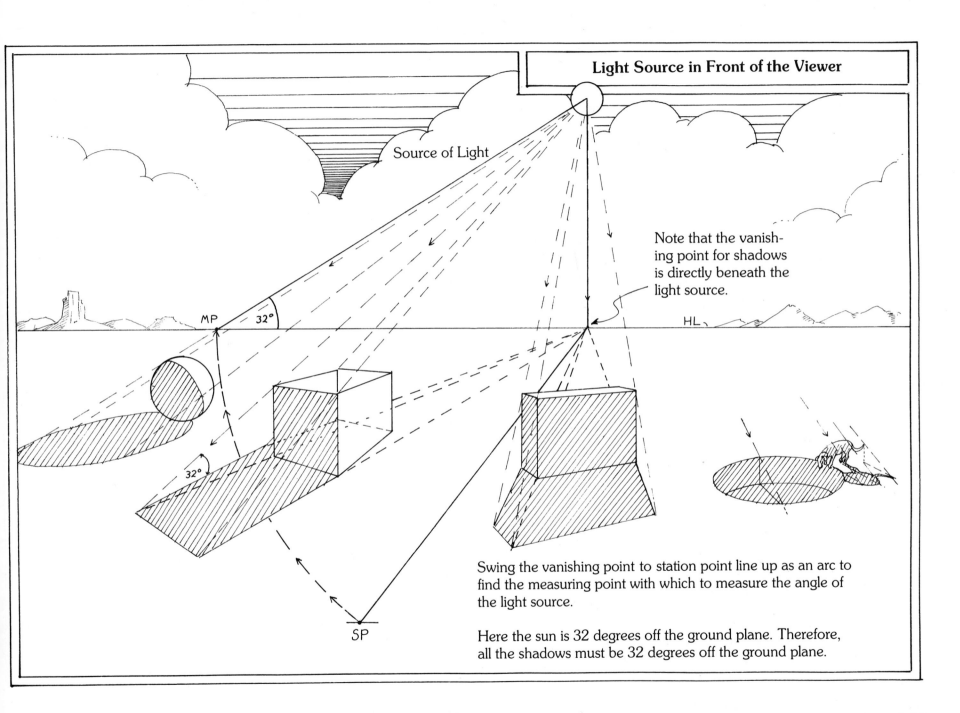

Light Source in Front of the Viewer

Source of Light

Note that the vanishing point for shadows is directly beneath the light source.

MP 32°

HL

32°

Swing the vanishing point to station point line up as an arc to find the measuring point with which to measure the angle of the light source.

Here the sun is 32 degrees off the ground plane. Therefore, all the shadows must be 32 degrees off the ground plane.

SP

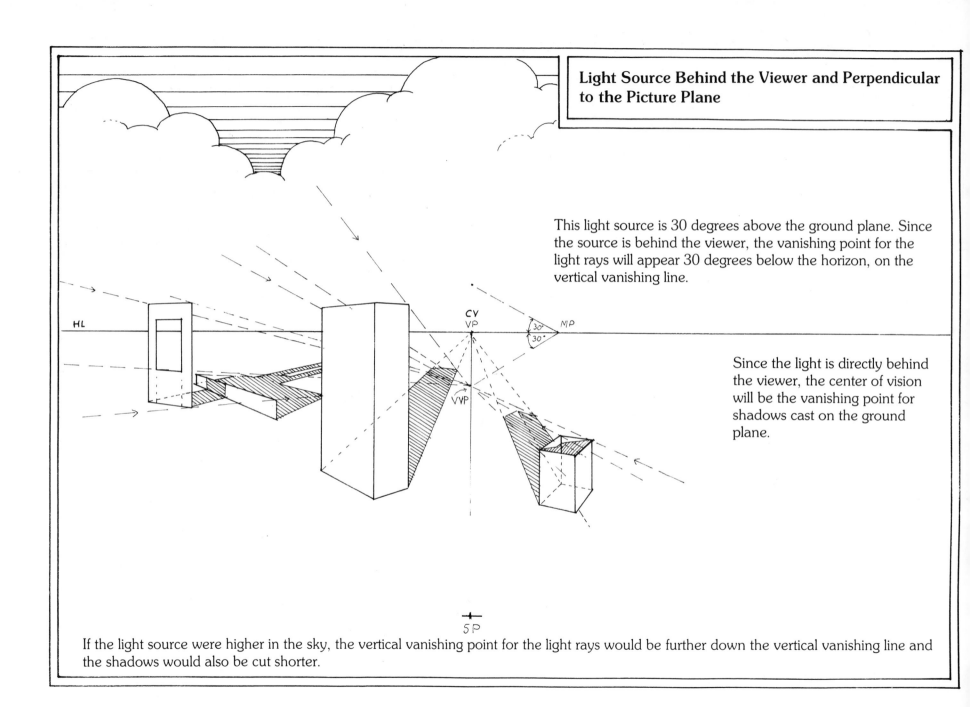

Light Source Behind the Viewer and Perpendicular to the Picture Plane

This light source is 30 degrees above the ground plane. Since the source is behind the viewer, the vanishing point for the light rays will appear 30 degrees below the horizon, on the vertical vanishing line.

Since the light is directly behind the viewer, the center of vision will be the vanishing point for shadows cast on the ground plane.

HL

CV
VP

30°
30°

MP

VVP

SP

If the light source were higher in the sky, the vertical vanishing point for the light rays would be further down the vertical vanishing line and the shadows would also be cut shorter.

120

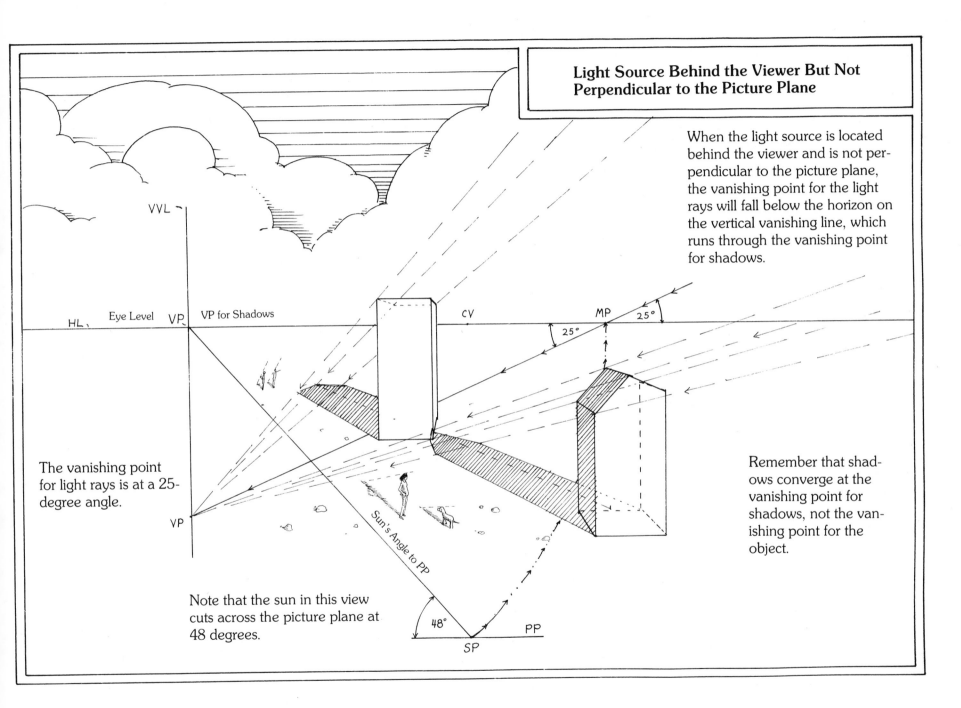

Light Source Behind the Viewer But Not Perpendicular to the Picture Plane

When the light source is located behind the viewer and is not perpendicular to the picture plane, the vanishing point for the light rays will fall below the horizon on the vertical vanishing line, which runs through the vanishing point for shadows.

VVL

HL 、 Eye Level VP. VP for Shadows CV MP 25° 25°

The vanishing point for light rays is at a 25-degree angle.

VP

Sun's Angle to PP

Remember that shadows converge at the vanishing point for shadows, not the vanishing point for the object.

Note that the sun in this view cuts across the picture plane at 48 degrees.

48° PP

SP

121

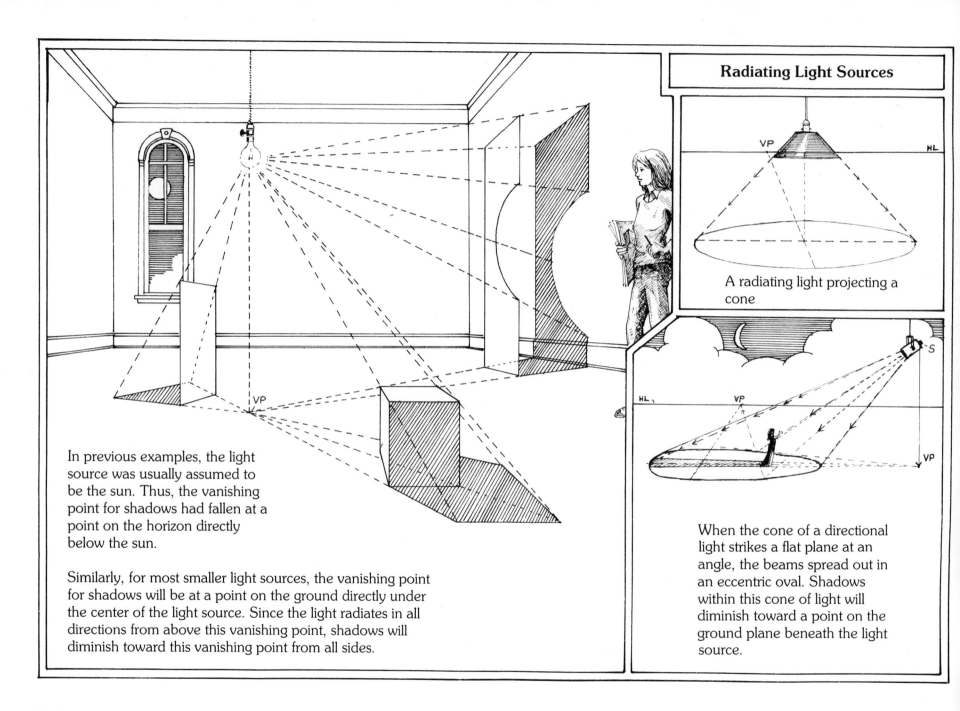

Radiating Light Sources

A radiating light projecting a cone

In previous examples, the light source was usually assumed to be the sun. Thus, the vanishing point for shadows had fallen at a point on the horizon directly below the sun.

Similarly, for most smaller light sources, the vanishing point for shadows will be at a point on the ground directly under the center of the light source. Since the light radiates in all directions from above this vanishing point, shadows will diminish toward this vanishing point from all sides.

When the cone of a directional light strikes a flat plane at an angle, the beams spread out in an eccentric oval. Shadows within this cone of light will diminish toward a point on the ground plane beneath the light source.

122

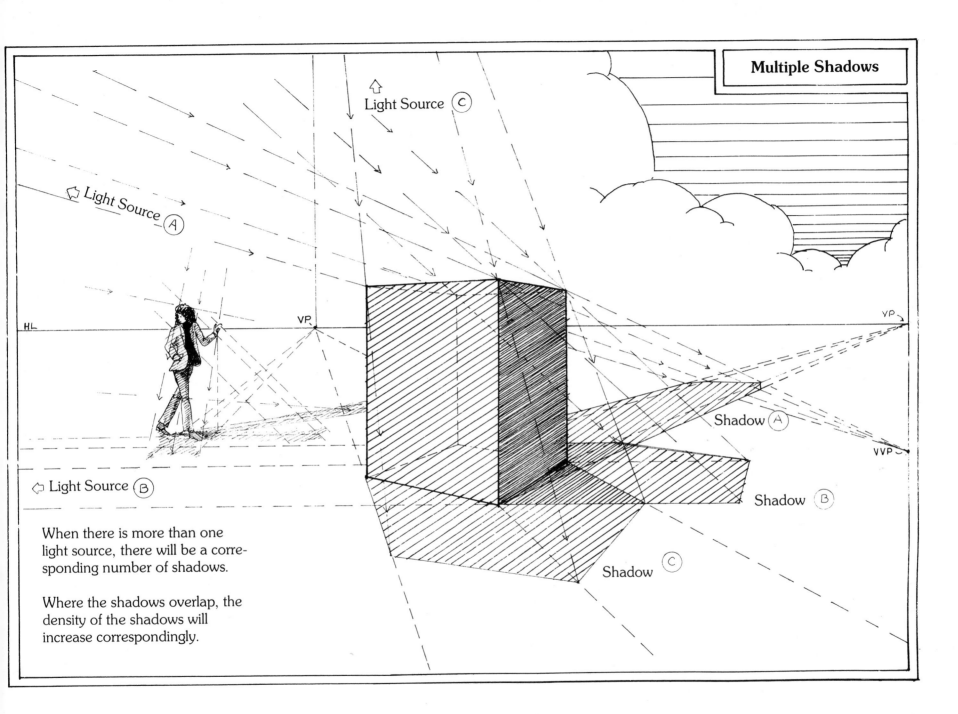

Light Source C

Light Source A

Light Source B

HL

VP

VP

VVP

Shadow A

Shadow B

Shadow C

When there is more than one
light source, there will be a corre-
sponding number of shadows.

Where the shadows overlap, the
density of the shadows will
increase correspondingly.

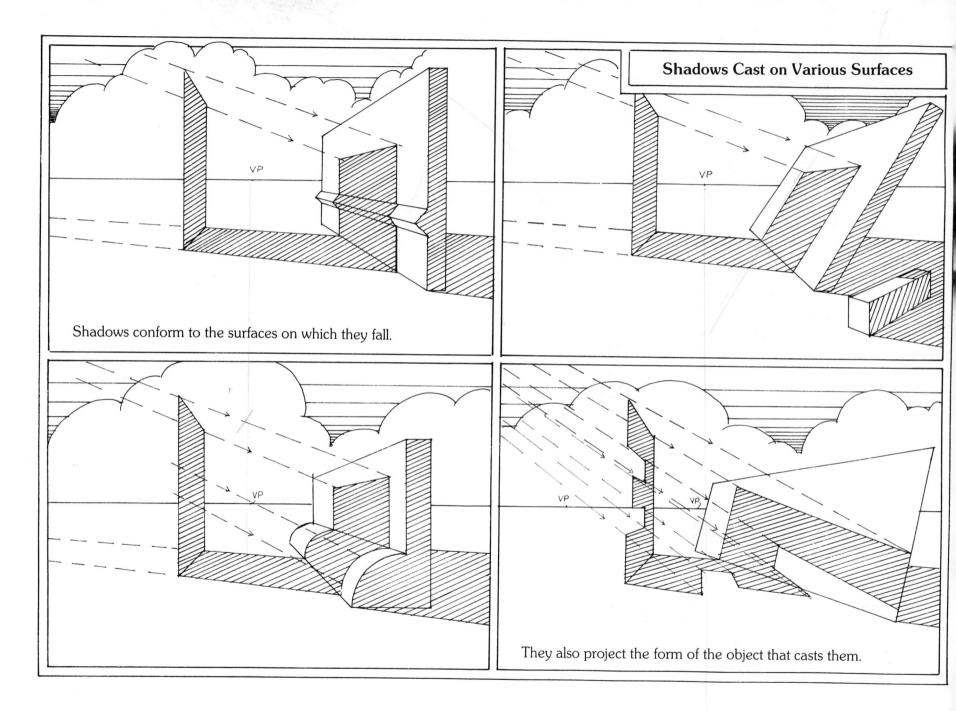

VP

Shadows conform to the surfaces on which they fall.

VP

VP

VP

VP

They also project the form of the object that casts them.

124

Reflections

A reflection is simply the mirror image, or equal and opposite extension of, the original object and its perspective system. Drawing parallel reflections requires only a simple extension of the object through the reflecting surface, while angular reflections require more complicated calculations.

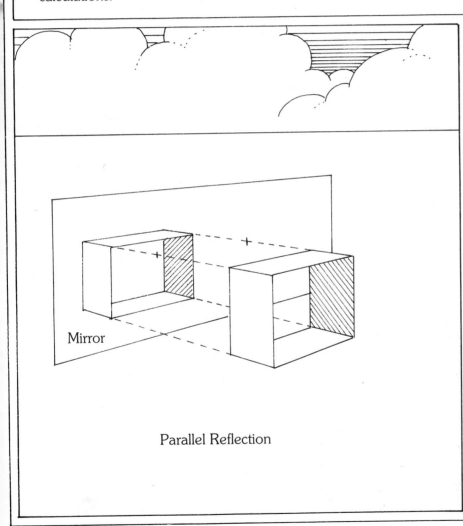

Mirror

Parallel Reflection

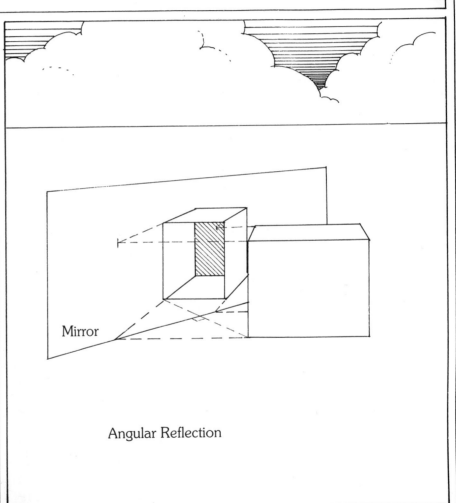

Mirror

Angular Reflection

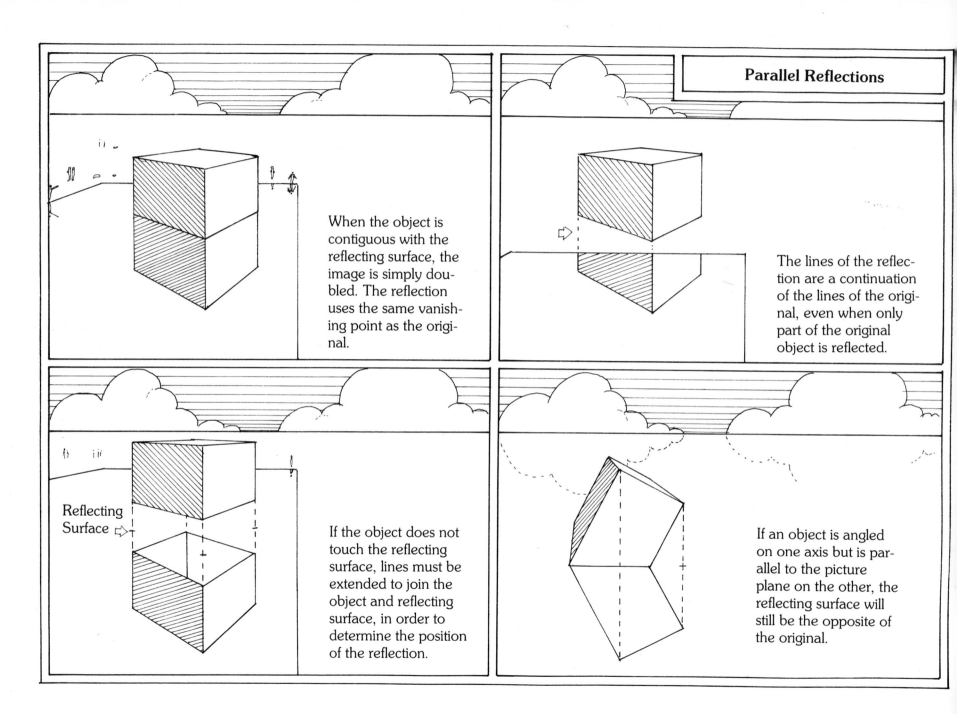

When the object is contiguous with the reflecting surface, the image is simply doubled. The reflection uses the same vanishing point as the original.

The lines of the reflection are a continuation of the lines of the original, even when only part of the original object is reflected.

Reflecting Surface ⇨

If the object does not touch the reflecting surface, lines must be extended to join the object and reflecting surface, in order to determine the position of the reflection.

If an object is angled on one axis but is parallel to the picture plane on the other, the reflecting surface will still be the opposite of the original.

126

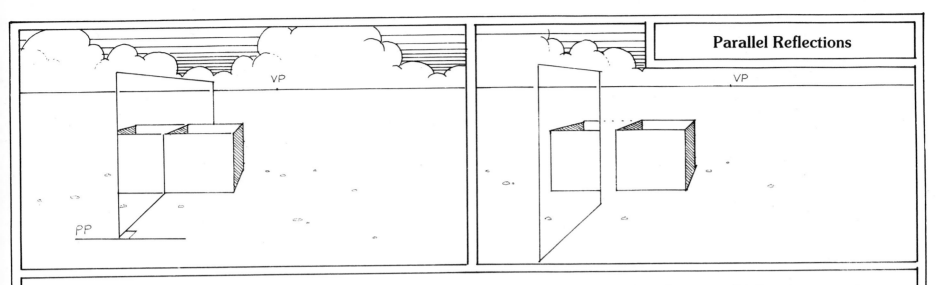

If both the reflecting plane and the object are perpendicular and parallel to the picture plane, the reflections will follow the same rules as those on the previous page.

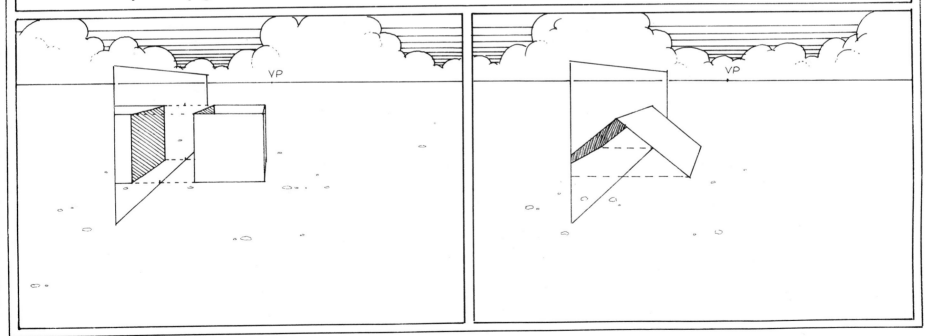

127

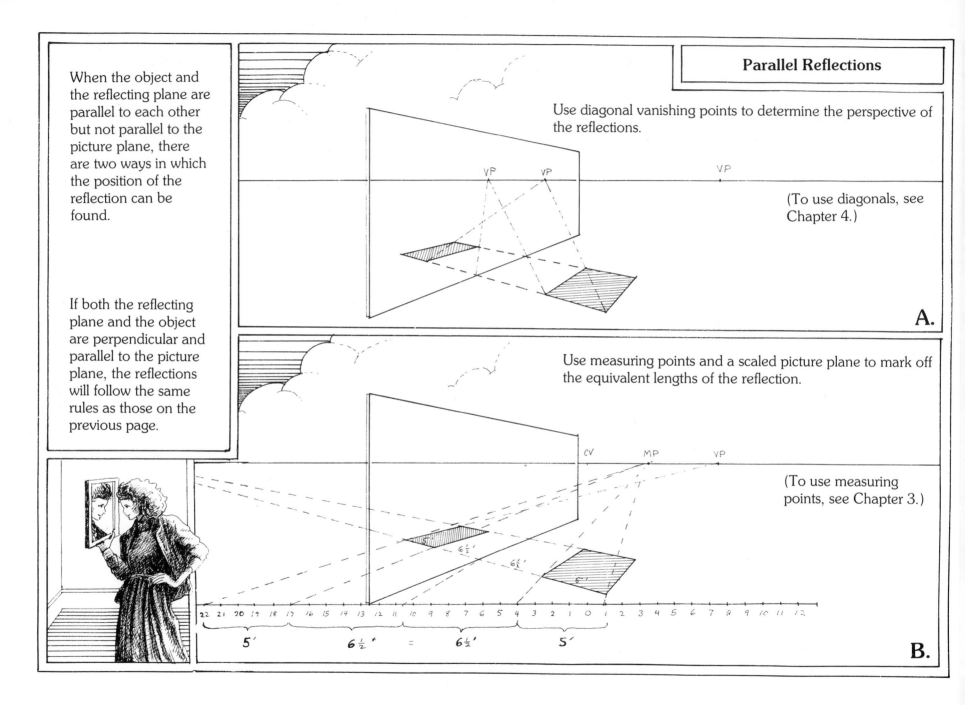

When the object and the reflecting plane are parallel to each other but not parallel to the picture plane, there are two ways in which the position of the reflection can be found.

Use diagonal vanishing points to determine the perspective of the reflections.

(To use diagonals, *see* Chapter 4.)

A.

If both the reflecting plane and the object are perpendicular and parallel to the picture plane, the reflections will follow the same rules as those on the previous page.

Use measuring points and a scaled picture plane to mark off the equivalent lengths of the reflection.

(To use measuring points, *see* Chapter 3.)

B.

128

It is a relatively simple matter to find the reflection when the object and reflective surface are parallel to each other, as shown in A and B. However, when the object and reflecting surface are at anything other than 90 degrees or 45 degrees to each other, the vanishing point of the reflection will be different from that of the object or its diagonals, as in C.

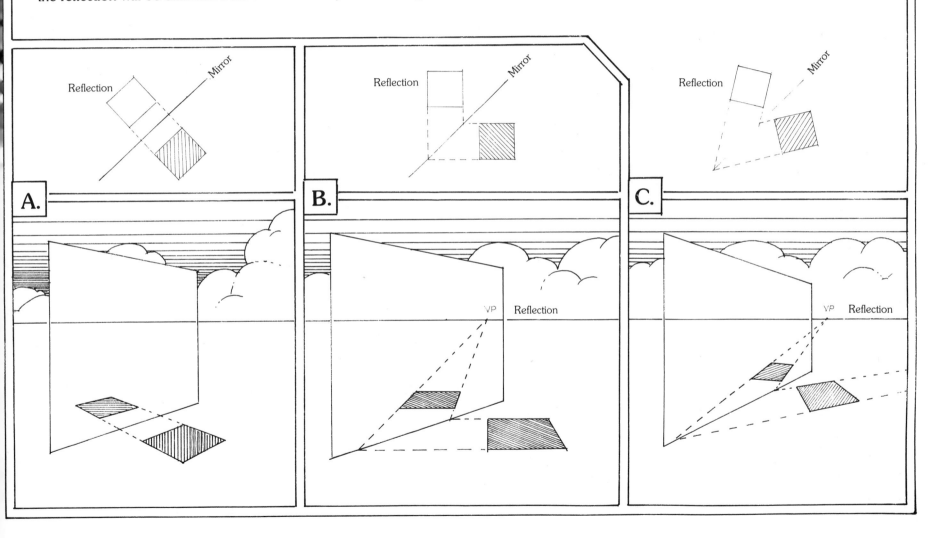

129

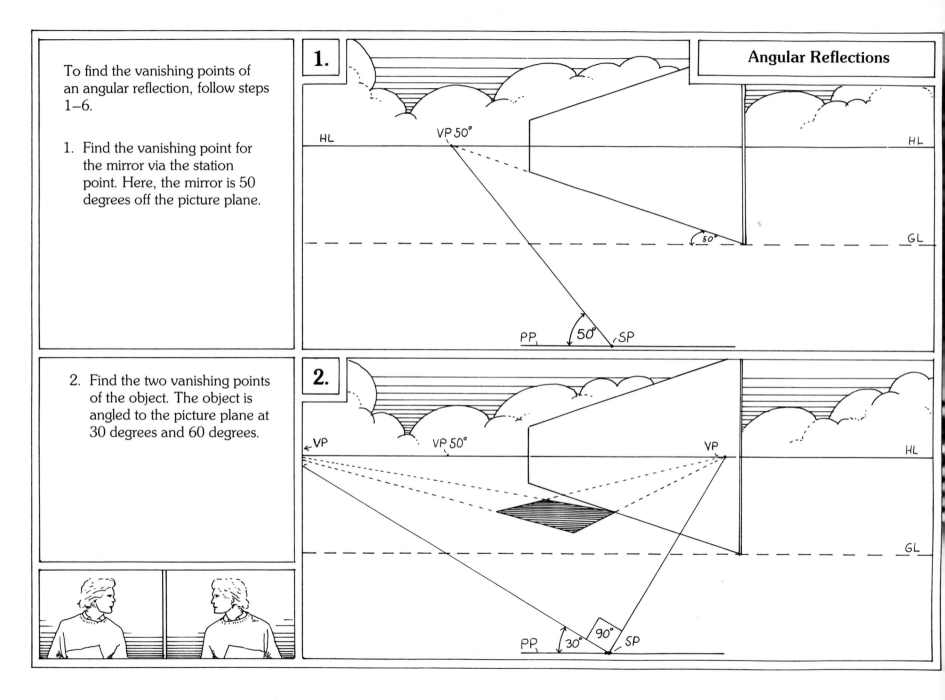

To find the vanishing points of an angular reflection, follow steps 1–6.

1. Find the vanishing point for the mirror via the station point. Here, the mirror is 50 degrees off the picture plane.

2. Find the two vanishing points of the object. The object is angled to the picture plane at 30 degrees and 60 degrees.

1.

HL

VP 50°

HL

GL

50°

PP

50°

SP

2.

VP

VP 50°

VP

HL

GL

90°

PP

30°

SP

130

3. Find the angle of the object to the mirror by subtracting the 30-degree angle of the object from the 50-degree angle of the mirror; this new angle is 20 degrees.

4. Find the vanishing point of the reflection by doubling the 20-degree angle of the object to the mirror.

Since the angle at which light strikes a mirror (angle of incidence) is equal to the angle of its reflection, this 40-degree line, which is 70 degrees off the picture plane when extended to the horizon, will establish the left vanishing point for the reflection.

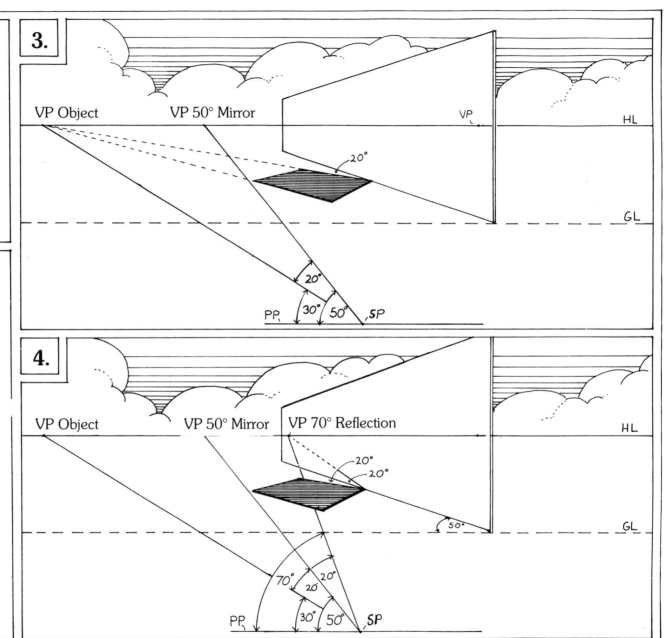

3.

VP Object VP 50° Mirror VP HL

20°

GL

PP 20° 30° 50° SP

4.

VP Object VP 50° Mirror VP 70° Reflection HL

20°
20°

50° GL

70° 20° 20°
30° 50°
PP SP

131

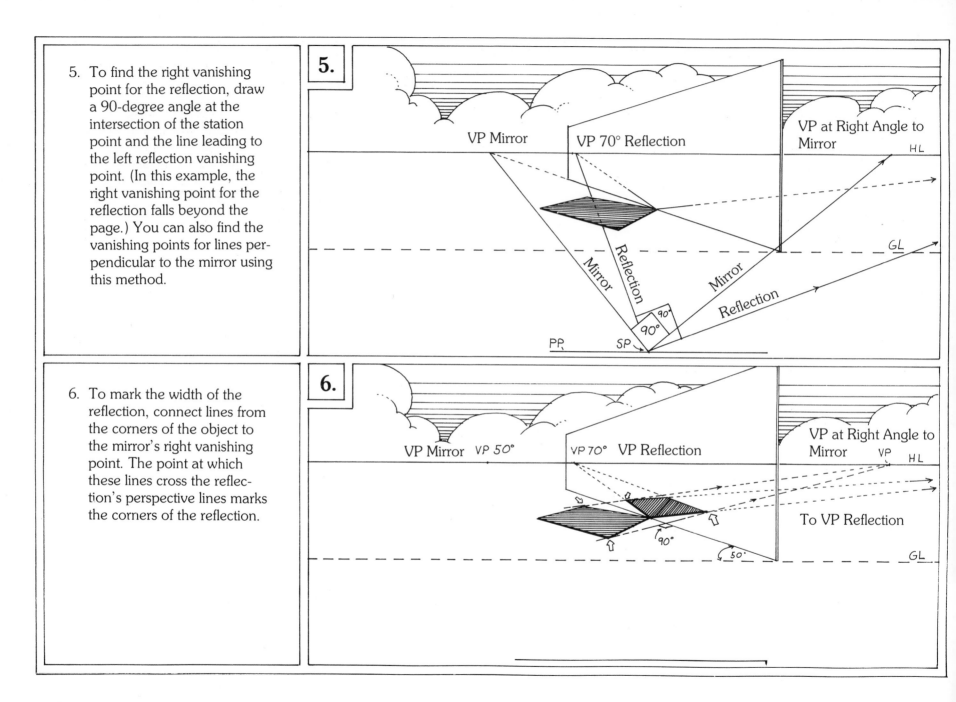

5. To find the right vanishing point for the reflection, draw a 90-degree angle at the intersection of the station point and the line leading to the left reflection vanishing point. (In this example, the right vanishing point for the reflection falls beyond the page.) You can also find the vanishing points for lines perpendicular to the mirror using this method.

5.

VP Mirror

VP 70° Reflection

VP at Right Angle to Mirror

HL

GL

Mirror

Reflection

Mirror

Reflection

90°

90°

PP

SP

6. To mark the width of the reflection, connect lines from the corners of the object to the mirror's right vanishing point. The point at which these lines cross the reflection's perspective lines marks the corners of the reflection.

6.

VP Mirror VP 50°

VP 70° VP Reflection

VP at Right Angle to Mirror VP HL

To VP Reflection

90°

50°

GL

132

1. Draw the plan above the picture plane. Here, the picture plane doubles as the horizon line. In laying out the plan, make sure the angle of the object and the angle of the reflection are equal and opposite.

2. Establish the distance from object to observer by setting the station point.

3. Establish the height of the observer from the ground line.

4. To find the mirror's vanishing point, set the 65-degree angle for the mirror at the station point.

5. Connect the lines between the station point and the key corners of the plan. Mark the points where these lines of sight cross the picture plane, then drop lines down into the view to mark off the proportions of receding planes.

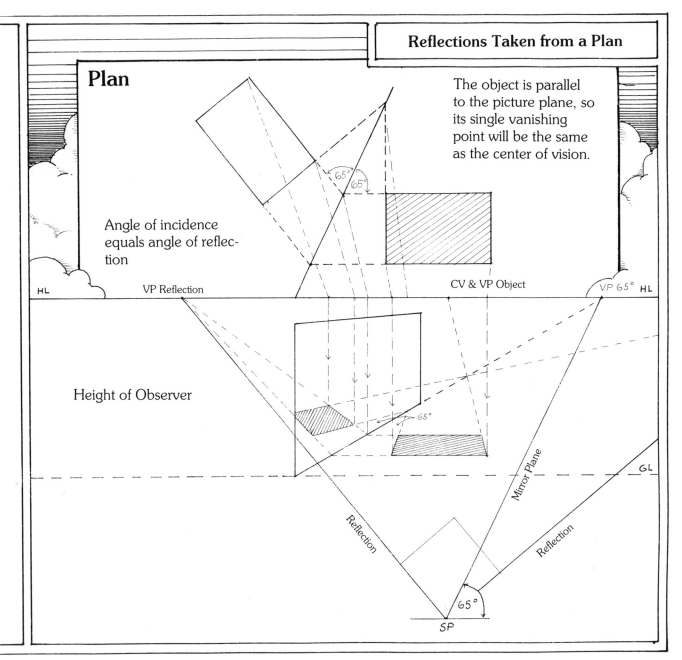

Plan

The object is parallel to the picture plane, so its single vanishing point will be the same as the center of vision.

Angle of incidence equals angle of reflection

65° 65°

HL VP Reflection CV & VP Object VP 65° HL

Height of Observer

65°

Mirror Plane GL

Reflection Reflection

65°

SP

133

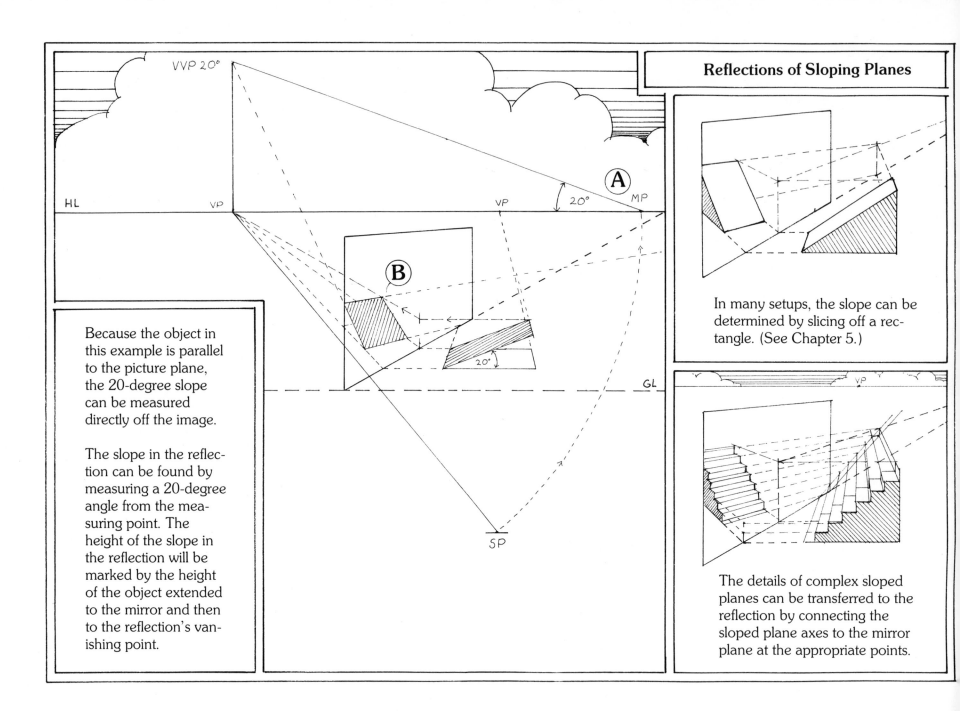

VVP 20°

HL

VP

VP

20°

Ⓐ

MP

Ⓑ

20°

GL

SP

Because the object in this example is parallel to the picture plane, the 20-degree slope can be measured directly off the image.

The slope in the reflection can be found by measuring a 20-degree angle from the measuring point. The height of the slope in the reflection will be marked by the height of the object extended to the mirror and then to the reflection's vanishing point.

In many setups, the slope can be determined by slicing off a rectangle. (See Chapter 5.)

VP

The details of complex sloped planes can be transferred to the reflection by connecting the sloped plane axes to the mirror plane at the appropriate points.

1. Set up the vanishing points for the mirror by establishing its right and left vanishing points on the horizon.

2. Using the measuring point, find the vertical vanishing point for the tilt of the mirror. Here, the angle is 70 degrees.

3. Draw the object. Note that it is 90 degrees off the ground plane, angling it 20 degrees off the tilted mirror.

4. To find the angles of the reflection's vertical lines, add another 20-degree angle to the angle of the mirror at the measuring point. This establishes the vanishing point for reflections on the vertical vanishing line.

5. Adding a 90-degree angle to this reflection angle will give you the vertical vanishing point below the horizon for the perpendicular angles of the reflection.

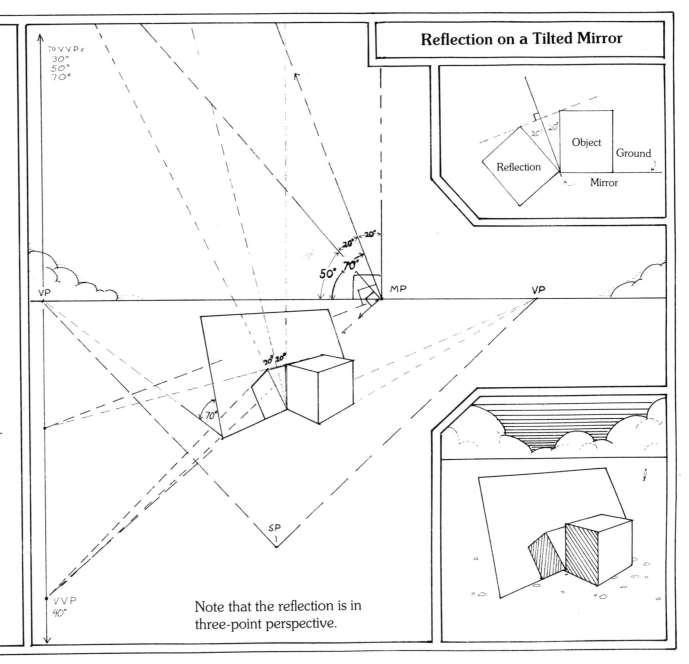

Reflection on a Tilted Mirror

Note that the reflection is in three-point perspective.

Examples of Perspective Views

8

Step-by-Step Construction and Analysis

1. Boxes
2. Table
3. Chair
4. House (Exterior)
5. House (Interior)
6. Cityscape
7. Spiral Staircase
8. Bicycle
9. Motorcycle

10. Classic Automobile
11. Contemporary Automobile
12. Boat Hull
13. Airplane
14. Spacecraft
15. Landscape
16. Human Figures
17. Spoon, Cup, and Glass

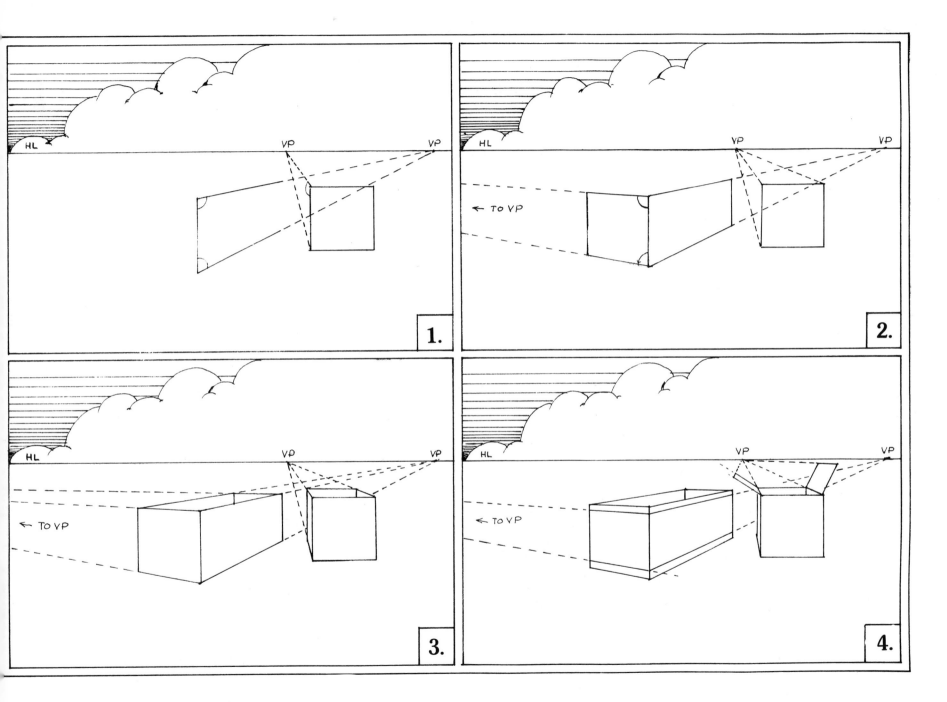

137

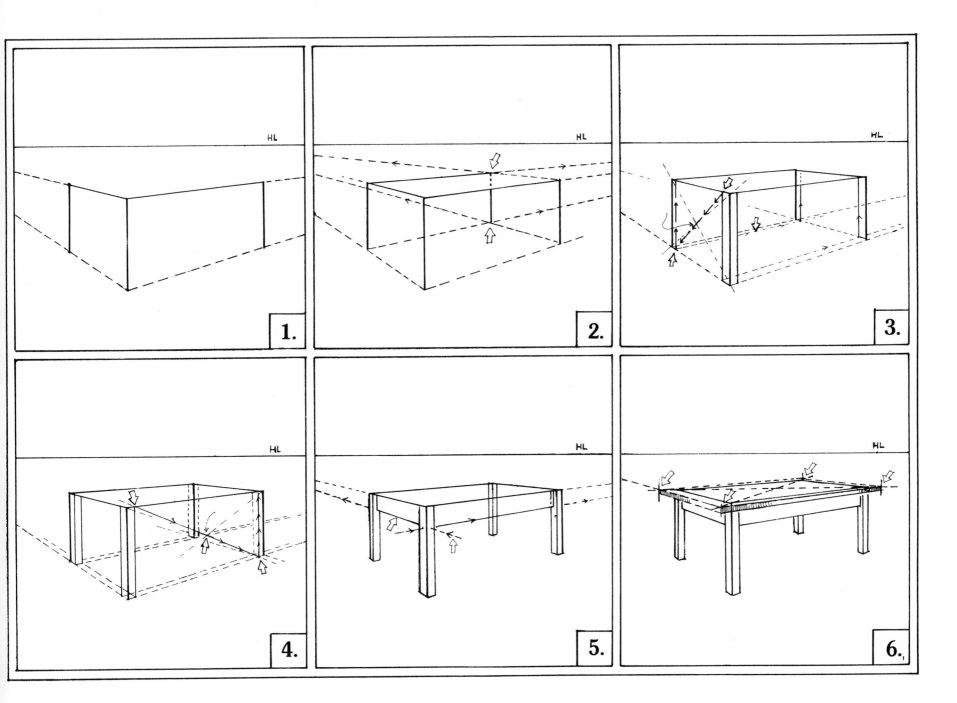

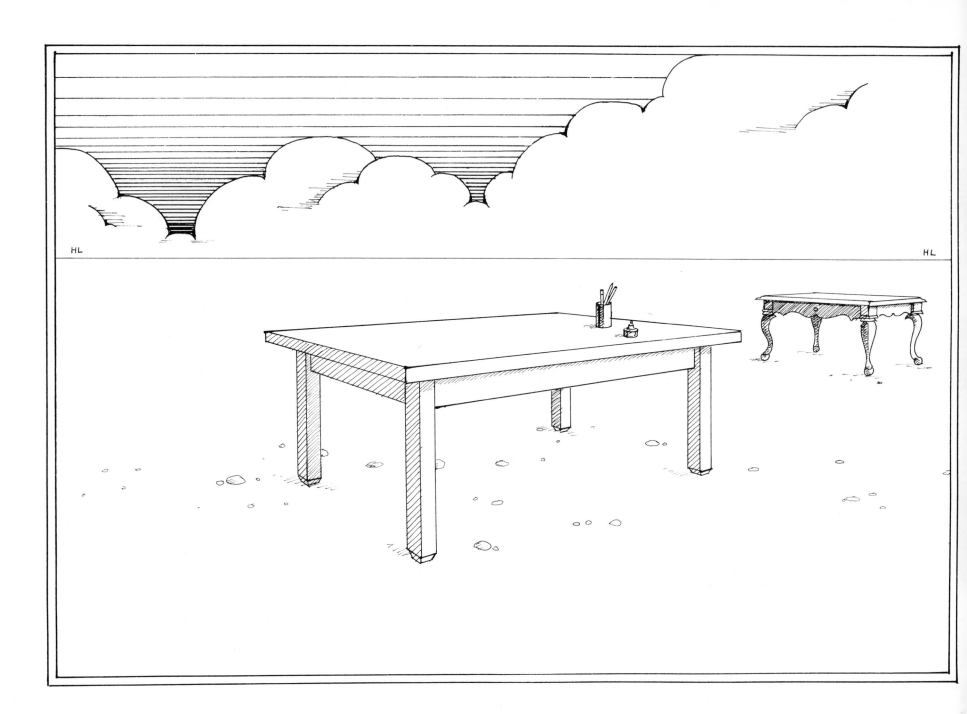

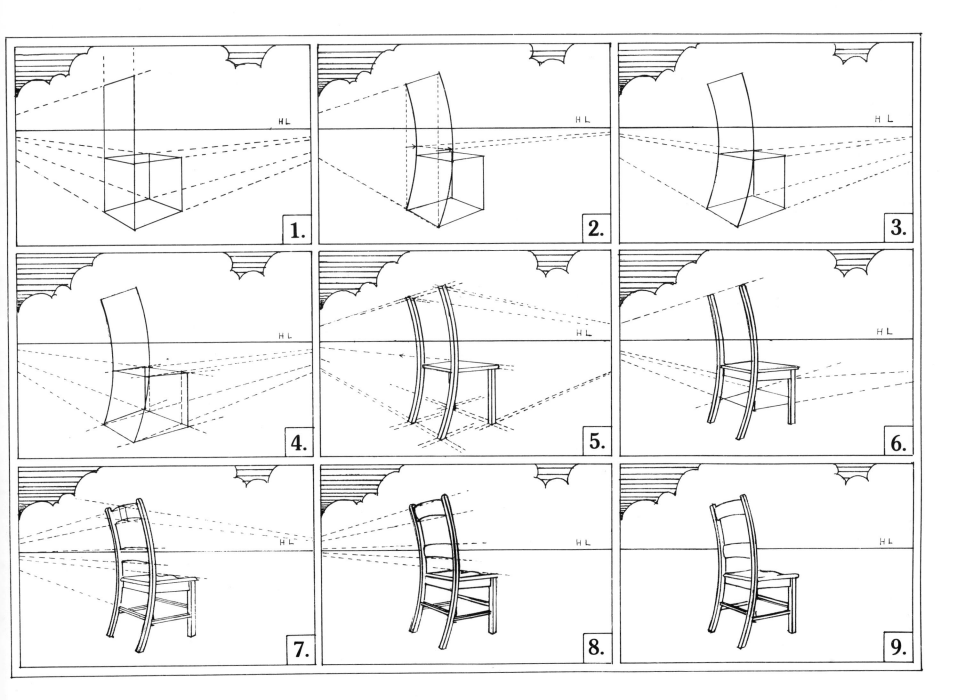

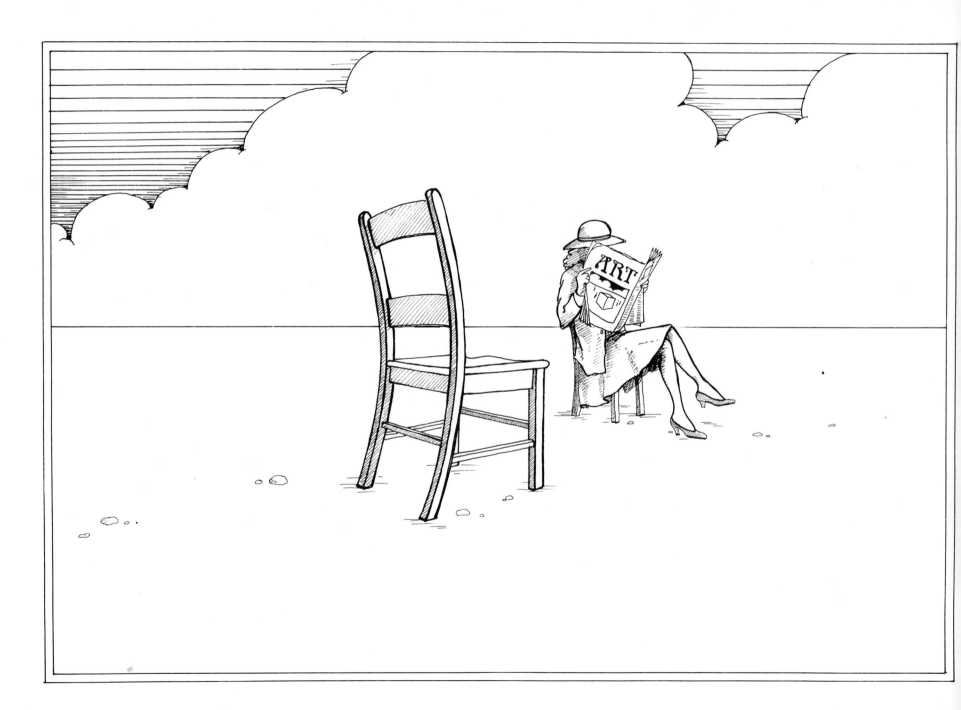

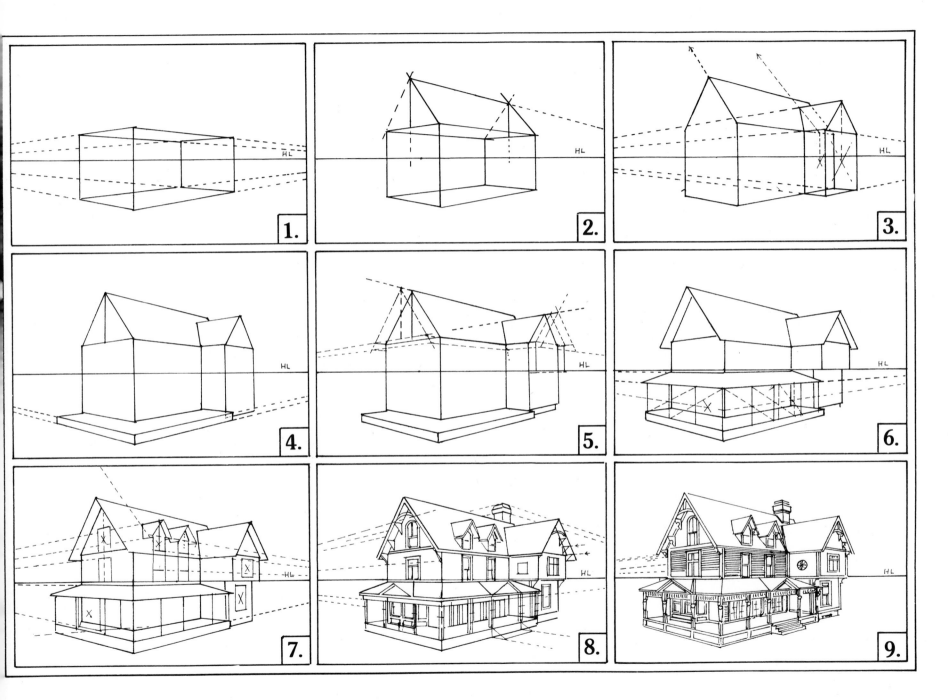

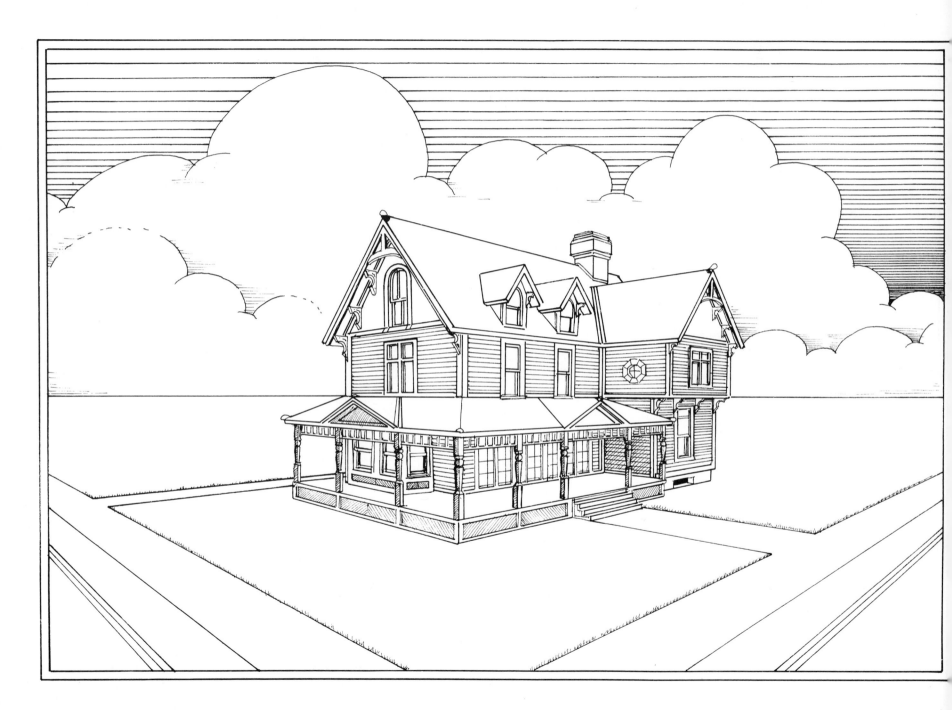

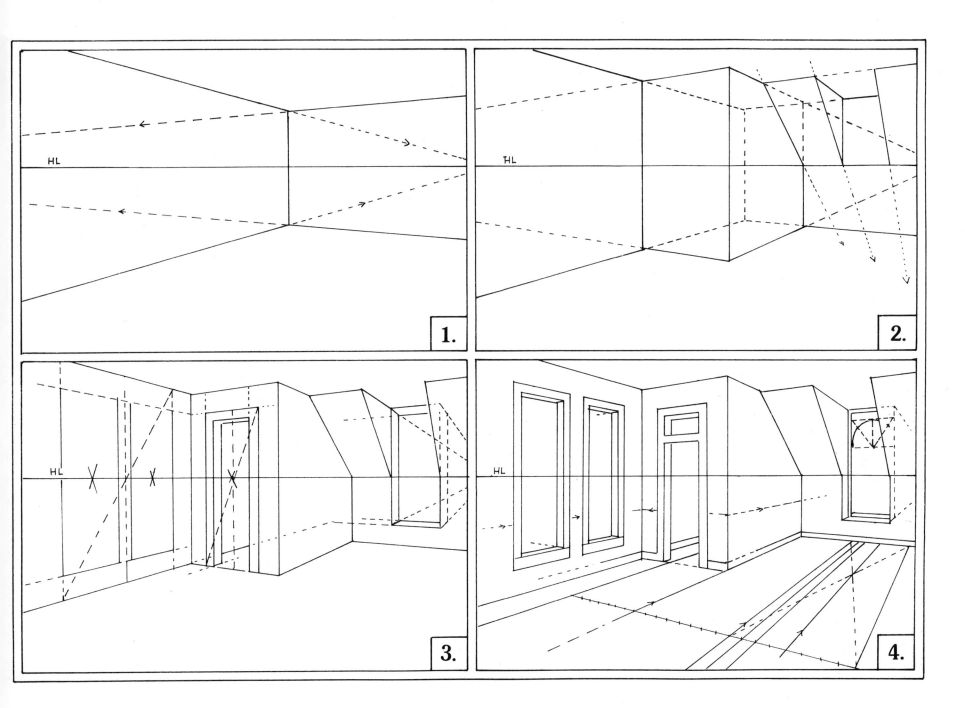

1.

2.

3.

4.

145

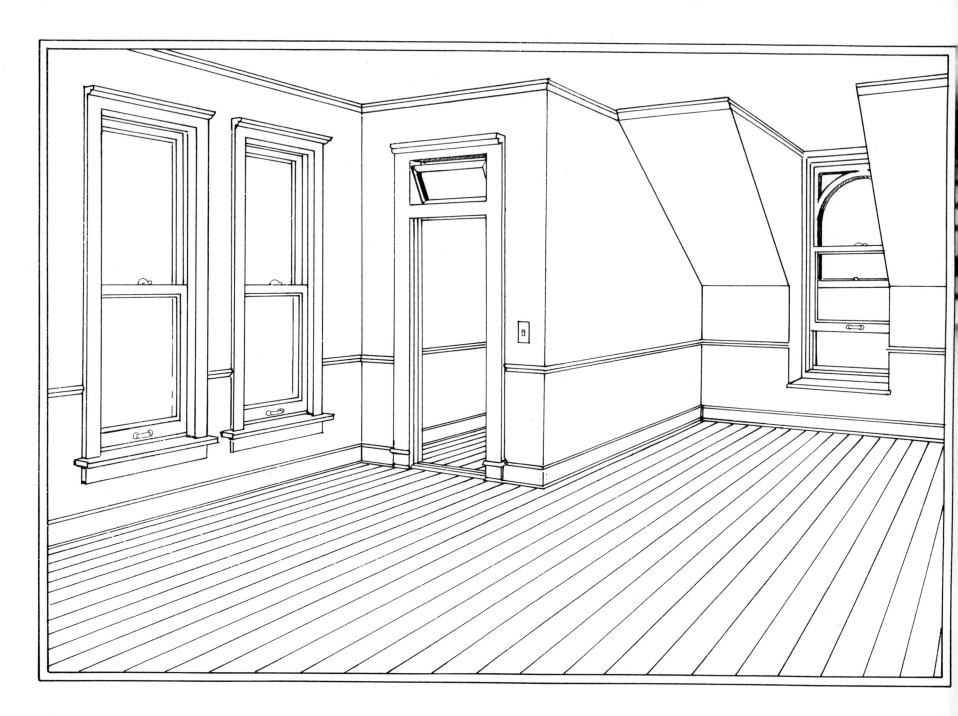

146

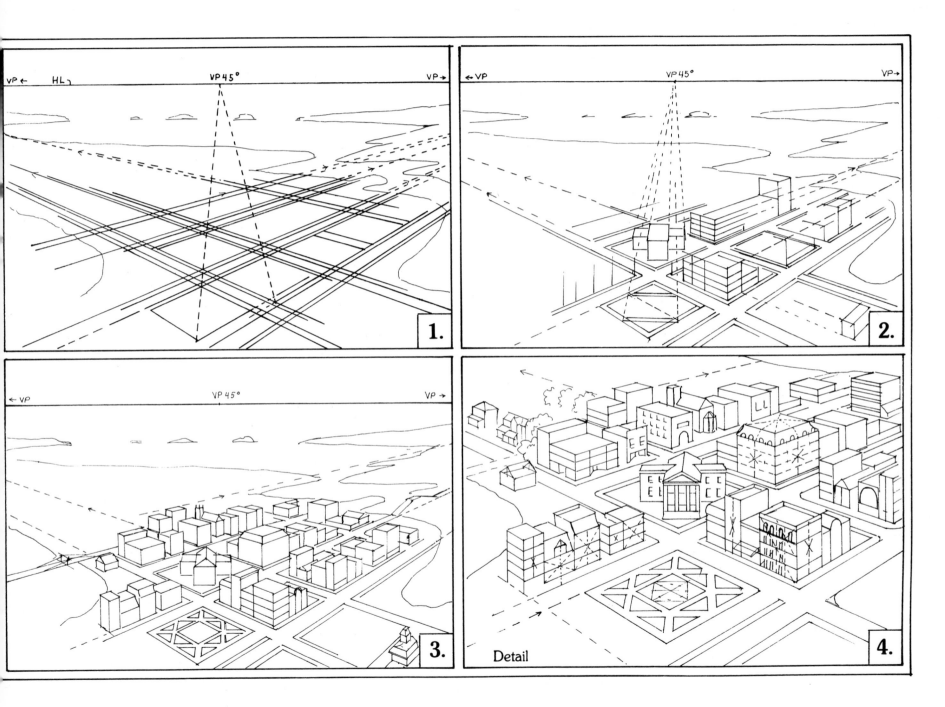

VP ← HL┐ VP 45° VP →

1.

← VP VP 45° VP →

2.

← VP VP 45° VP →

3.

Detail

4.

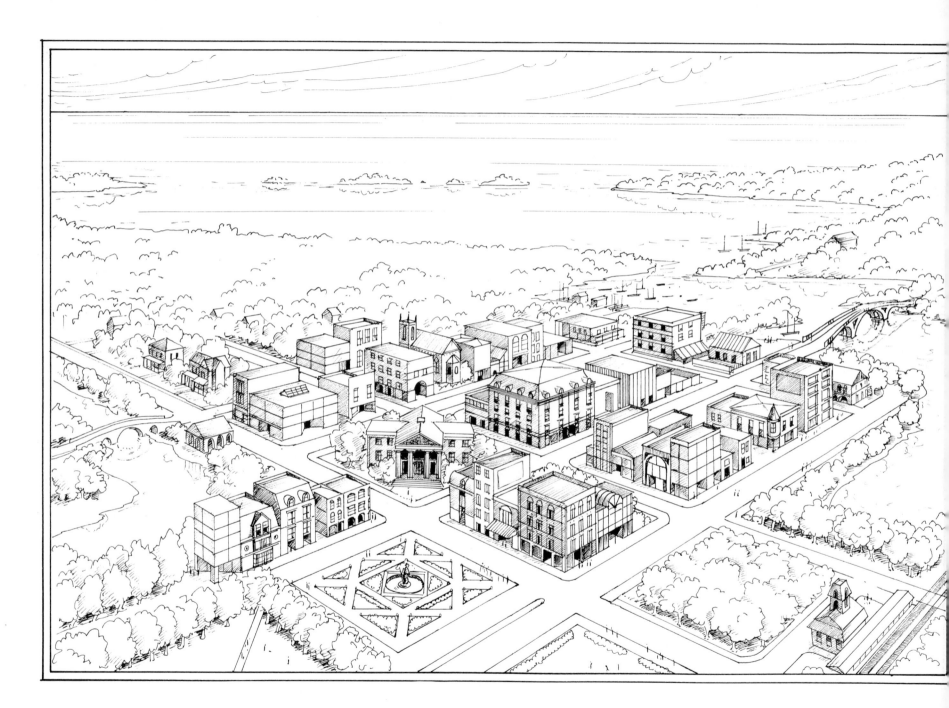

148

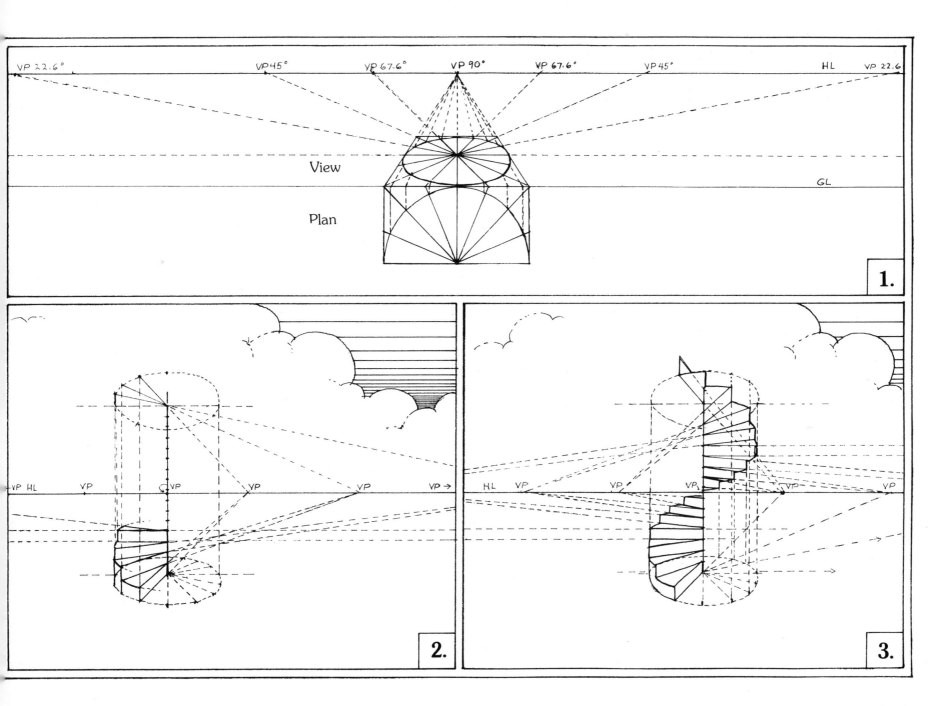

VP 22.6° VP45° VP 67.6° VP 90° VP 67.6° VP 45° HL VP 22.6

View

GL

Plan

1.

VP HL VP VP VP VP VP →

2.

HL VP VP VP VP VP

3.

149

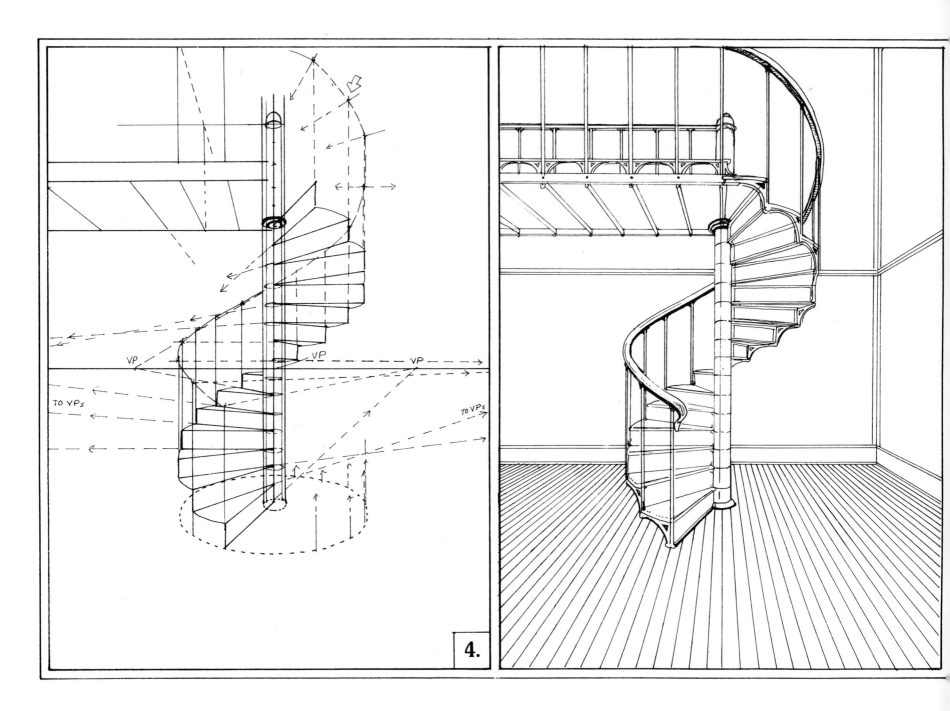

VP

VP

VP

TO VPs

TO VPs

4.

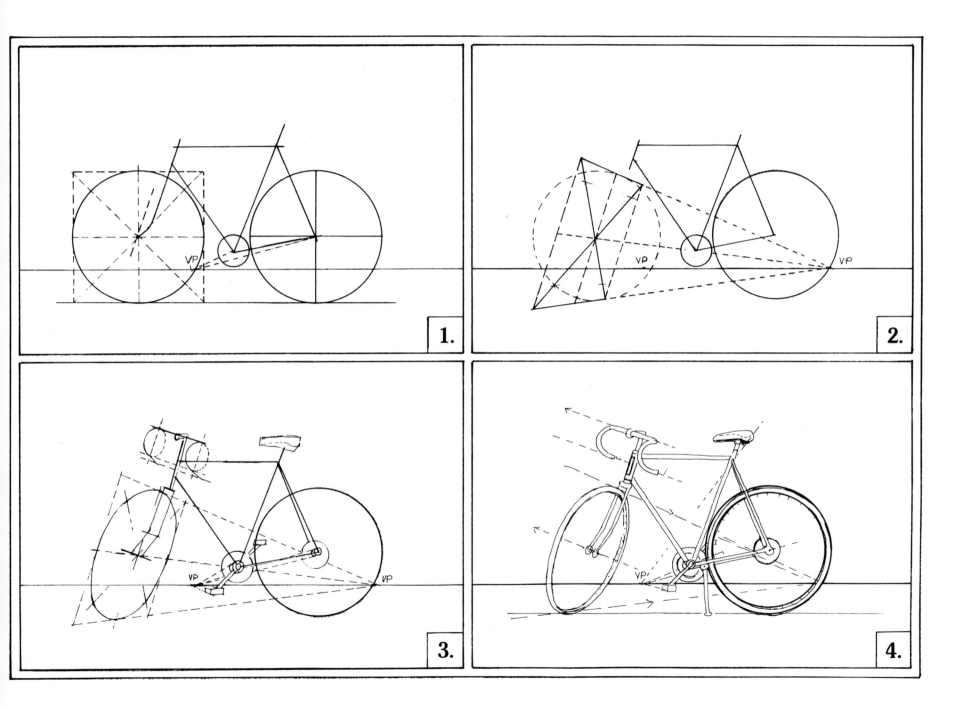

1.

2.

3.

4.

151

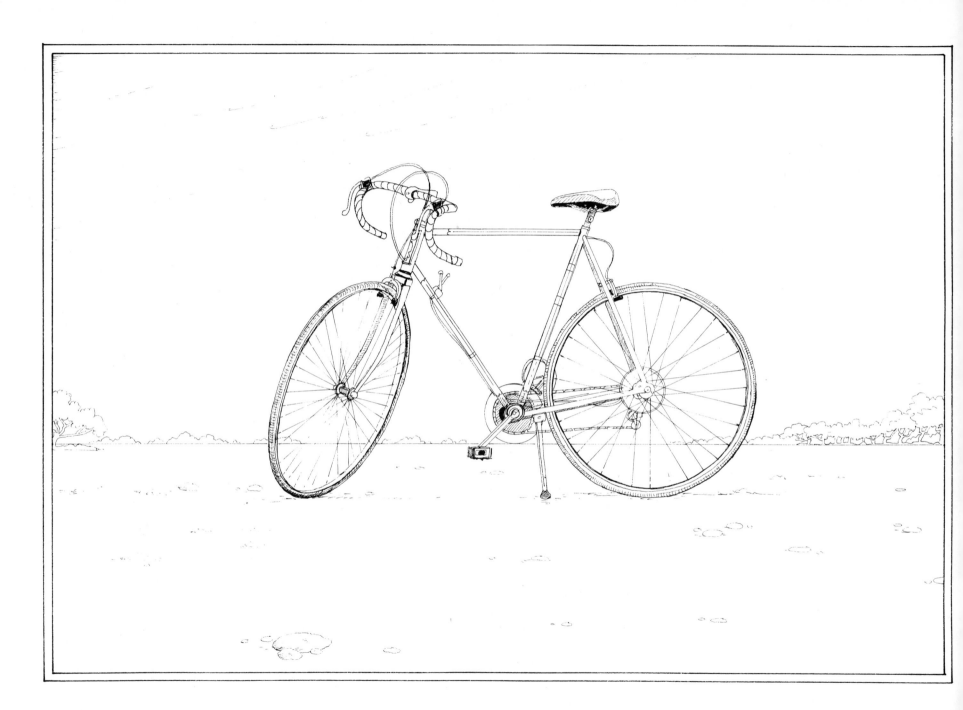

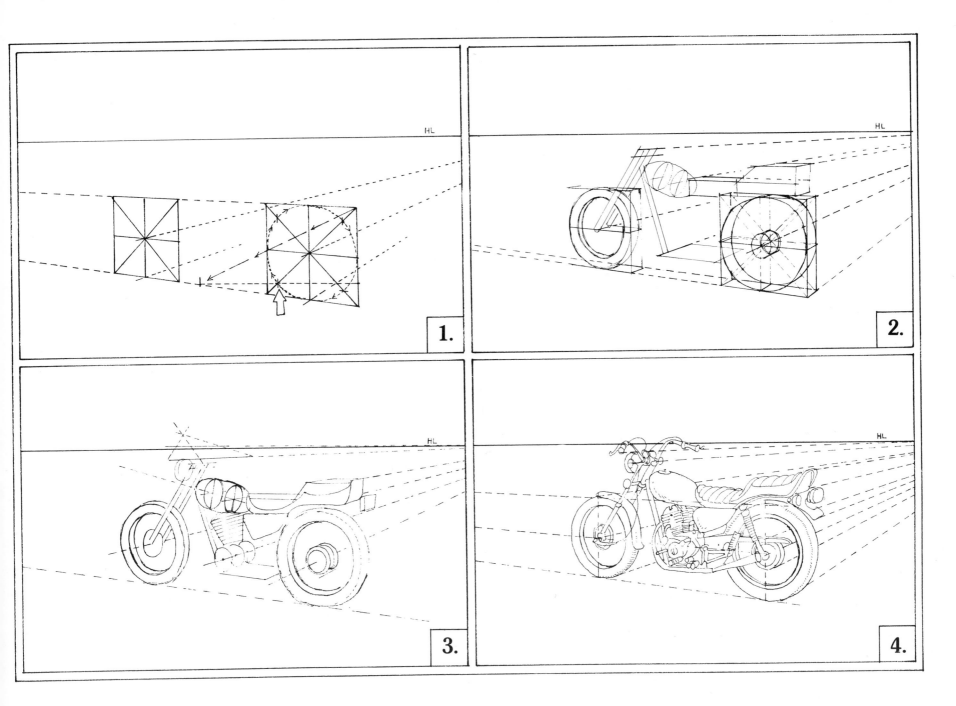

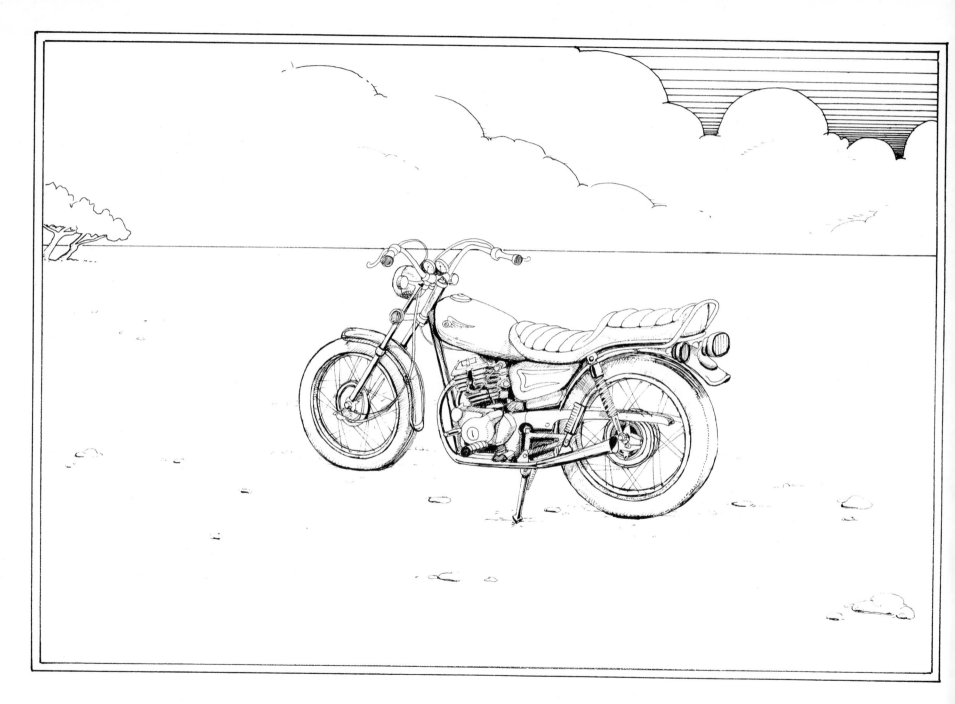

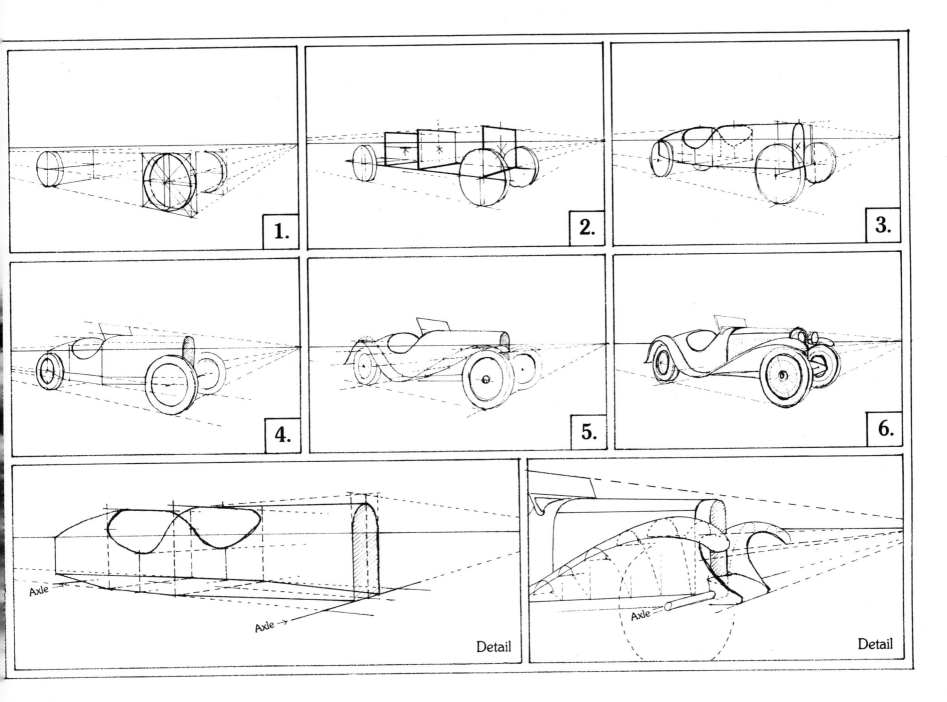

1.

2.

3.

4.

5.

6.

Axle

Axle →

Detail

Axle

Detail

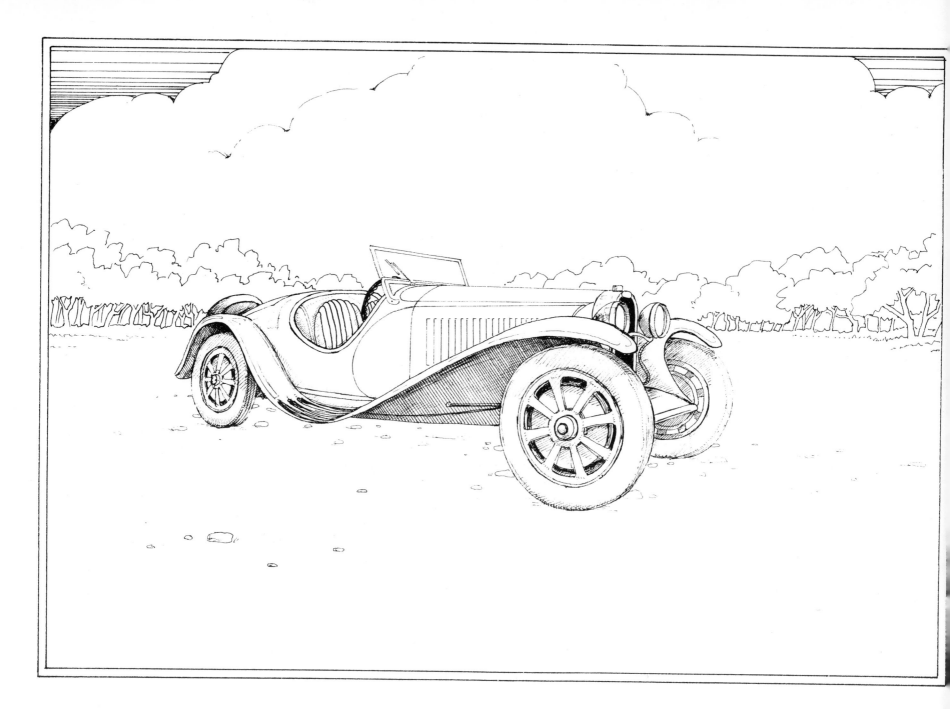

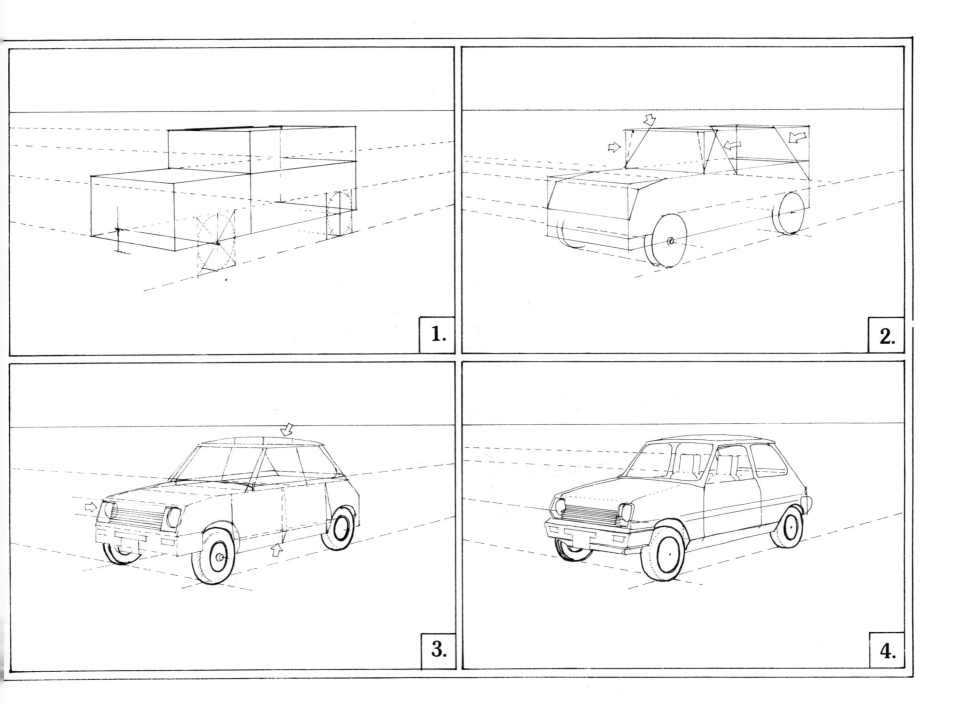

1.

2.

3.

4.

157

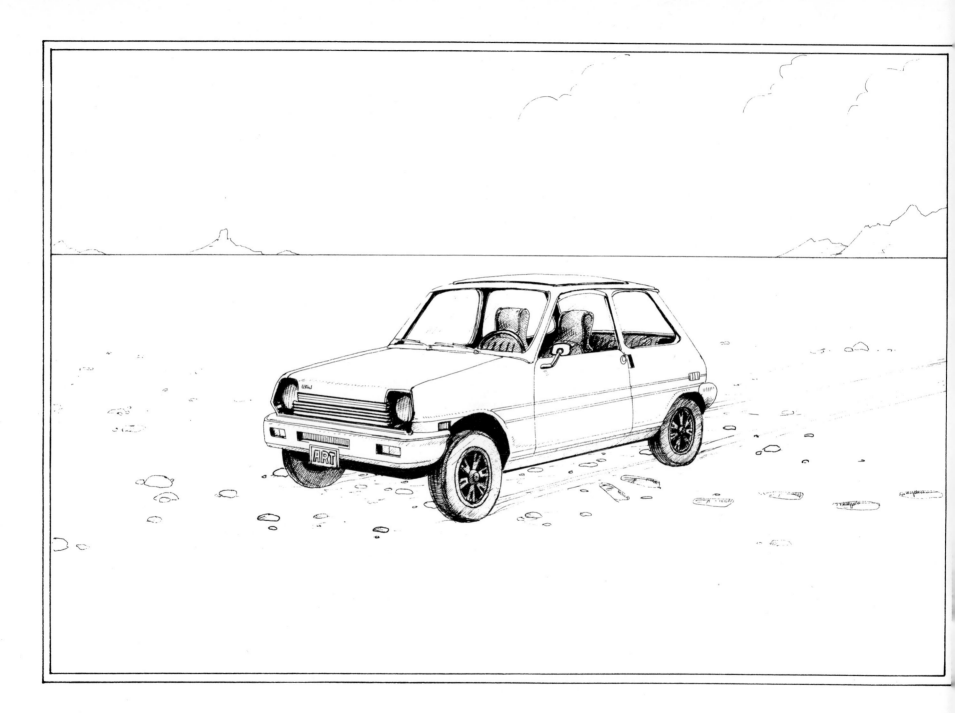

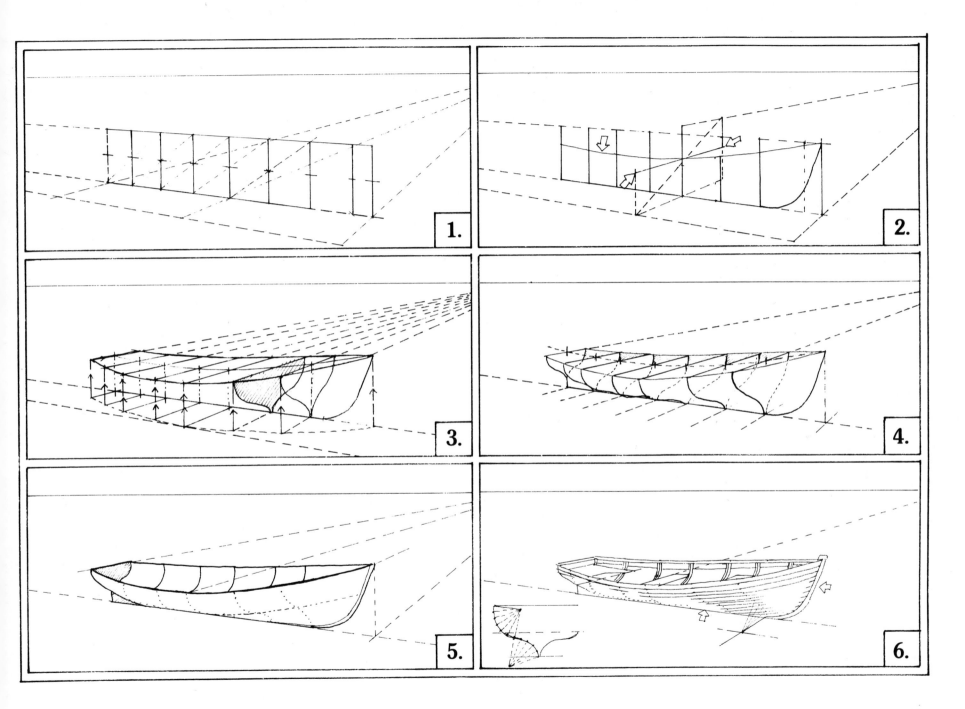

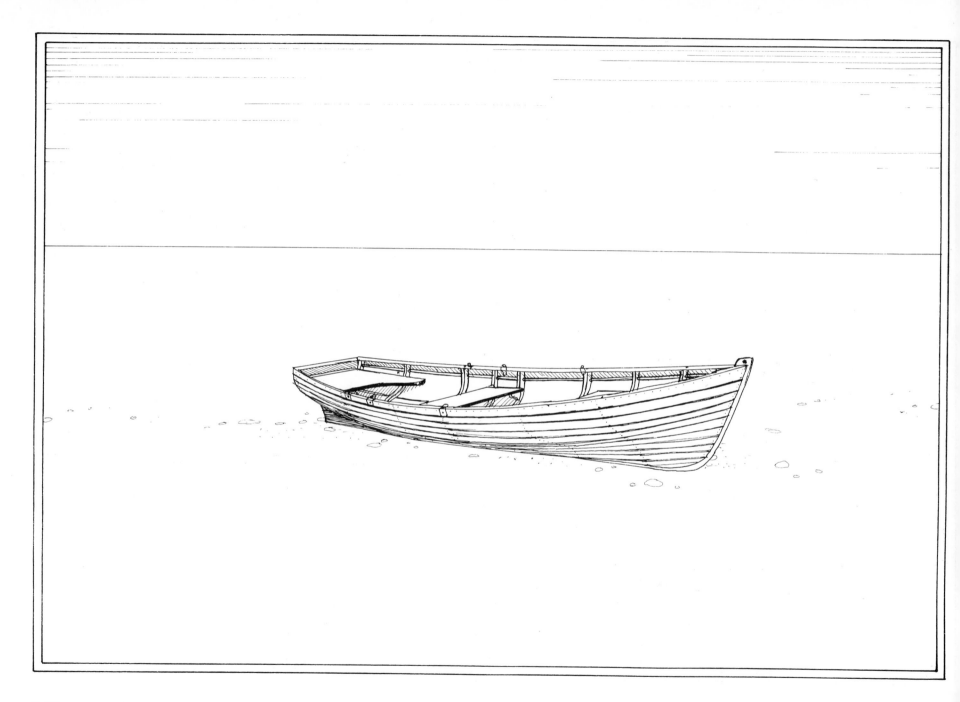

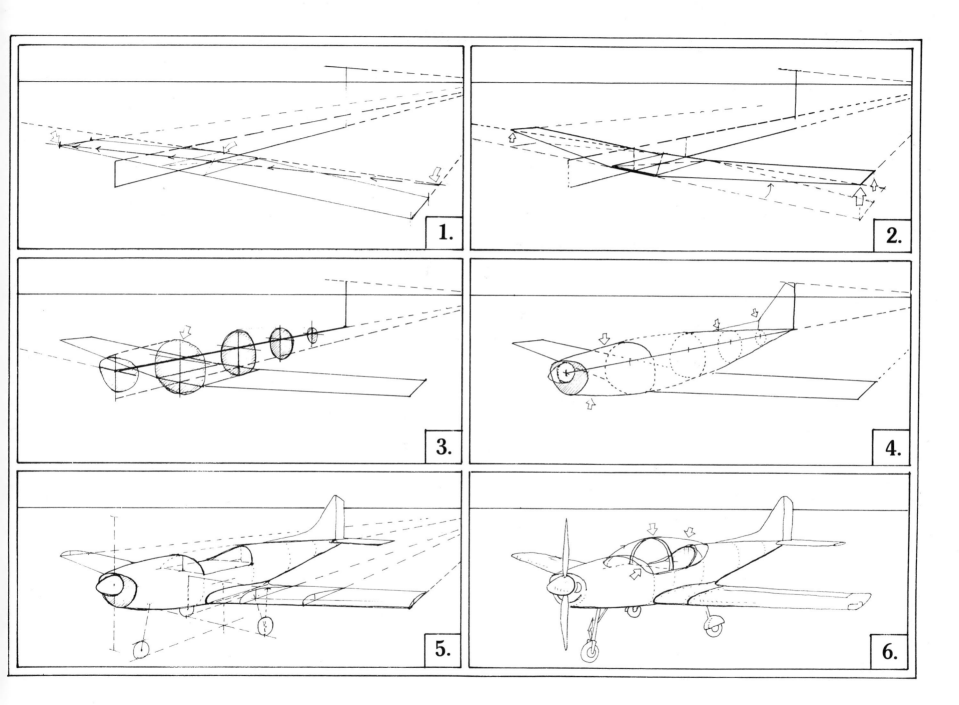

1.

2.

3.

4.

5.

6.

161

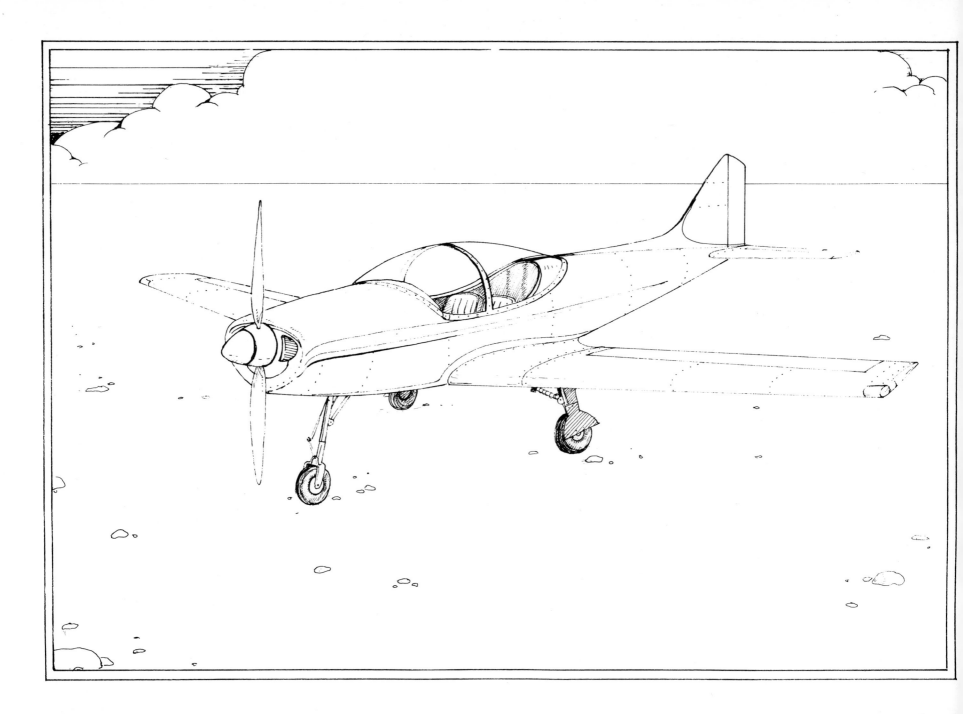

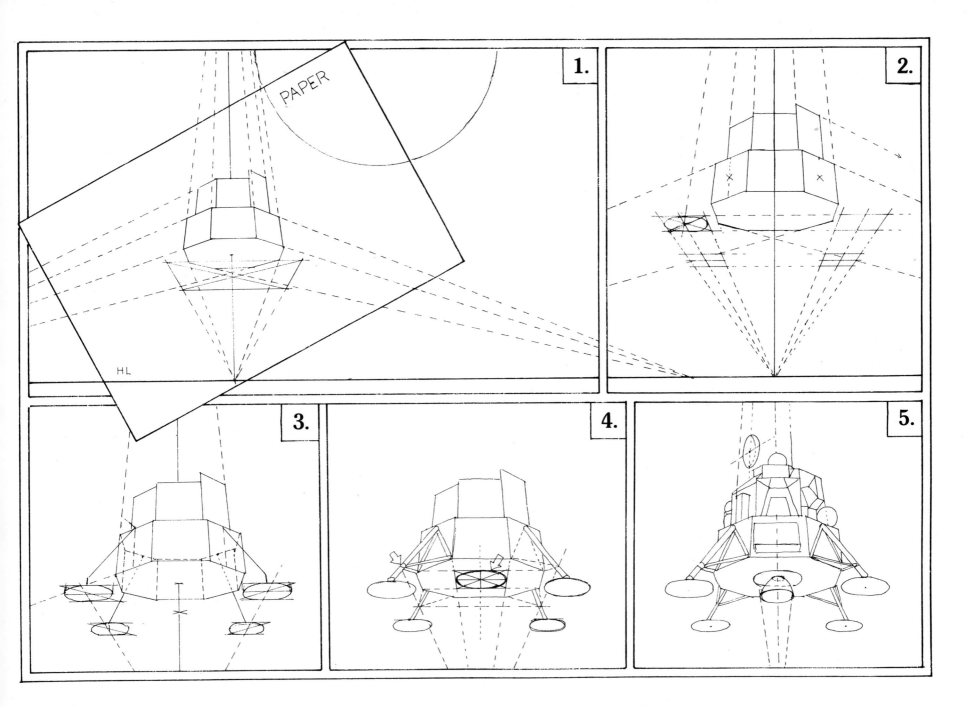

1.

PAPER

HL

2.

3.

4.

5.

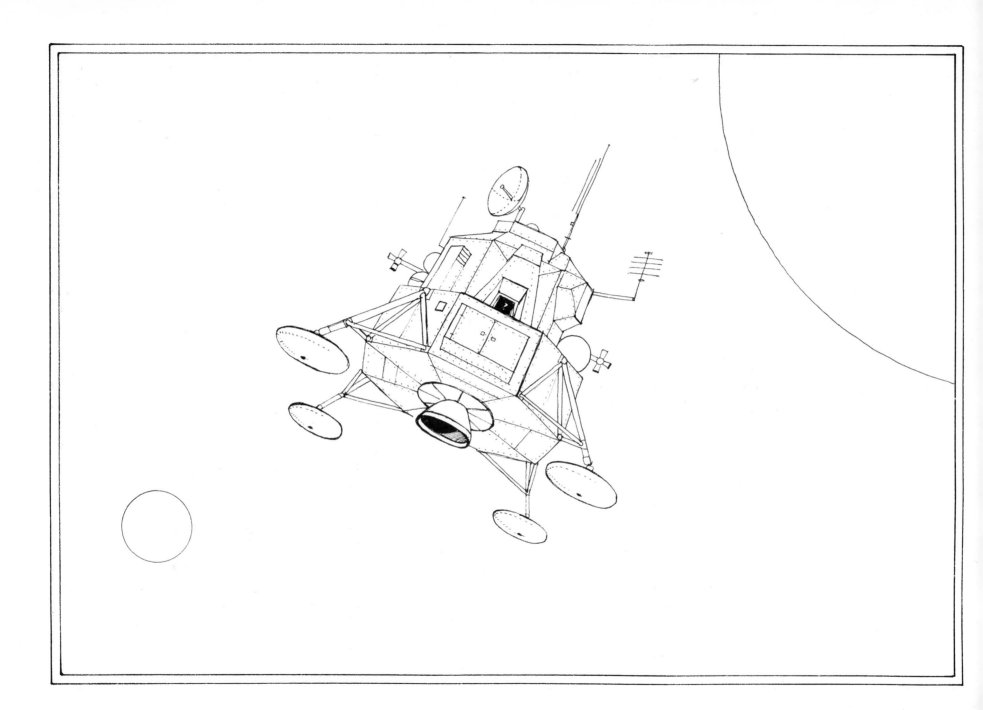

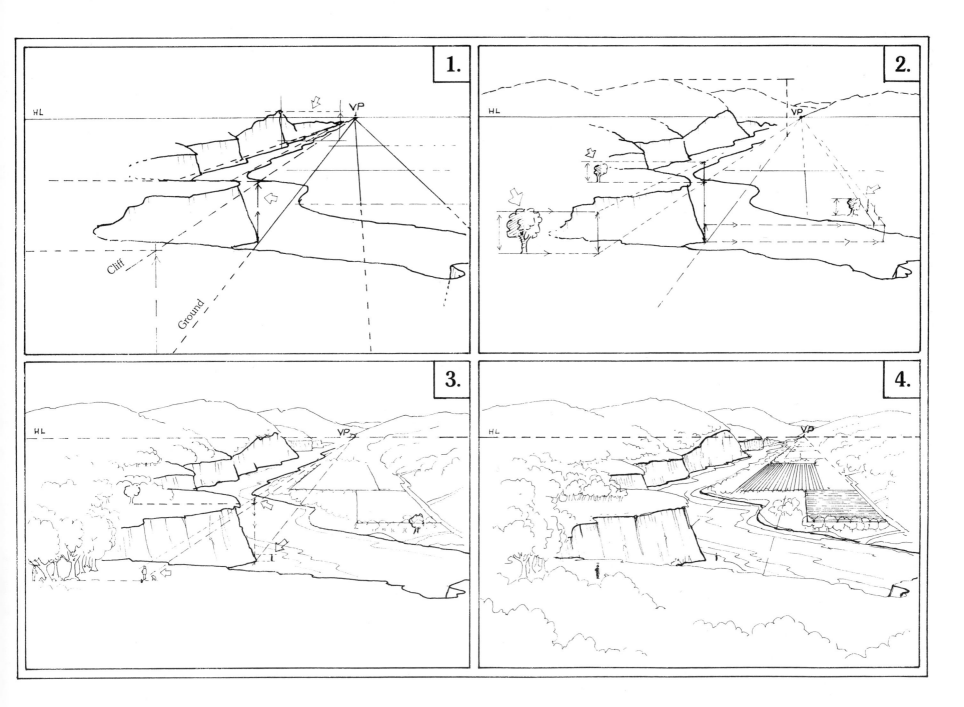

1.

HL

VP

Cliff

Ground

2.

HL

VP

3.

HL

VP

4.

HL

VP

165

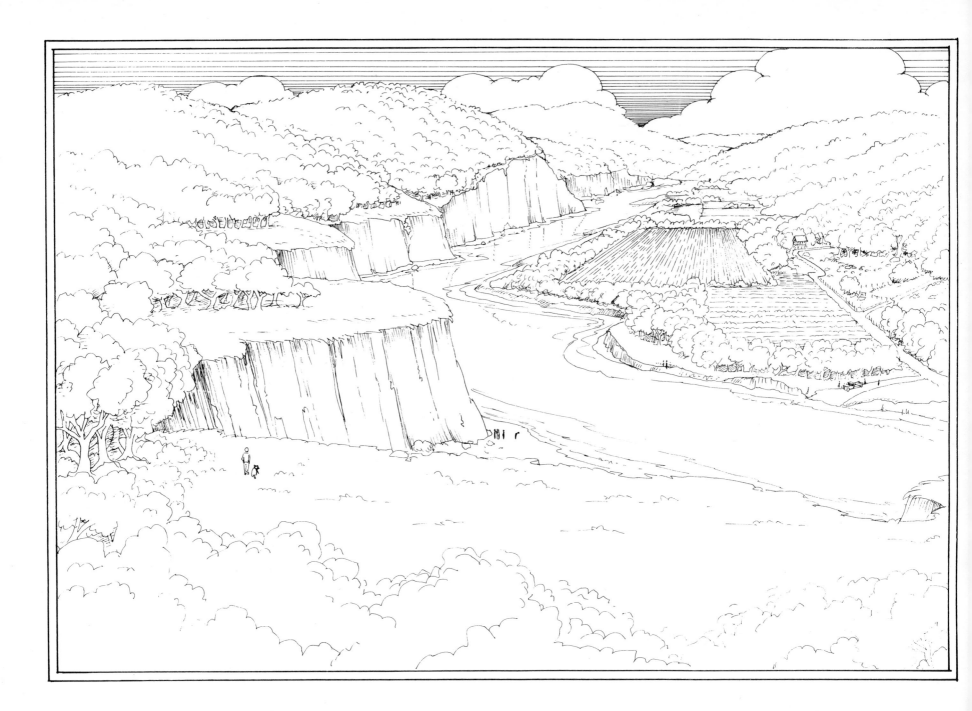

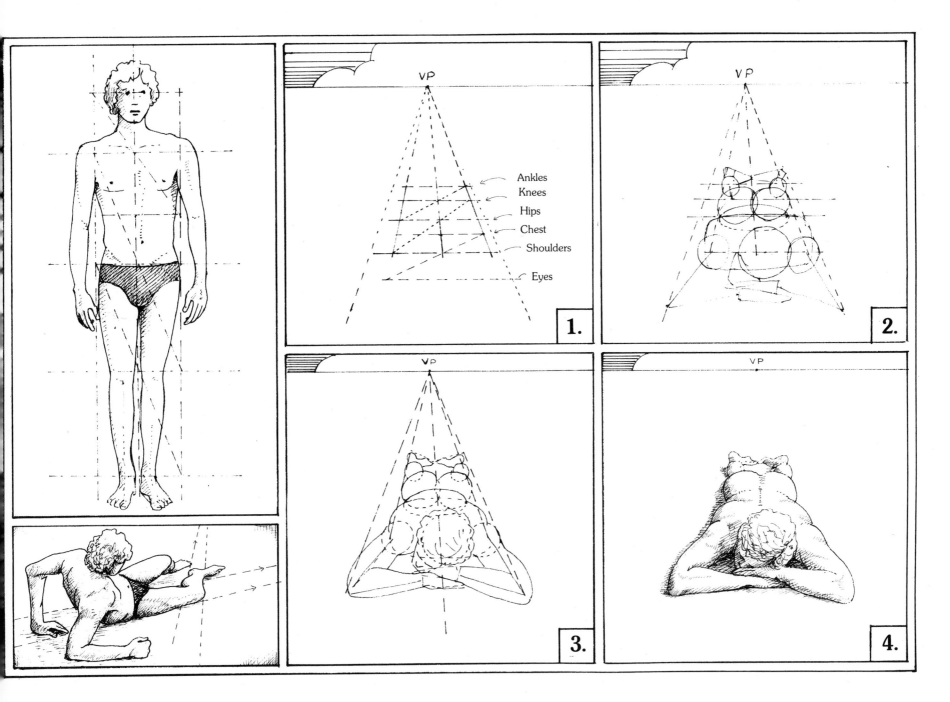

Ankles
Knees
Hips
Chest
Shoulders

Eyes

1.

2.

3.

4.

167

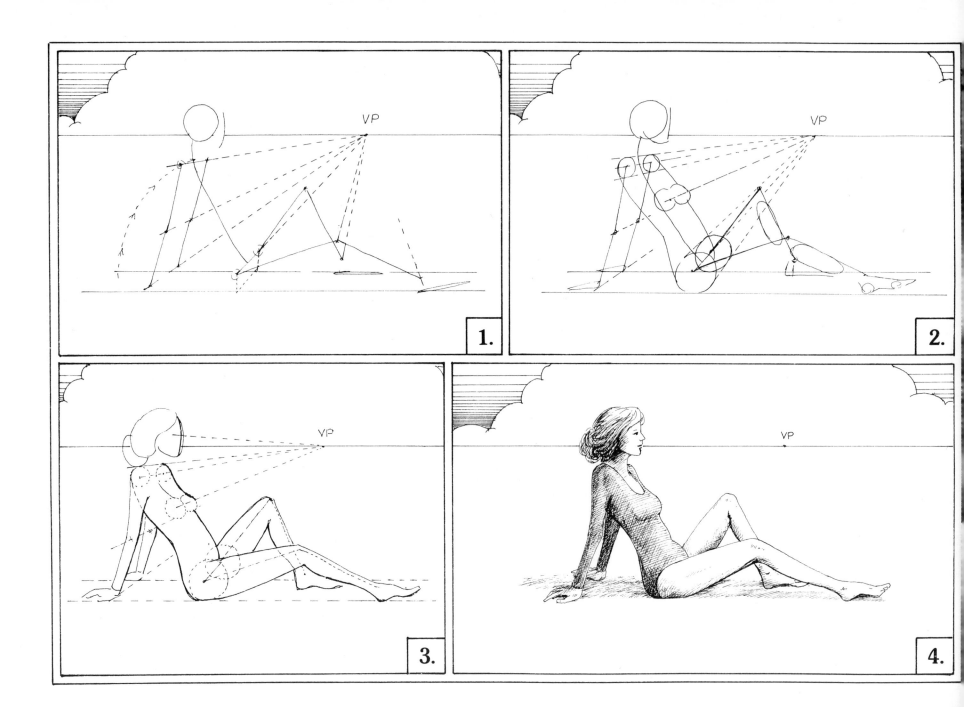

1.

2.

3.

4.

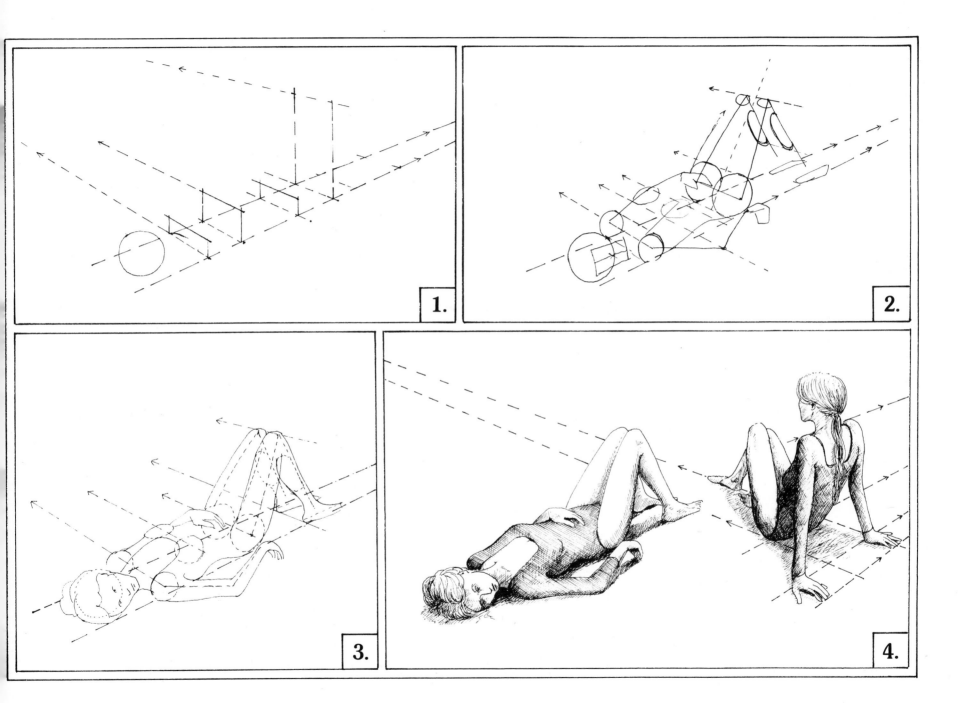

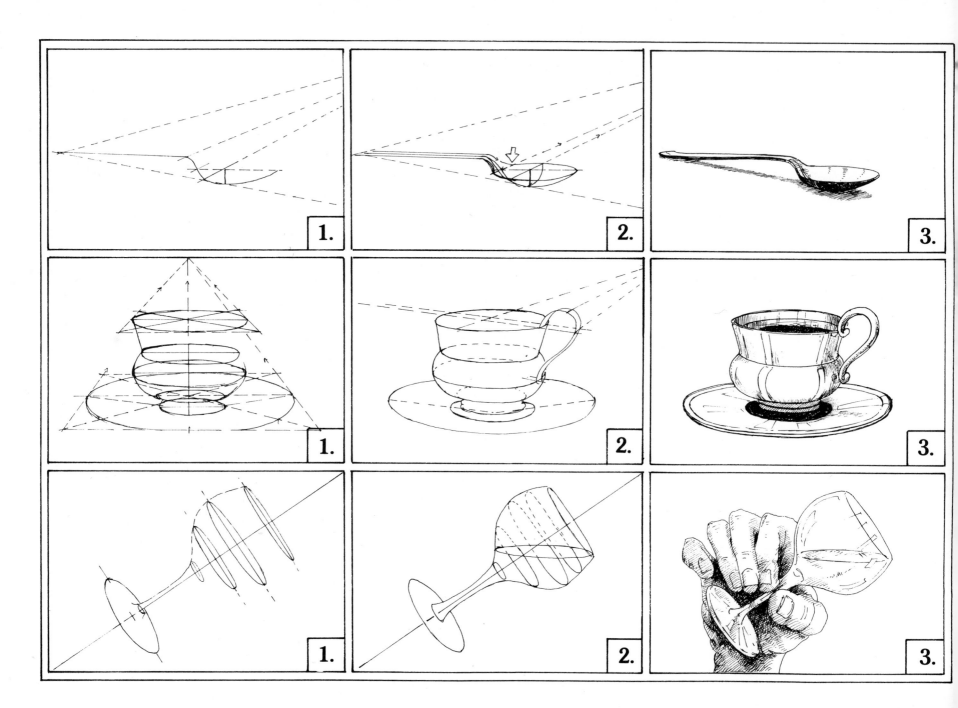

Index